OCT. L.D.R.S #1 cover.

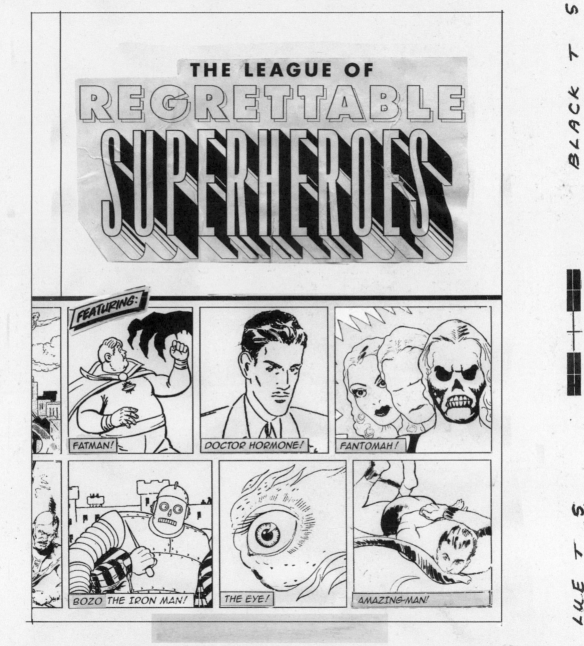

**For Mom and Pop, and their house
stuffed to the rafters with comic books**

Copyright © 2015 by Jon Morris
All rights reserved. No part of this book may be reproduced
in any form without written permission from the publisher.
Library of Congress Cataloging in Publication Number: 2014909459
ISBN: 978-1-59474-763-2
Printed in China
Typeset in Futura and Plantin
Designed by Timothy O'Donnell
Production management by John J. McGurk

All illustrations in this book are copyrighted by their respective copyright
holders (according to the original copyright or publication date as printed
in the comics) and are reproduced for historical purposes. Any omission
or incorrect information should be transmitted to the author or publisher
so that it can be rectified in any future edition of this book. All DC Comics
characters, related logos, and indicia are trademarked and copyrighted by
DC Comics Inc. All Marvel Comics characters, related logos, and indicia
are trademarked and copyrighted by Marvel Comics Inc. All Dell Comics
characters, related logos, and indicia are trademarked and copyrighted by
Dell Comics Inc. All Harvey Comics characters, related logos, and indicia
are trademarked and copyrighted by Harvey Comics Inc. All Archie Comics
characters, related logos, and indicia are trademarked and copyrighted by
Archie Comics Inc.

Quirk Books
215 Church Street
Philadelphia, PA 19106
quirkbooks.com
10 9 8 7 6 5 4 3 2 1

THE LEAGUE OF
REGRETTABLE
SUPERHEROES

BY JON MORRIS

QUIRK BOOKS
PHILADELPHIA

INTRODUCTION

SUPERHEROES ARE BIG!

Contemporary culture has embraced super-heroes in a major way. Hardly a month goes by without an announcement about the release of a new blockbuster superhero movie. Superhero television shows are all over the airwaves, with more waiting in the wings. Superheroes popul-ate our video games, advertising, clothing, and collectibles—even home furnishings. You can make your bed with superhero sheets and light your house with superhero lamps.

Perhaps this ubiquity should come as no surprise. When superheroes burst onto the scene almost eighty years ago, they captured the public imagination like nothing before. Bold, distinctive, and sometimes bizarre, the four-color caped crusaders quickly leapt from drugstore comic book racks to newspapers,

radio, movie theaters, and television. True, their popularity has had its ups and downs. But however you look at it, brightly colored defenders of right and goodness like Captain America, Superman, Wonder Woman, and Spider-Man have become household names. Even once-obscure characters like the X-Men or Guardians of the Galaxy have achieved silver screen success.

Still, not every Spandex-clad do-gooder manages to make the big time. From the very origins of the genre to the newest digital graphic novels, the family tree of costumed crimefight-ers includes hundreds of third-stringers and Z-listers: near-misses, almost-weres, mighta-beens, nice tries, weirdos, oddballs, freaks, and even the occasional innovative idea that was simply ahead of its time.

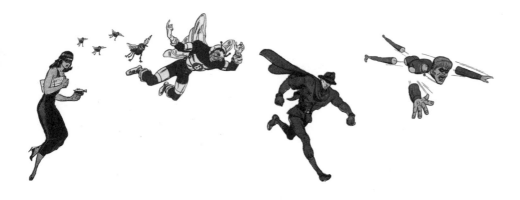

In the pages that follow, you'll meet largely forgotten heroes, those who walked away from their comic book careers without so much as a participation ribbon to show for it. They are some of the most intriguing also-rans in comics history: super-centaurs, crime-fighting kangaroos, modern-day Draculas, shape-changing spaceships, and even an all-powerful disembodied flying eye. We call these second-tier (or lower) superheroes "regrettable," but it's important to remember that none of these characters are inherently bad. Sometimes, the only factor that kept them from succeeding was bad timing, an unstable marketplace, or merely being lost in the crowd. There's not a single character in this book who doesn't have at least the *potential* to be great. All it takes is the perfect combination of creative team and right audience to make even the wildest idea a wild success.

In fact, several members of the League of Regrettable Superheroes have been revived, revamped, reintroduced, or otherwise regifted with a new lease on life. A few are attempting a comeback even now. In comics, there's always a chance that a seemingly vanished character will come back from extinction. With superheroes becoming more popular with every passing day, you never know when a once-regrettable hero might return and become the next media sensation—or at least find devoted fans among a whole new generation of comics readers.

To count these heroes out and consign them to oblivion without appreciating what they represent—evolving notions of heroism, insights into comics history, and a sampling of fantastic fashion trends in cape-and-cowl ensembles— well, that would be *truly* regrettable.

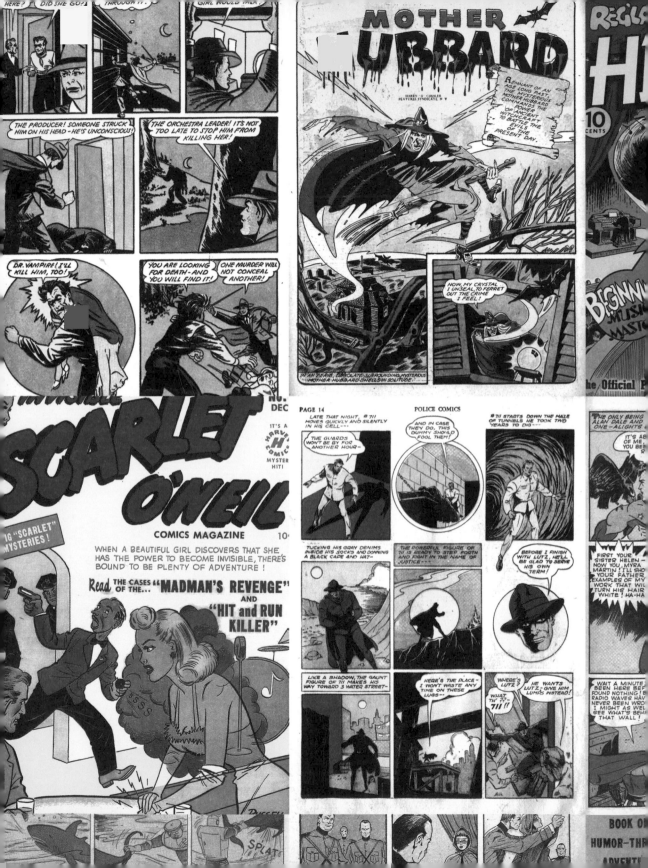

THE GOLDEN AGE 1938–1949

AH, THE GOLDEN AGE OF SUPERHEROES, an exuberant era of two-fisted action and adventure, when every Super-Tom, Wonder-Dick, and Amazing-Harry could throw on a cape and a cowl and give Hitler the business!

Superheroes were a brand-new phenomenon when Superman debuted in *Action Comics #1*, late in the spring of 1938. Prior to the Man of Steel hefting sedans and sending ne'er-do-wells scurrying, colorful crimefighters had been restricted to a few garish characters in the pulp magazines— notably the Spider, the Shadow, and Doc Savage, along with a dozen or so other injustice-intolerant crusaders standing up against evil. These vigilantes possessed elements of superherodom; some had secret identities, some possessed paranormal abilities, some wore what might be considered a costume.

But it was Jerry Siegel and Joe Shuster's red-caped champion who combined those disparate characteristics into a heroic template that is still emulated today. After Superman the floodgates opened, and magazine racks were deluged with atom rays, jet packs, leering villains, and triumphant figures clad in primary-colored costumes leaping over cityscapes. Any word that could precede "-Man" or follow a color suddenly became the sobriquet of a four-color crimebuster. This was a time when the conventions of the superhero genre were still being set, and few ideas seemed too crazy to achieve Superman-level success. Countless publishers scrambled for a foothold in the burgeoning comic book industry, although not all of their efforts met with success. Fortunately for our purposes, the failures tended to be *plenty weird*.

NOTE: Not everyone agrees on the exact limits of these comicbook-dom epochs, but the debut of Superman is generally considered the big bang of superhero comics.

711

"I'm #711, and my place is back behind these walls!"

Created by:
George Brenner
(who also created
The Clock—the
first masked hero in
comics!)

Debuted in:
Police Comics #1
(Quality Comics,
August 1941)

Rap sheet:
Perjury, Conspiracy,
Poor Forethought,
Lack of Planning

© 1941 by Quality Comics

OMETIMES, IT DOESN'T PAY to be a nice guy. Attorney Daniel Dyce finds that out the hard way when he decides to do a favor for his good friend Jacob Horn, whose wife is about to give birth. It seems Horn won't be able to attend the delivery because of a little problem: he's about to begin serving a life sentence behind bars. The scheme the two men hatch is so unlikely that it belongs on the corniest of sitcoms: Dyce will confess to Horn's crimes while Horn visits his wife in the hospital. After a few days, Horn will turn himself in and clear Dyce's name. You'd think an attorney would have devised a better plan . . .

Fate plays its hand and Horn crashes his car en route to the hospital. With his friend dead, no one can clear Dyce, who has no choice but to tunnel out of jail and adopt a crime-fighting identity, of course! Basing his costumed persona on his prison number (and not the famous convenience store), Dyce becomes 711, a caped and masked figure who torments criminals by night and returns to his prison cell by morning. His calling card: a mirrored business card with prison bars painted on it to show criminals their future!

From a crime-fighting perspective, 711's decision to remain in jail pays off in the form of prison gossip, allowing Dyce to eavesdrop on the schemes of his fellow inmates and their nefarious associates. On more than one occasion, the crooks who get busted by 711 end up in the same prison as Dyce. Apparently, this bonus gives the crime-fighter enough satisfaction to keep going back to the Big House.

For the most part, 711 puts the screws to common thugs, crooks, and gangsters. His ultimate enemy is a baddie who repeatedly refers to himself in the third person as "Oscar Jones—Racketeer!" At least one of 711's foes is entertainingly bizarre: Brickbat, a bat-masked figure in a lime-green suit who kills by throwing exploding bricks (packed with deadly gas) at his victims.

The reason 711 hasn't been seen since his first series may be his ignoble method of cancellation: he was fatally shot during a fight with Oscar Jones (racketeer!). To add insult to injury, the only witness to the murder was the hero who would take over 711's feature slot in *Police Comics*, a psychic troubleshooter named Destiny.

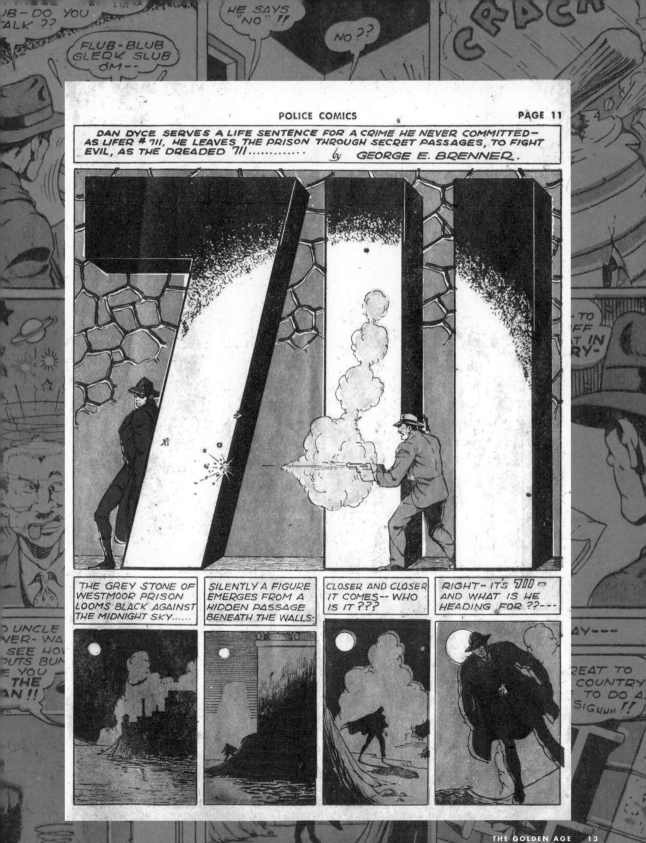

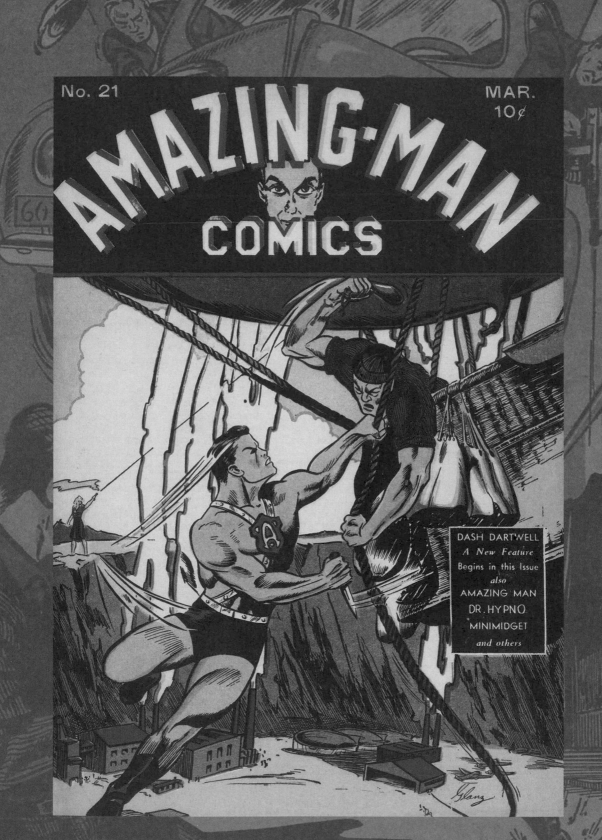

AMAZING-MAN

"No guns allowed in this little gathering!"

UPERMAN WAS SUPER, and Captain Marvel may have been a marvel, but only Amazing-Man was, well, amazing! Debuting in 1939, along with a slew of other imitators of the wildly popular Man of Steel, Amazing-Man set himself apart because he delivered on his name. On the cover of his very first appearance (which was, somehow, the fifth issue of the *Amazing-Man* comic), Amazing-Man is depicted killing a venomous snake with his bare teeth while his hands and legs are bound behind him. Amazing-Man was so busy juggling green Nazi gorillas and swatting jungle cats that it took him a year and a half before he got around to hefting a sedan above his head on the cover of his book, like all the other super-Johnnies-come-lately.

It helps that Amazing-Man's origin is so distinctly his own. Born John Aman, he spends twenty-five years in a mysterious lamasery and graduates via a ceremony to prove his "ultra-manhood." Seven deadly challenges are offered by the Council of Seven. Aman repeats the snake-biting trick, plays human pincushion for a knife-throwing inquisitor (introduced as "Lady Zina, the knife-thrower," which is a pretty specific job for a lamasery), and learns to supplement his tremendous strength and intelligence by transforming himself into a cloud of green mist.

Aided first by a "daring girl reporter" named Zona Henderson, and later by kid sidekick "Tommy the Amazing Kid," Amazing-Man spent twenty-two issues matching wits with the Great Unknown—a hooded figure who wielded terrific telepathic powers. He also took time out to rattle a few Nazis when the opportunity arose.

When the character entered the public domain, Amazing-Man received a second lease on life—or, more accurately, four new leases. Malibu Comics added him to the lineup of their 1990s-era superteam title *The Protectors*; DC Comics transformed him into the first African American member of its World War II–era megagroup, the All-Star Squadron; Dynamite has employed him in their *Project Superpowers* line; and Marvel has repurposed his given name of John Aman in adventures with Iron Fist and Captain America.

So, if the character turned out to be so popular, why didn't his original incarnation catch on? Sadly, Amazing-Man could fight everything but the competition. A crowded marketplace drove the publisher, Centaur, out of business, and Amazing-Man into obscurity.

Created by:
Bill Everett

Debuted in:
Amazing-Man Comics #5; numbering continued from the unrelated *Motion Pictures Funnies Weekly* (Centaur Publications, September 1939)

Great act of bravery:
Wearing shorts and suspenders as a superhero costume

© 1939 by Centaur Publications

ATOMAN

"There's no doubt about it!
I am radio-active!"

Created by:
Ken Crossen and
Jerry Robinson

Debuted in:
Atoman #1 (Spark,
February 1946)

Atomic number:
Zero

© 1946 by Spark

VEN IN THE RELATIVELY innocent Golden Age of comics, superheroes were no strangers to the peculiar—and unlikely—benefits of prolonged exposure to radioactivity. Radium, uranium, and general "atomic power" found its way into no small number of ray-beams, serums, and "atomic belts," granting recipients tremendous power in some vague scientific-sounding way.

Although the science is extremely shaky, Atoman may have been the first superhero whose atomic-inspired powers had some basis in reality. At least his origin, as recounted in the first issue of his eponymous series, begins with a refresher course on the history of atomic power, complete with cameos from scientific celebrities. If Atoman's origin isn't the first in comics that directly references Albert Einstein, it's certainly the only one that makes mention of Nobel-snubbed physicist Lise Meitner.

Our hero—mentioned in the same captioned breath as Einstein and Meitner—is Barry Dale, who works at "The Atomic Institute," a foundation dedicated to researching the constructive uses of atomic energy. Barry is tricked into betraying the institute by a racketeer and would-be atomic energy tycoon named Mister Twist. When Twist's thugs shove him off a balcony to his apparent death, Barry handily survives the fall and realizes that he's in possession of amazing atomic powers. In addition to the boilerplate super-abilities of flight, super-speed, and "atomic strength" (ominously, Barry describes this as the ability to wipe out entire cities), he gains "Atomic Vision," the power to "explode atoms" and the capacity to generate tremendous heat. Thanks to his training in the scientific method, Barry concludes that long and repeated exposure to radiation has caused what he refers to as "an atomic explosion . . . inside of me!" He equates the phenomenon with Marie Curie's discovery that prolonged exposure to radium had "made her body radio-active"—although, to be accurate, no one ever saw Curie flying around in an orange bodysuit.

Donning a homemade costume, the self-christened Atoman upsets Twist's atomic apple cart, saves his colleague Zelda James, "expert laboratory technician," from a face full of acid, and generally gives Superman a run for the money in the super-stunts department. Atoman is racing explosions, catching acid in his bare hands, and slapping planes out of the sky.

But Atoman possessed a short half-life, for the self-described "guardian of a new age of peace, security and happiness for all people" managed to get to only a second issue before publisher Spark closed its doors.

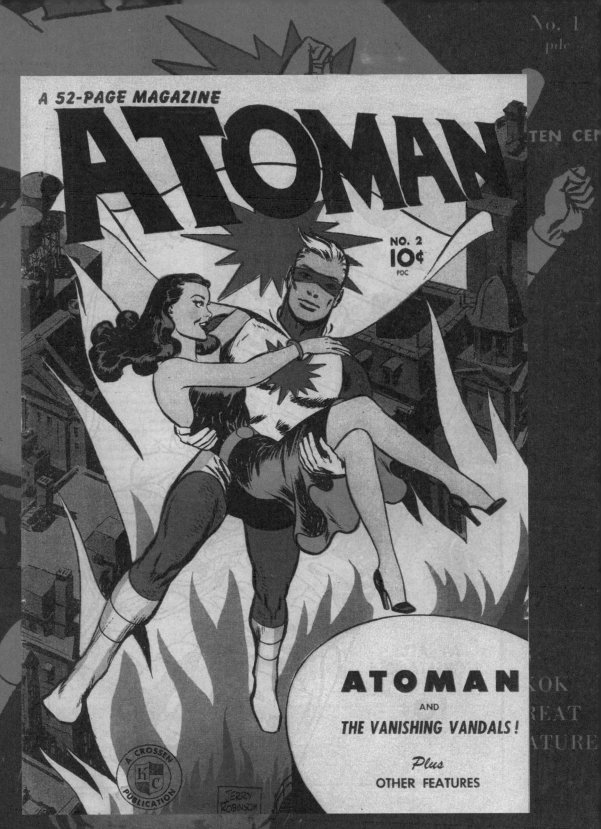

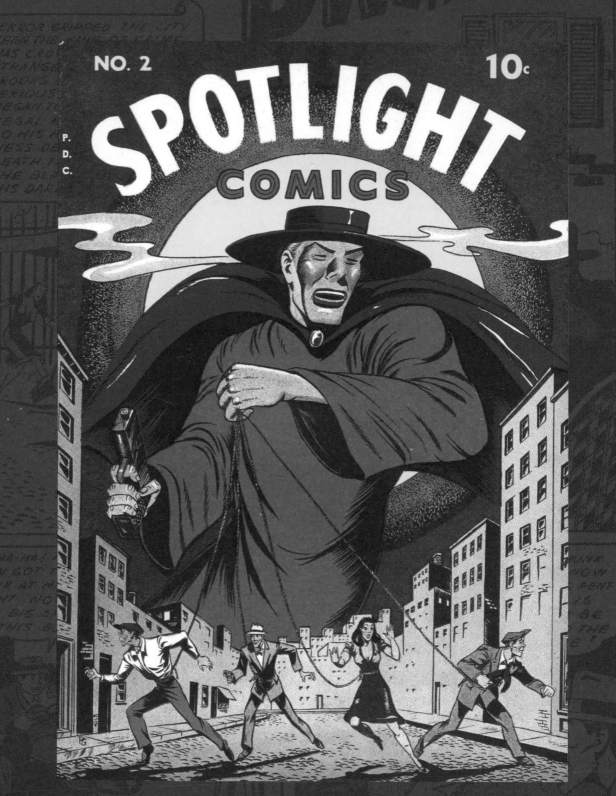

THE BLACK DWARF

"That gun in your pocket gives me ideas—bad ideas!"

HE HEAD-SCRATCHING PSEUDONYM of this short-statured superhero seems to imply a mash-up of two distinct schools of exploitation cinema. But whatever drove the Black Dwarf to adopt his outlandish outfit—not to mention his war on crime—remains up to the readers' best guess, for his motives went unexplained. Professional sportsman "Shorty" Wilson, as his nickname implies, stood about shoulder high to the average man. But when this former All-American football star donned his gaucho hat, black robes, and twin automatic pistols, he became the Black Dwarf, scourge of the underworld (his only-slightly-below-average height notwithstanding).

Like the Shadow—whose singular outfit the Black Dwarf's costume seemed to intentionally recall—"Shorty" was aided by a team of agents. His crew consisted of ex-criminals converted to the side of law and order (or at least devoted to ushering crooks to an early grave—the Black Dwarf's gang played rough). They included demolitions expert Nitro, acrobat and stuntman Human Fly (or "Fly," for short), a pickpocket named Dippy, and the Dwarf's girlfriend, the lovely but deadly Arsenic.

Colorful cast aside, the highlight of the Black Dwarf's adventures lay in the language: tough-talking dames and mugs threw around street-level slang with such fluidity that some of the better examples seem almost like poetry. "Ixnay on the horseplay, my noble knave" warns the Dwarf while facing a foe of intimidating stature, "or I'll pop lead pellets into your gizzard!" "You can't play blind man's bluff when your shoes squeak, chum!" he advises on another occasion, before flattening a foe by adding, "Take a bite of knuckle pie!"

When sharp wordplay failed to get results, the Dwarf and his agents were happy to resort to violence. Few other comics of the era would have portrayed the hero cheerily firing a bullet through a bad guy's shooting hand or dangling a ne'er-do-well by a noose around his neck. But the Black Dwarf had no qualms about leaving a trail of dead bodies in his wake.

Circumstances weren't so final for the Black Dwarf, though. When Harry "A" Chesler's line of comics shut down, some of his properties were licensed by publisher St. John and given a second life under new names. With the original art for his adventures relettered and recolored, the Dwarf renewed his war on crime as the Blue Monk, with his girlfriend now donning the more sinister sobriquet "Satana."

Created by:
Paul Gattuso (and Dana Dutch?)

Debuted in:
Spotlight Comics #1 (Harry "A" Chesler Publishing, November 1944)

Also known as:
The Blue Monk, "Hey Shorty!"

© 1944 by Harry "A" Chesler Publishing

THE BOUNCER

"Call me the Bouncer, because I bounced the laziness out of your soul!"

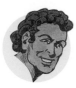

Created by:
Robert Kanigher
and Louis Ferstadt

Debuted in:
The Bouncer,
unnumbered issue
(Fox Features,
1944)

Headquarters:
The Bouncy Castle
(Not really, but
wouldn't that be
great?)

©1944 by Fox Features

VEN AMONG THE WILD and weird fraternity of absurd superheroes, the Bouncer is a genuine oddball. His superpower: bouncing. His secret identity: a statue. And his sidekick: his own descendant!

The Bouncer is the mythological figure Antaeus (spelled Antaes in the comic), who once wrestled Hercules. This version not only draws strength from the earth, as in the original legend, but also is capable of rebounding from any fall "like a rubber ball." Furthermore, this talent is passed on to his progeny throughout the generations.

Fast-forward to the modern day, when Antaes's latest descendant, Adam Antaes Jr., wants nothing to do with adventure. Still smarting from a controversial career as a collegiate athlete—his semidivine bouncing ability made him a natural at the high jump, and the hurdles were a piece of cake, but his supernatural athleticism also made him the target of detractors and skeptics—Adam decides to retire from physical labor.

Yes, it's the quiet, cerebral life of a sculptor for Adam Jr. But when his friend (and embattled district attorney) John Manly is threatened by a luminous and ruthless criminal named the Glow Worm, adventure comes calling! Without warning, one of Junior's own sculptures of his mythological ancestor comes to life and drags his great-great-great-(etc.)-grandson into battle, the two of them bounding and leaping their way to victory against evil.

The Bouncer and his contemporary partner make for quite a spectacle. Antaes the elder remains decked out in the purple toga and sandals he wore in ancient times, while Antaes Jr. apparently can't be bothered to change out of his work clothes. The apathetic sculptor bounces into action still wearing his plaster-splattered smock and, of course, beret—he is an artist, after all.

Besides bizarre enemies like the Glow Worm and Mr. Lucifer—a circus clown who insists he's the devil—the Bouncer had another interesting gimmick. He invited his readers to join him on his adventures. Youngsters were asked to send in photos and descriptions of themselves (along with parental consent). Two entries were chosen every month to enter the "Comics Hall of Fame" as the Bouncer's guest stars, drawn into the adventures with Antaes Jr. and his high-stepping predecessor. All told, it was an interesting ploy, particularly for a character who already possessed more gimmickry than most.

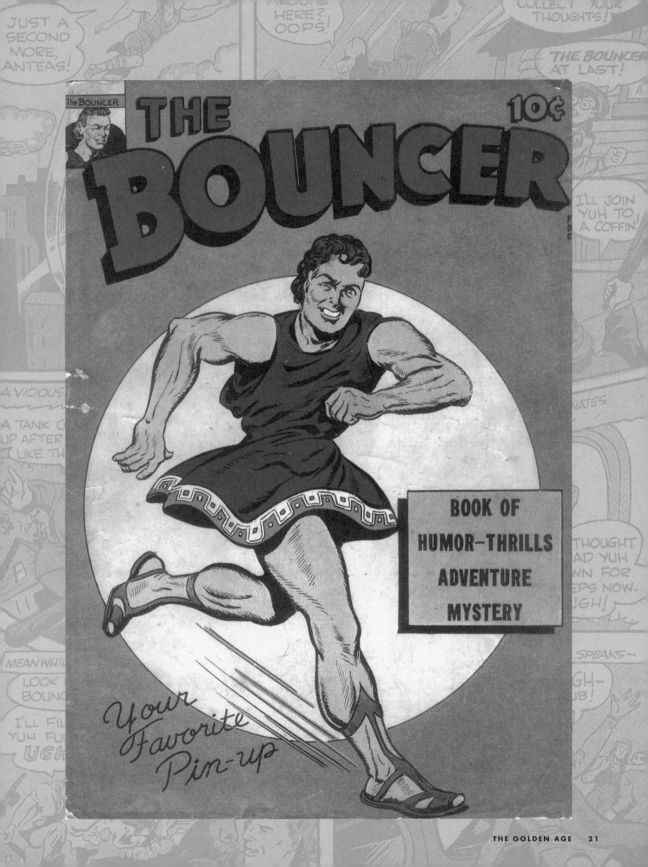

BOZO THE IRON MAN
"Dead—every one of them!"

ARVEL COMICS HAS A bona fide motion picture phenomenon in Iron Man, its armored Avenger. But their handsome, brilliant, wisecracking Tony Stark isn't comicdom's first hero to go by that name, not by a long shot. That honor belongs to one of the medium's first robot superheroes who claimed the name twenty-four years earlier: Bozo the Iron Man.

An invention of the embittered genius Dr. Van Thorp, the hulking steel-gray Bozo debuts as a terrorizing "Iron Monster" dispatched on missions of robbery, kidnapping, murder, and destruction. Despite the many crimes committed at the hands of the Iron Man, however, Bozo remains blameless. The towering metal creature is only a tool operated by remote control. (Curiously, Bozo's appearance somewhat contradicted his air of menace: the robot's iron face is permanently contorted into a frozen grin, and his enormous skull is capped with a beanie propeller, albeit a high-performance one; Bozo could fly at speeds greater than 400 miles an hour).

When the police and fire departments are stymied in their quest to destroy the metallic menace, they call on Hugh Hazzard, a crime-fighter of unspecified pedigree who manages to hijack Bozo's controls from its inventor and turn the metal monstrosity into a force for good. For the remainder of the giant robot's adventures, Hazzard was at the helm, although he varied in his choice of perch. In some adventures he directs Bozo remotely; in others he wears Bozo like armor; and in still others, he can control the robot only by clinging to its back.

Despite debuting as Bozo's pursuer-turned-partner, Hugh Hazzard is implied to be something of a big shot, with a rich backstory all his own. The mention of his admittedly dramatic name sends ripples of excitement throughout the police station. When all other means of contacting him fail, the police commissioner confidently launches a signal flare into the sky, knowing that Hazzard will recognize it as a blazing message of vital importance to him alone! Shades of the Bat-Signal, and it works just as well.

With Hazzard at the controls, one of Bozo's routine verbal peculiarities is repeated use of the words *birds* and *babies* to refer to the crooks he was presently thrashing or, at the very least, anticipating the imminent thrashing thereof. "You take these birds to the police," he says after apprehending some miscreants. "Not so fast, you birds—your game is up!" he might quip while slamming a curled metal fist into a criminal's skull. "Now to find those babies!" he'd declare, with the robot's leering rictus of a visage imparting an unusual amount of menace to the sentiment.

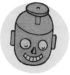

Created by:
George Brenner
(as "Wayne Reid")

Debuted in:
Smash Comics #1
(Quality Comics,
August 1939)

**Not to be
confused with:**
Tony Stark, a.k.a.
Iron Man; Bozo the
Clown

© 1939 by Quality Comics

→

Hazzard held the reins on Bozo for another forty appearances of the dopey-looking robot. In his final story, Bozo suffers the indignity of being pursued by neighborhood kids conducting an impromptu scrap metal drive to raise money for war bonds—with Bozo as the scrap. Plenty of superheroes vanish, only to reappear in some new iteration later. Bozo met his end being recycled, only this time, literally.

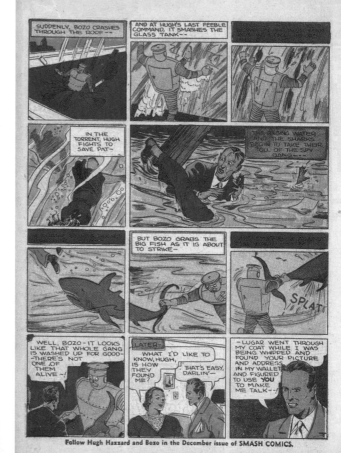

Follow Hugh Hazzard and Bozo in the December issue of SMASH COMICS.

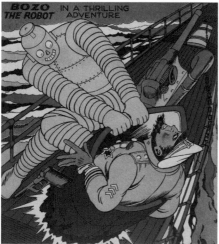

EDITOR'S NOTE...

Bozo is one of dozens, if not hundreds, of robot superheroes in comics, including Machine Man, the Vision, the Red Tornado, 8 Man, and more. The character also pioneered the man-inside-the-machine motif for superheroics, which Iron Man later adopted. The ultimate expression of that premise may be Robotman, a hero whose android body houses a genuine human brain. The idea, as well as the character name, has been used twice by DC Comics: once for a Golden Age-era crime fighter, and again for a character in the 1963 misfit team the Doom Patrol.

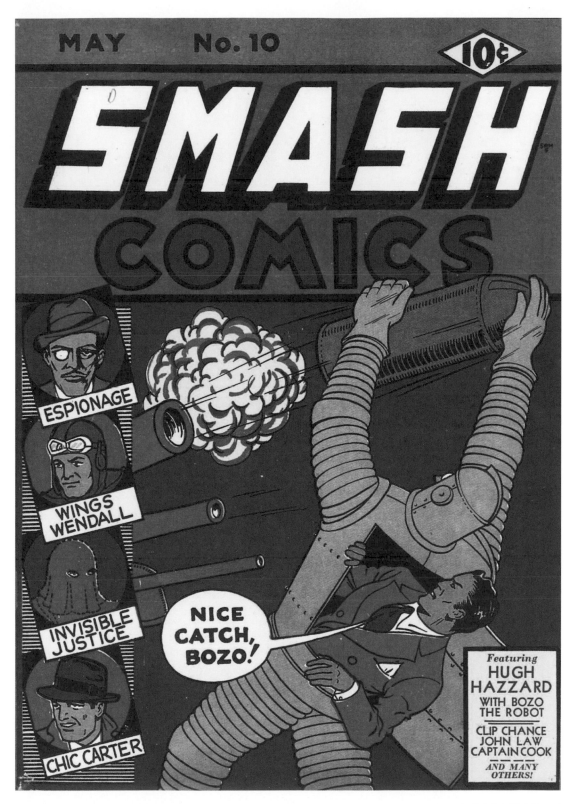

CAPTAIN TOOTSIE

"After that excitement, men, we need another Tootsie Roll! It'll pick us up—FAST!"

Created by:
C. C. Beck,
Pete Costanza

Debuted in:
Assorted titles,
July 1943

Primary interests:
Tootsie Rolls,
democracy, and a
brand of physical
and mental alertness
one does not
typically associate
with Tootsie Rolls

© 1943 by
Tootsie Roll Industries

THE BULKY BROAD-SHOULDERED silhouette of this character might look familiar to even the most casual comic fans. Not to mention the broad grin, the dark cartoonish squint to the eyes, and the lantern-like jawline hanging above a red tunic bearing a bright-yellow emblem. He brings to mind the original Captain Marvel, but he's Captain Tootsie, defender of justice, hero to children, and advertising mascot for the delicious chewy taste of Tootsie Rolls! He's also one of the earliest inductees of the proud fraternity of superpowered spokes-heroes.

His familiar look is no coincidence, for this captain was created by C. C. Beck and Pete Costanza, both vital members of the team that produced Captain Marvel's many appearances throughout the 1940s and early '50s. Aided by his friends in the Secret Legion (an organization of children who probably palled around with him for the easy availability of Tootsie Roll treats), Tootsie found himself fighting mad scientists, crooks, gangsters, wild bears, and alien invasions in equal measure. Powering his fight against crime: a steady stream of chewy, chocolatey Tootsie Roll candies, energy-providing sugar bursts that sent Cap on a spree of general do-goodery.

The Captain's single-page adventures took the opportunity to teach a little science, societal customs, and even survivalism to the kids who consumed his intermittent adventures like so many paper-wrapped parcels of gummy goodness. Not only did typical escapades see the Captain fighting escaped crooks and wild bears, but they also reminded kids to stay away from sharp ledges . . . and taught them how sniper rifles work. Valuable information!

With that in mind, it really was no surprise when Captain Tootsie graduated from interstitial ad pages to his own full-length comic book in 1950, bringing with him a heaping helping of jet-age space science. Both issues of CT's short-lived series *Captain Tootsie and the Secret Legion* involved Tootsie and his young allies rocketing away from earth and into mystery on the dangerous planes of nearby Venus and the asteroid belt.

While Captain Tootsie appeared in only two eponymous titles, he was present in the pages of dozens of different superhero comics throughout the 1940s. In fact, he holds the distinction of being one of the few superheroes of the era to have crossed companies and appeared in comics from publishing houses as diverse as Fawcett, National, Archie, and even the Sunday newspapers.

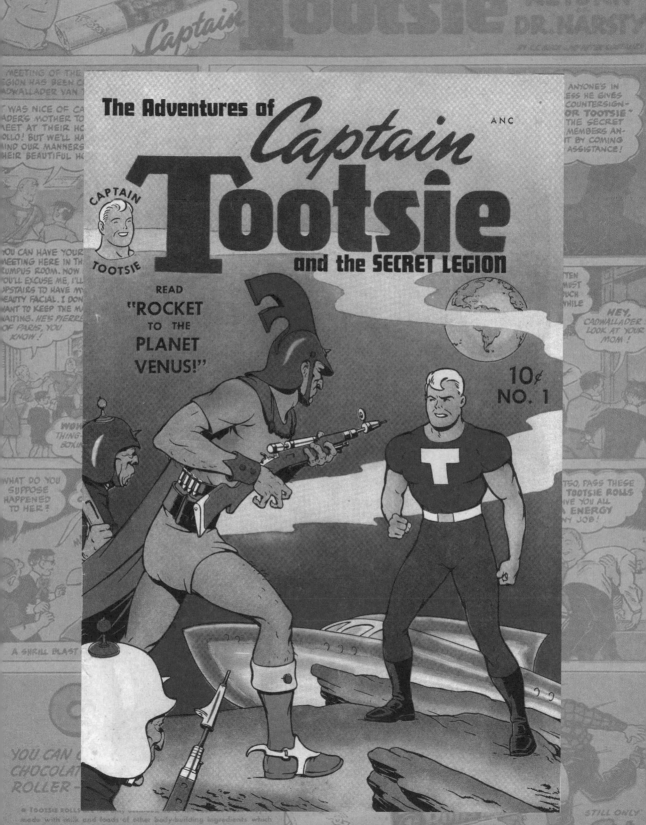

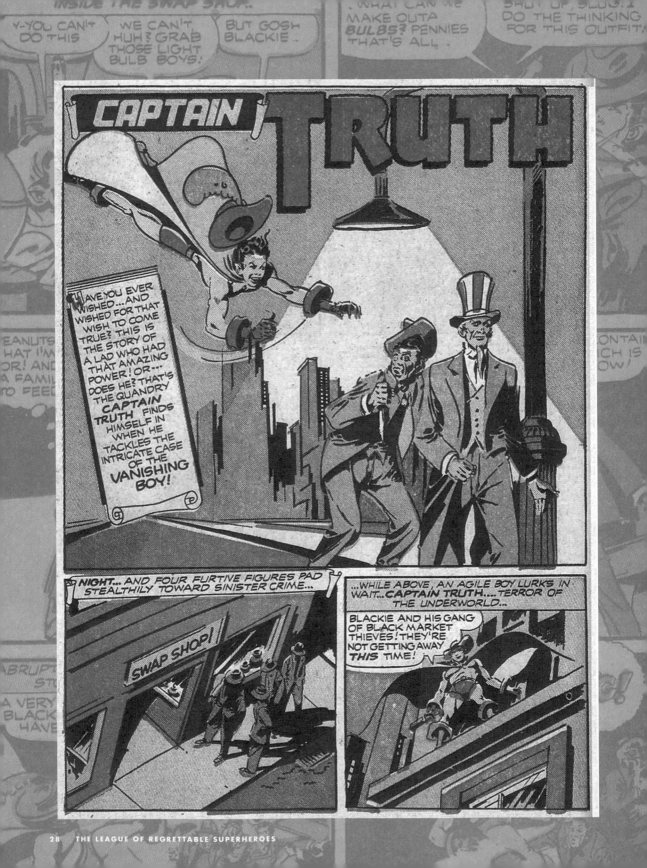

CAPTAIN TRUTH

"I'm going to show you the consequences of your crimes ... !"

AS SUPERHERO COSTUMES GO, most of Captain Truth's outfit probably wouldn't raise an eyebrow. If anything, it's understated. Bare chested and bare limbed, the young captain was practically dressed down for crime-fighting in his combination of shorts, boots, gloves, and long flowing cape. An outfit like that is the superheroic equivalent of sweat pants and a ratty T-shirt. What really puts the ensemble over the top: his enormous musketeer hat, complete with oversized feather!

The origin of Captain Truth's flamboyant costume—and whether it had anything to do with his tremendous strength or ability to fly—remains untold; indeed, not much background was given during the character's sole appearance. What we do know is that Captain Truth, a.k.a. "The Power Boy," is in fact Ken Elliot, and like many superheroes he's an orphan. But where other orphaned superheroes get adopted by kindly strangers, or at least have a family fortune to fall back on, Ken lives in poverty without parents or guardians. After being evicted from his tenement, he finds himself homeless.

Although our glimpse into Captain Truth's civilian life is brief, it's unusual because it's so close to the dirty streets. Most other superheroes of the day were adventuring on fantastic planets or leaping from rooftops. Ken Elliot's world was full of poverty, hungry families, broken-hearted children, and ramshackle homes. In fact, Captain Truth's real power may reside in his social conscience. Over the course of his story, he cheers for the razing of his decrepit home so that it can be replaced by safer, cleaner low-rent housing. Later, he fulfills a young friend's wish that his father—caught up in crime because he's desperate to feed his family—would abandon his criminal career. (Also, he rescues a tungsten shipment vital to America's war effort, just so we know Captain Truth can multitask).

Along the way, Captain Truth finds time to whip up a stirring audiovisual presentation showing how the war effort depends on everyone pulling together—even ex-crooks! Unfortunately, although Captain Truth always kept up his optimism, he couldn't keep up his popularity. The closest he experienced to a second appearance was a reprint of his singular adventure seventeen years after his debut.

Created by:
Bob Fujitani

Debuted in:
Gold Medal Comics #1 (Cambridge House, 1945)

Possible additional superpowers:
Super-millinery, couch surfing

© 1945 by Cambridge House

THE CLOWN

"I'm giving away free passes—
here's yours, buddy!"

Created by:
Unknown

Debuted in:
Spitfire Comics #1
(Harvey Comics,
1941)

**Possible alternate
identities:**
The Avenging
Paperweight, The
Much-Regretted
Career Change

© 1941 Harvey Comics

ANY SUPERHEROES RECEIVE INSPIRATION for their adventurous alter egos from some important personal symbol. A bat crashes through the window of a gloomy study, a childhood taunt becomes a high-flying alias, a symbol from a destroyed world stands for "hope." And if you're the frustrated and embattled police commissioner Nick Nolan, a ceramic paperweight depicting a fat jolly clown will do the trick.

The newly appointed commissioner trains his sights on racketeer Harry Judd, the resident bad guy who holds the city in the grip of a terrible crime spree and whose fancy lawyers are able to spring every man the cops throw in the pokey. ("You just produce this writ of habeas corpus—free 'em!" Judd says, telling his personal attorney how to do his job.) Frustrated and worn out, Nolan finds himself idly regretting that he was forced to carry on the "family tradition" of law enforcement. Recalling the merry, carefree days of his youth, he regards a clown-shaped paperweight and bemoans, "Oh, to be back in the old circus again." And that gives him an idea . . .

Soon, the rotund and jolly figure of a clown takes to city streets, advertising a circus (which, oddly, never seems to materialize) and promptly curtailing a shakedown being carried out by Judd's men. Before long the Clown has clobbered two of Judd's toughest thugs, forced his way into the crime boss's office, and received an invitation from the city's king of rackets to join the sprawling criminal enterprise (don't worry kids—the Clown's just playing along). Offering equal partnership to a thug-slugging clown doesn't seem like the wisest way to operate a criminal empire, but Judd's the expert, I guess.

The clown get-up works wonders for Nolan, for his brusque manner, comical disguise, and a handful of juggling balls packed with knockout gas allow him access to the gangster's books. Before you can say "Emmet Kelly," Judd and his criminal empire are shut down permanently—a roaring success for one of the most ludicrous superhero disguises on record. After a second appearance, the Clown permanently bowed out.

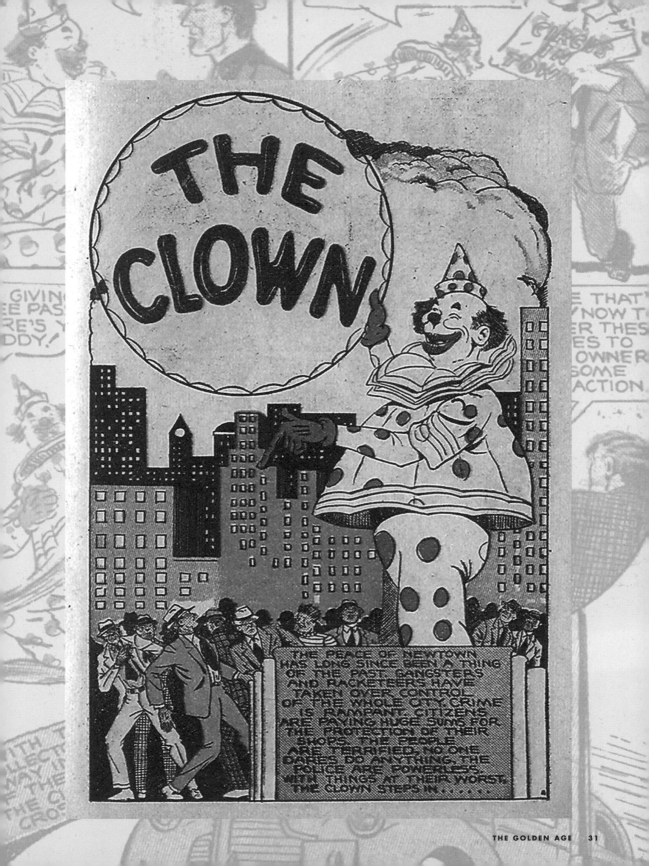

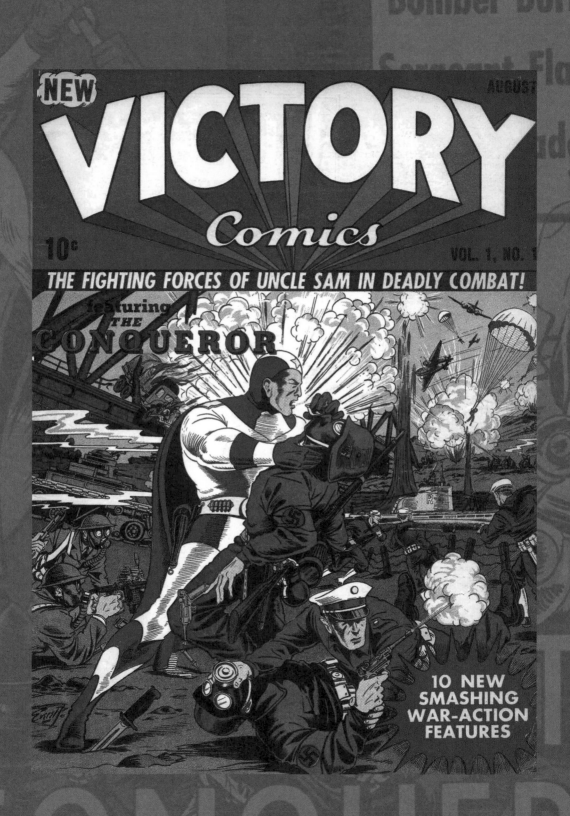

THE CONQUEROR

"I am going to rid the world of Adolph Hitler."

NOT EVERY HERO POSSESSES such clarity of purpose that they know what to do with their superpowers the minute they get them. But self-doubt isn't a shortcoming that plagues the Conqueror. Within moments of receiving his superhuman strength, his mission is clear: he's got to kill Hitler! Whatever his other shortcomings, Bill Everett's patriotic hero didn't lack ambition. For four issues in 1941, the single-minded Conqueror stormed Europe in search of his target, along the way executing Nazi officers, agents, and spies and lining his trail with wrecked remnants of the German war machine.

Brutal, relentless, humorless, and dressed a little like a waiter in an ice cream shop, the Conqueror didn't skimp on action. His covers portray him leading a tank assault with his gun and knife drawn, choking Wehrmacht soldiers amid the chaos of battle on a fume-soaked battlefield, and opening fire on enemy soldiers from point-blank range with a hefty stationary machine gun easily cradled in his arm. "The Fighting Forces of Uncle Sam in Deadly Combat!" promised every cover of *Victory Comics*, and the Conqueror did his part to make sure the quota of deadly conflict was reached.

The Conqueror's stories are so densely action-packed that his origin had to be covered in a two-page text piece elsewhere in his debut issue (it couldn't be allowed to cut into the deadly combat, right?). When amateur pilot Daniel Lyons crashes his plane near the Rocky Mountains, he's saved by Dr. James Norton, the "Cosmic Ray Professor" himself! You've heard of him, right? A turn under the reclusive scientist's "Cosmic Ray Lamp" not only heals the young man's injuries but also easily doubles his strength, mental acuity, and vitality—powers that Lyons (almost immediately) dedicates to the destruction of the führer.

Wartime superheroes were never the subtlest characters, but the Conqueror really ramps up the rhetoric. He interrupts a gathering of Nazi agents in the middle of saying "Heil Hitler!" to interject "Heil MURDERER, you mean!"; he also refers to Hitler as "The Beast" and keeps a laser focus on his mission. Other superheroes who made the Nazis their personal targets were at times distracted by saboteurs, crooks, gangsters, thugs, and the occasional weird creature or supervillain. But not the Conqueror—for him, it was always Berlin or bust!

Unfortunately, the outcome was "bust." After four appearances, the Conqueror folded, along with his magazine, leaving the dispatching of the führer in the capable hands of the Allied forces.

Created by:
Bill Everett

Debuted in:
Victory Comics
#1 (Hillman
Periodicals,
August 1941)

Last seen:
Moving inexorably
toward Berlin

©1941 by
Hillman Periodicals

DOCTOR HORMONE

"You want to stop death—I can stop it! I will increase the size of your army. I will make your soldiers immune to death!"

Created by:
Robert Bugg

Debuted in:
Popular Comics
#54 (Dell Comics,
August 1940)

Adherence to basic medical ethics:
Spotty

© 1940 by Dell Comics

THE NAME "DOCTOR HORMONE" may sound like a name you'd see emblazoned on the side of a protein powder concoction or face cream sold on late-night television. He was, in fact, a short-lived superhero who briefly stood against the forces of tyranny in the early 1940s.

An aged scientist who had spent the whole of his life studying the beneficial powers of hormones, Doctor Hormone—evidently his real name, by he way—is rejuvenated upon his deathbed by a "youth hormone" of his own invention, plus a spin under his "angstrom ray machine." Now a fit and energetic young man of twenty-five, the doctor and his granddaughter Janey (that's Janey Hormone, one would assume) bring the mighty power of hormones to benefit the world. Old women are made young again! Babies are grown into men! Boy Scout troops are transformed into full-grown soldiers, and an entire nation is transformed into half-animal human hybrids to repel an invading army! It's actually sort of horrifying as Doctor Hormone plays fast and loose with the lives of children and babies. How many other heroes would be proudly celebrated by a caption describing how he "experiments on a dying infant"?

Another unusual element of Doctor Hormone's brief catalog of adventures is that it was an ongoing serial (most comics at the time featured standalone stories in each issue). During a half dozen adventures, Doctor Hormone pitted the power of his transformative hormone pills first against the evil nation of Eurasia (and its leader Rassinoff, who'd been transformed into a donkey-man and nicknamed "Ass-inoff" by his detractors), and then against an even more insidious foe. Subtly dubbed "Nazia," the aggressive warlike nation was the doctor's persistent enemy through the remainder of his adventures.

Apparently, eternal youth and half-animal soldiers could take Doctor Hormone only so far. In his final appearance, he and his granddaughter are aided in their struggle to keep Texas free of Nazians (and their hooded allies, unmistakably dubbed "The Klan") by a mysterious unseen presence calling itself "The Thinker." A disembodied voice wielding tremendous power, the Thinker grants Doctor Hormone some of his awesome strength. Doc becomes a giant, blows a plane out of the air with super-breath . . . you know, the usual.

At the end of the story, the Thinker brings Dr. Hormone and Janey back through time to his headquarters, a great Roman temple sitting safely amid the hellish whorl of primordial chaos. There, Hormone and Janey sleep, awaiting the Thinker's further orders. They were never heard from again.　　　　→

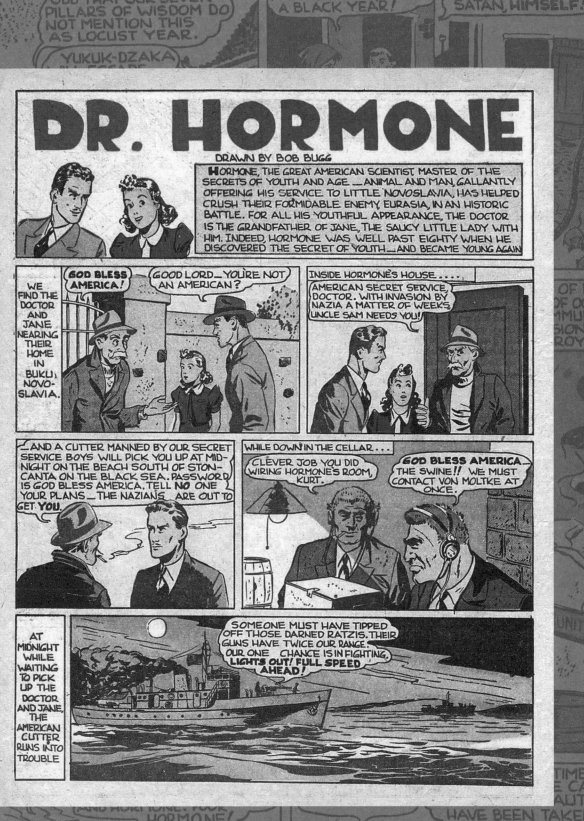

ROLL CALL...

A lot of superheroes depend on medicine and pills for their powers. For his vim and vigor, the original Blue Beetle relied on Vitamin 2X; Captain America was the product of a Super-Soldier Serum. Hourman devised his own Miraclo pills, which granted him a concise sixty minutes of superhuman vitality.

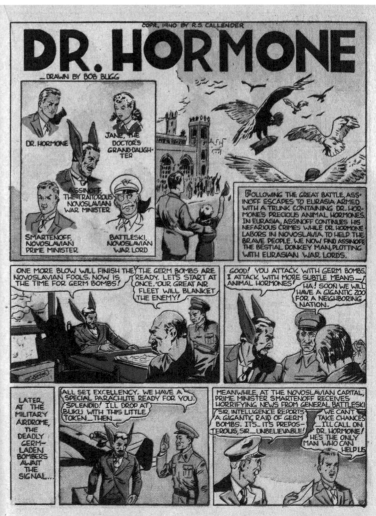

DOCTOR HORMONE

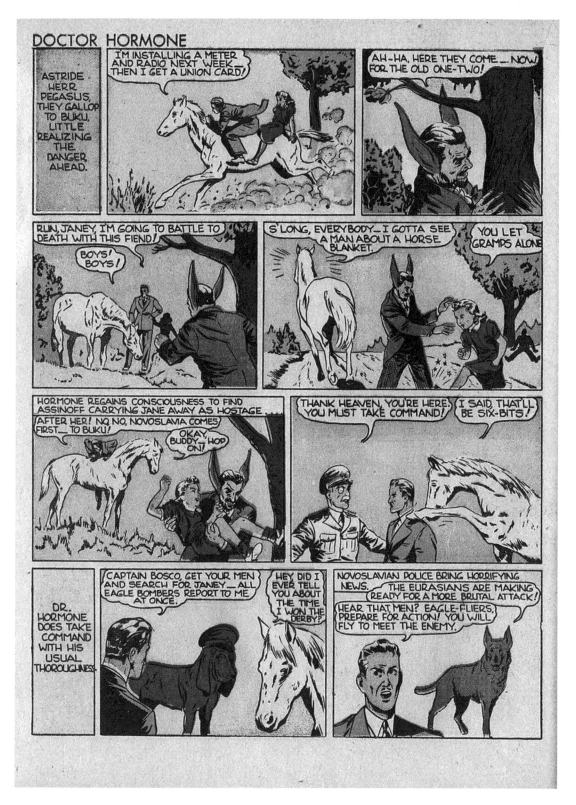

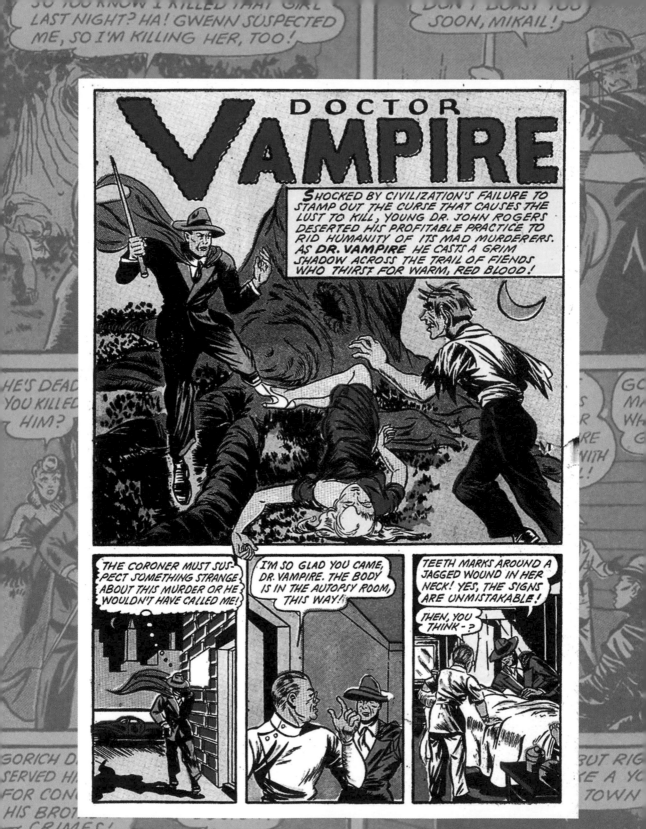

DOCTOR VAMPIRE
"One murder will not conceal another."

EW COMIC CHARACTERS ARE as shrouded in mystery as Doctor Vampire. No credits were included with his sole appearance in Skyrocket Comics (a comic that ran only one issue and was undated), so the identity of his creative team is unknown. Even stranger, the Doctor's singular seven-page adventure leaves a lot to the imagination.

"Shocked by civilization's failure to stamp out the curse that causes the lust to kill," states the character's briefly recounted origin, "Dr. John Rogers deserted his profitable practice to rid humanity of its mad murderers." Fair enough. Armed with a heavy, pointed walking stick, the pseudonymous Doctor Vampire (a doctor of what, exactly?) takes to the night to wipe out the vampire menace.

Whatever his medical specialty, the doctor's pseudonym is a confusing choice. He calls himself Doctor Vampire, but he *fights* vampires. This muddies the water, to say the least. Imagine a Nazi-fighting superhero naming himself Doctor Nazi, a Captain Crime who battled criminals, or the Red Burglar turning out to be a guy who catches burglars.

Doc's one and only adventure takes him to the scene of grisly vampire murders committed at a red barn playhouse (which is in the middle of nowhere yet is depicted as especially popular with the tux-and-tails crowd). As an investigator, Doctor Vamp leaves a lot to be desired. He wanders about the barn, coming face-to-face with a slavering vampire without seeming to recognize his fang-filled mouth for what it is. Maybe they didn't cover this stuff in vampire medical school. Or maybe it wasn't vampires that Doctor Vampire was really hunting. While listening to the band, Doctor Vampire thinks, "Gypsy stuff! Gypsy blood has often been tainted with the killer strain." Whoa, Doctor Vampire, that's racial profiling. Maybe it's for the best that he never made a second appearance.

Created by:
Who knows?

Debuted in:
Skyrocket Comics #1
(Harry "A" Chesler
Publishing, ca.
1944)

**Not to be
confused with:**
Librarian
Frankenstein;
Choreographer
Mummy; Wolfman,
Attorney-at-Law

© 1944 Harry "A" Chesler
Publishing

DOLL MAN

"You should know that NO FIST can hold the DOLL MAN!"

Created by:
Will Eisner (as "William Erwin Maxwell") and Lou Fine

Debuted in:
Feature Comics #27 (Quality Comics, December 1939)

Vital statistics:
Height: 6 inches; inseam: 3 inches

© 1939 by Quality Comics

F YOU ASK AVERAGE people on the street what superpower they'd like to have, most folks would pick flying, or super-strength, or invisibility—but probably not shrinking. Size reduction is something of a bum super-ability, and even the inch-high heroes for whom getting small is a primary power generally have some extra super-talent to fall back on. Ant-Man, for instance, also controls ants. The Wasp can fire sting-rays. And Shrinking Violet of the Legion of Super-Heroes has Superboy on speed dial.

Darrell "Doll Man" Dane, however, made a career out of shrinking to a modest six inches . . . and that's it. A research chemist who invented a concoction that allowed him to shrink dramatically in stature, he never questioned the limited usefulness of his discovery. His gravitas wasn't helped by his choice of costume: a collared red cape and flimsy sky-blue onesie that left his arms and legs completely bare.

Yet, Doll Man was an immediate hit for its parent publisher, Quality Comics. The so-called World's Mightiest Mite not only regularly nabbed the coveted cover spot on the company's premier anthology title, *Feature Comics*, he soon headlined his own eponymous quarterly book to boot. Despite boasting no other superpower besides standing knee high to a grade-schooler, the daring Doll Man found ways to use his short stature to his advantage: sneaking up on crooks, spying on fifth columnists, and knocking out no-goodniks with a surprisingly full-sized sock on the chin. Typically, Doll Man's adventures hinged on some conveniently fun-sized foe or menace—he found himself fighting trained pets and vicious vermin as often as he tangled with full-sized crooks.

In short order, Doll Man acquired a sidekick—his girlfriend Martha, who shrunk down and adopted the name Doll Girl. Where Darrel had developed his Doll Man powers through chemical means, Martha seemed to have picked up similar shrinking abilities merely by association. Her transformation into Doll Girl was the result of intense concentration and a series of mental exercises designed to replicate Doll Man's six-inch frame. The diminutive duo collected a colorful rogues' gallery, notably the seductive Mademoiselle de Mortire, the cadaverous Corpse, the grotesque Vulture, the leering Skull, and even the Dress Suit, a murderous—but bodiless—set of formal clothes. Doll Man also picked up a pet "Wonder Dog" named Elmo, a Great Dane who often acted as the hero's steed. When transportation by dog wasn't feasible, he hopped onto his "Doll Plane" to get where tiny feet cannot travel. →

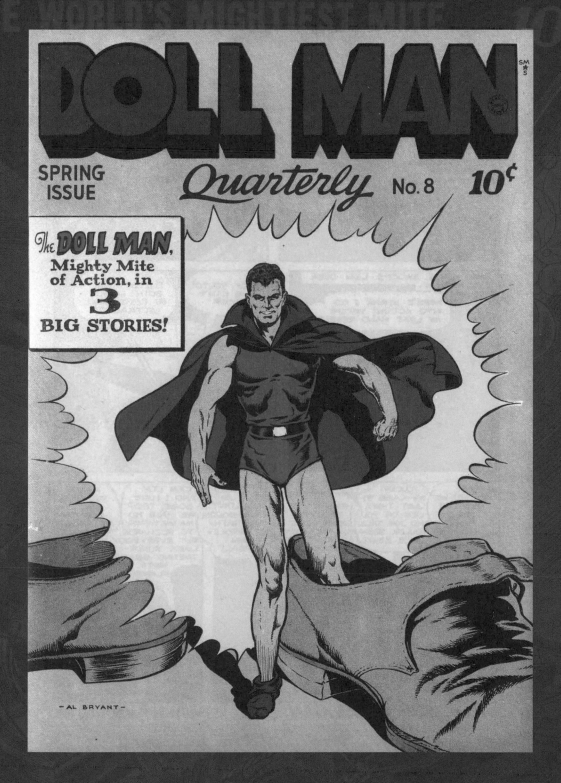

Reintroduced into comics after a two-decade hiatus—sans girlfriend, dog, and plane—a solo Doll Man was subsequently amped up by his new owners at DC Comics with a mental energy blast meant to even the playing field against average-height adversaries. His increase in powers proved insufficient to renew reader interest in this pint-sized paladin, but Doll Man has enjoyed a few more attempted revivals. Typically, he fights alongside his fellow revived characters from the Quality Comics stable, most recently alongside a new version of the fetching Phantom Lady. But none of these efforts managed to replicate the outsized success of the Doll Man's early career.

ROLL CALL...

Probably twice as many superheroes increase in size compared to those who shrink. They include Giant-Man, Black Goliath, Atlas, Colossal Boy, Apache Chief, Stature, and Tower.

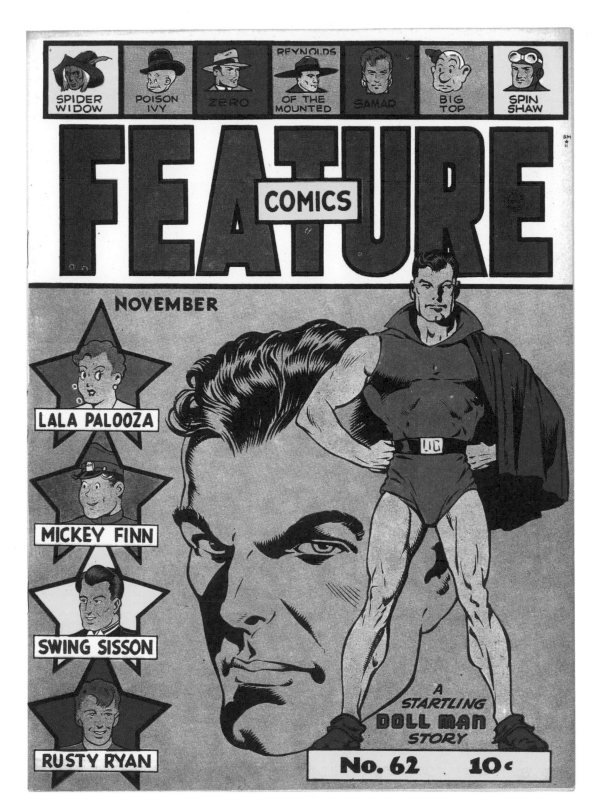

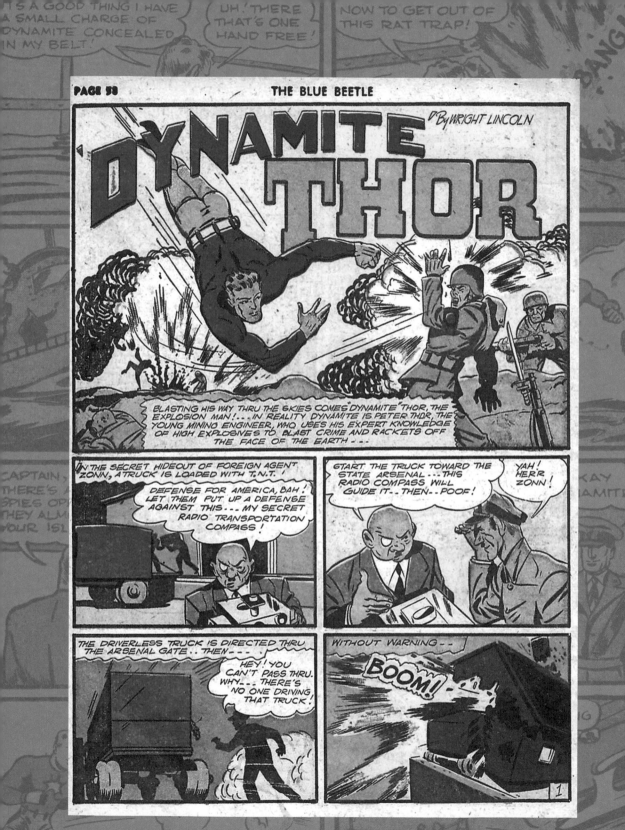

DYNAMITE THOR
"Got a match, buddy?"

ETER THOR WAS ONE of the world's leading experts on explosives; in fact, he was such a skilled demolitions expert that he'd figured out a way to render himself invulnerable to the devastating power of detonation. Dynamite, nitroglycerin, TNT . . . anything that exploded was just loud noises and puffs of smoke as far as Mr. Thor was concerned. What exactly the guy did to protect his body against blowing up isn't clear. But apparently that's all the impetus he needed to throw on a costume, strap on a belt full of explosives, and launch a crime-fighting career as Dynamite Thor.

For accuracy's sake, it's worth mentioning that although "Dynamite Thor" was the name on the cover, the character's superhero codename was simply "Dynamite" (although he was billed on the cover of his debut issue as "Thor"). Whatever the case, this was the superhero you most hope your child will never emulate, seeing as his powers relied on flinging "explosive pellets" at his foes and whizzing through the air by detonating his dynamite-laden belt.

So, while other flying heroes relied on oversized wings, magic capes, antigravity apparatus, and other nondestructive means of propulsion, Dynamite Thor made himself airborne by detonating the explosives he kept on his belt. One stick of dynamite would launch him skyward; he'd ignite another to change direction, and then fire off a chain of them to travel aerodynamically. It's worth noting that although Dynamite Thor was invulnerable to explosions, bystanders were probably not so lucky. Yes, Dynamite taking flight could be a fatal experience for a crowd of looky-loos.

Explosion-proof Thor was still somehow susceptible to bullets, blackjacks, and a conk on the noggin with a lead pipe. Fortunately, he usually managed to find a way to blow up any immediate threat, and he usually kept a "neutron shield" (whatever that is) handy in case his belt full of explosives didn't do the trick. Less durable was Dynamite Thor's wardrobe—maybe it's all the explosions, but he rarely wore the same outfit twice.

Created by:
Wright Lincoln

Debuted in:
Weird Comics #6
(Fox Feature
Syndicate, 1940)

Personality type:
Would it surprise
you if we said
"explosive"?

© Fox Feature Syndicate,
1940

THE EYE

"Fools! To think bullets could harm The Eye!"

Created by:
Frank Thomas

Debuted in:
Keen Detective Funnies vol. 2, #12 (Centaur Publications, December 1939)

Also known as:
Detective Eye

© 1939 Centaur Publications

MOST SUPERHEROIC PSEUDONYMS ARE intended to be understood metaphorically. Iron Man isn't really a man made of iron, Green Lantern isn't a piece of verdant camping equipment, and, by and large, the Beast is in fact a lovely fellow. When it comes to superheroes whose names *can* be taken literally, or, better yet, at—*ahem*—face value, there's no more outstanding example than the Eye.

An actual living, speaking, crime-fighting disembodied floating giant eyeball, the Eye was a mysterious presence that loomed ominously in the pages of *Keen Detective Funnies*, a book that also offered more quotidian fare, such as Dean Denton (Scientific Detective), Dan Dennis F.B.I., and Spark O'Leary, Radio Newshawk.

Appearing amid curtains of flame or billows of smoke, the Eye was in a class by himself (or, uh, itself?). A tireless witness and avenger of injustice, the seemingly supernatural entity possessed an array of powers bordering on the omnipotent. He also seemed to have a few limitations. Despite being able to fly, melt steel, appear and vanish suddenly, manipulate invisible forces, and, oh, be a giant flaming eye all the time, the Eye relied on human assistants to act as his agents against crime.

After appearing in *Keen Detective Funnies* under the masthead of "The Eye Sees!" the Eye went on to star in its own solo book, with an apparent change of career: the ocular avenger was now billed as Detective Eye. Apparently, the Eye had been taking correspondence classes between adventures.

After fewer than a dozen appearances, the Eye vanished as mysteriously as it debuted, and never once had an origin been so much as hinted at. Then again, what kind of origin would explain "The Eye"? Had it once been a man, bitten by a radioactive eye? Was an eye rocketed from a doomed planet, its only survivor? Did an eye burst through a brooding billionaire's library window, inspiring him to fight crime? Perhaps we're better off not knowing.

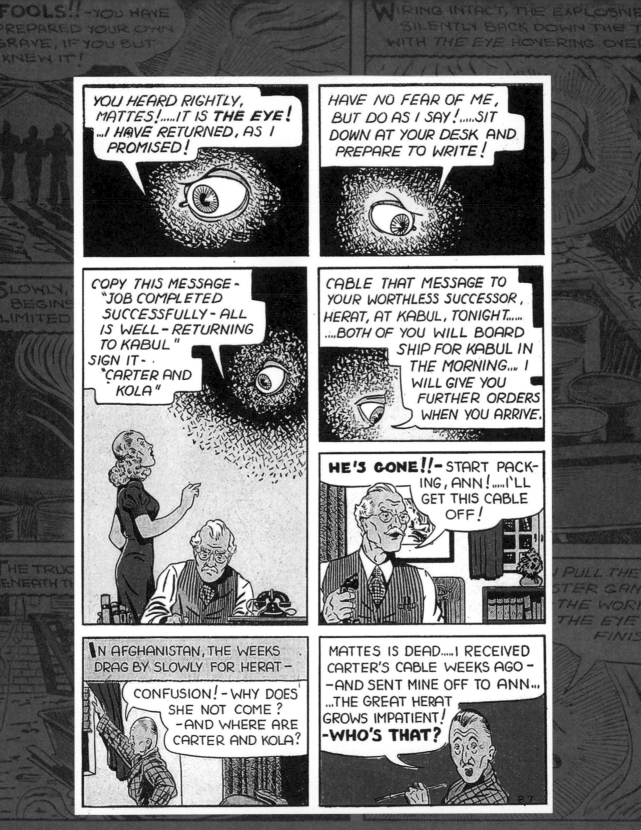

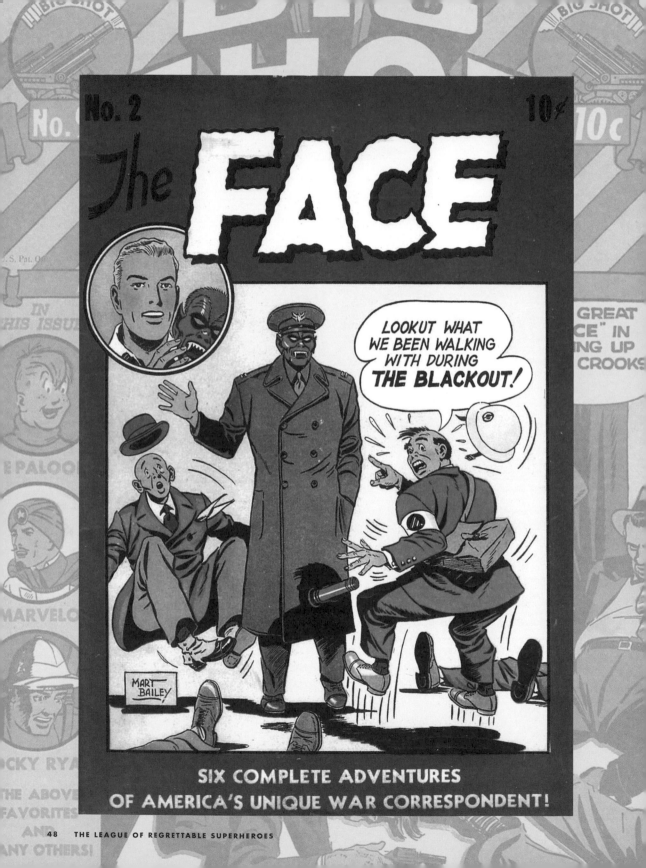

THE FACE

"She fainted! Well, my face isn't any pleasant thing ... "

A CERTAIN CAPED CRUSADER once observed that criminals are a cowardly and superstitious lot. Luckily for crime-fighter Tony Trent, his particular breed of criminals take cowardly to a new level—sometimes they flat out faint from terror!

The Face is a long-lived costumed crime-fighter who managed to catalog more than a hundred Golden Age appearances without so much as a single measly superpower to his name. What the nattily dressed do-gooder did possess, however, was apparently the world's most terrifying fright mask. The Face's signature look was that of a green-faced fang-toothed gremlin sporting black-rimmed eyes and pointed ears. He completed his ensemble with an elegant eveningwear-inspired look—gloves and a dark tuxedo, occasionally accompanied by a smart-looking hat. Of course, the Face dressed up to fight crime. What was he, uncouth?

"The rubber mask was made especially for my face," he explains to no one in particular while unmasking in his car after a successful night of crook-terrorizing. He continues, "Every curve and bump of my head is followed so that it fits my features exactly," and then adds, smiling, "The man who made it for me died—so none can trace me!"

For the most part, the Face was a run-of-the-mill detective character whose mask served a double purpose; besides obscuring his civilian identity, it gave him a momentary advantage against any crooks or killers he might stumble across. Startled and terrified by his gruesome visage, the Face's opponents would be temporarily paralyzed by fright, giving our grim-looking hero the element of surprise. If his opponents didn't faint dead away, the Face had ample time to outdraw or apprehend them.

Ironically, Tony Trent's day job kept his face hidden from the public as well. He was a radio announcer (and part-time newsman) whose outrage over the injustices he reported drove him to adopt his costumed identity. If incidental outrage doesn't seem enough to justify his bizarre methodology, know that Trent also happened to witness crooks disguised as cops murdering a man, which further encouraged his crusade against evil.

When the popularity of superheroes began to wane in the late 1940s, the Face gave up his fright mask and took to battling crime as plain ol' Tony Trent. Eventually, he hung up his hat for good, which was probably for the best. After six years of spooking criminals, surely the shock value of a green-faced goon lunging at crooks from the shadows must have been wearing off.

Created by:
Mart Bailey (with Gardner Fox and Vince Sullivan) as "Michael Blake"

Debuted in:
Big Shot Comics #1 (Columbia Comics, May 1940)

Unused alternate identities:
The Mug, the Pan, the Punim, the Map, the Guy in the Mirror

© 1940 by Columbia Comics

FANTOMAH
"Fantomah wills it!"

Created by:
Fletcher Hanks (as "Barclay Flagg")

Debuted in:
Jungle Comics #2
(Fiction House,
February 1940)

Complexion:
Definitely a
"Summer,"
except when she's
transformed her
head into a blazing
skull

© 1940 by Fiction House

SHE PRECEDED WONDER WOMAN by more than a year and is arguably the first female superhero in comic books, but chances are you've never heard of Fantomah—Mystery Woman of the Jungle!

Statuesque, white-skinned, blonde-haired, and blue-eyed, at first glance Fantomah appears to share much in common with the other animal-protecting, resource-preserving, leopard-skin-clad "jungle queens" who followed in the footsteps of Sheena, Queen of the Jungle. What makes Fantomah different from her sorority sisters of the savannah, however, has a great deal to do with her creator.

Fletcher Hanks is a legendary and notorious figure in comicdom, having produced the entirety of his strange, alarming, and unpredictable catalog of stories in a brief three-year period before vanishing from the medium. His comics were typified both by bold, stiff, yet informal artwork that recalled woodcut prints and by stories in which near-omnipotent protagonists devised cruel and byzantine punishments for their enemies. Hanks remains one of the most mysterious figures in comics, despite a recently renewed surge of interest in his work (due in large part to a pair of excellent collections edited by Paul Karasik and published by Fantagraphics Books). A reportedly troubled individual, Hanks produced complicated and bizarre creations that seemed to reflect his inner turmoil. In stories that resemble fever dreams, unearthly figures who emerged from mysterious realms and visited elaborate punishments on their enemies were the order of the day.

Like Hanks's other best-remembered creation, Stardust the Super-Wizard (page 117), the essentially all-powerful Fantomah was capable of supernatural acts of bizarre chastisement, executed without mercy on plunderers, killers, and would-be tyrants who threatened her domain. She banishes one villain to a dinosaur-populated asteroid, transforms a pair of jewel thieves into creatures resembling a cross between grasshoppers and dandelion leaves, and in one spectacular feat demolishes a squadron of military bomber planes—and all occupants therein—with living sandstorms and a flying formation of jungle lions. Wow!

No less shocking was Fantomah's physical transformation. At rest, she appeared as a gorgeous woman with smoky, mysterious eyes. When angered, however, her skin adopted a sky-blue pallor and her lovely face burned away to reveal a furious blazing skull (although she kept her luxurious golden locks in either state). →

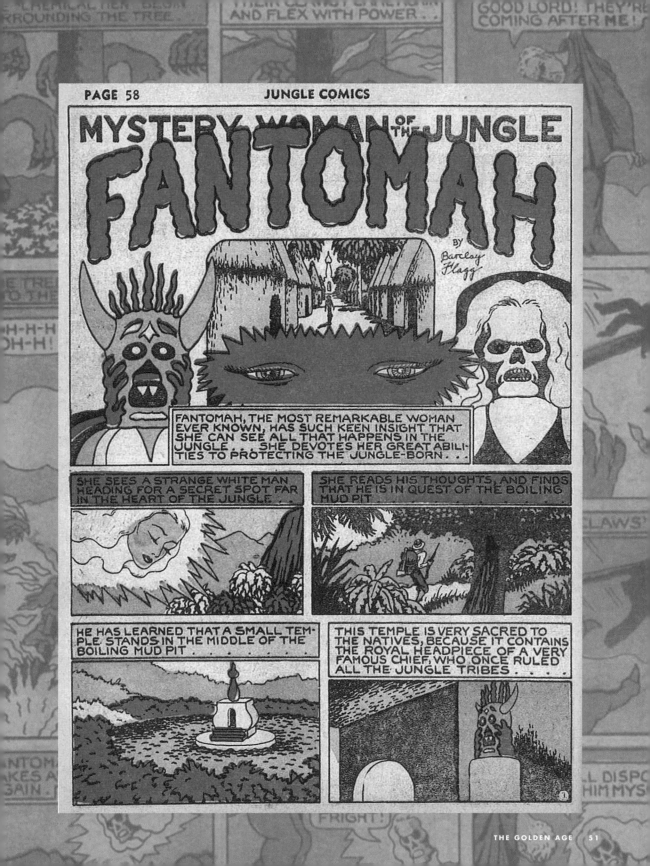

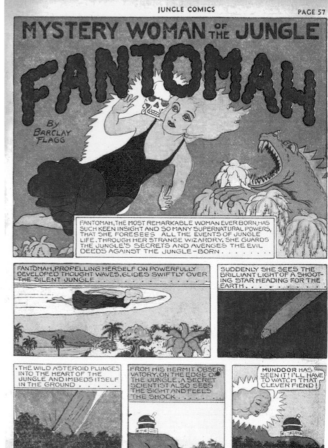

When Hanks left the feature halfway through its run, subsequent writers took the opportunity to tone down the character's extravagances. She was quickly reduced from terrifying omnipotent avenger to the queen of a hidden jungle empire, left to wrestle snakes and panthers with nothing more than her all-too-human cunning and strength, just like all the other girls in the jungle.

ROLL CALL...

Fantomah may have been the first female superhero, but she had plentiful company soon enough, from nonpowered heroines like the Black Cat, Lady Luck, Phantom Lady, and the Woman in Red to superpowered female crime-fighters such as Canadian superheroine Nelvana of the Northern Lights (page 95) and the powerful Miss Victory. Nearly omnipotent superheroines are uncommon in Golden Age comic books, but a few other powerful "goddess" types include Venus, Diana the Huntress, Phara, and the Sorceress of Zoom.

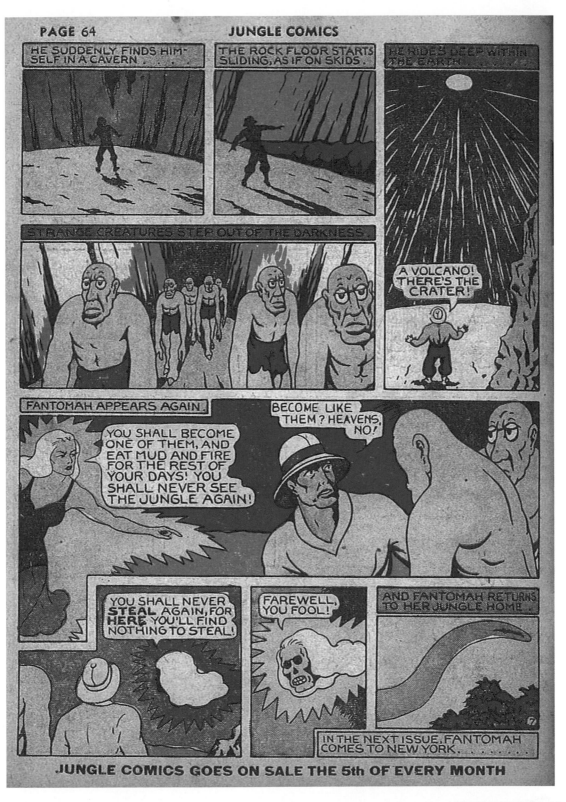

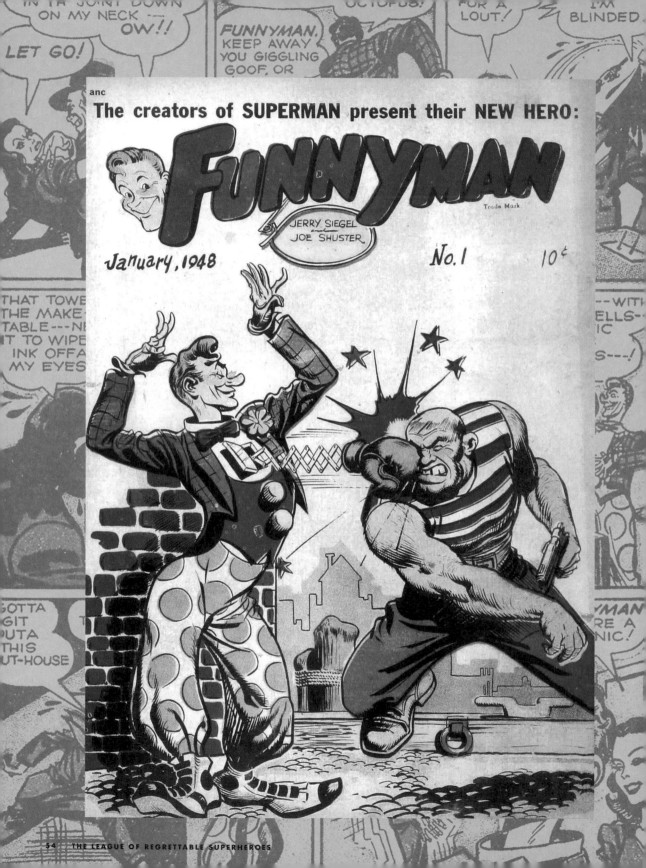

FUNNYMAN

"I like the idea of cleaning up on wrong guys with jabs and gags!"

JERRY SIEGEL AND JOE SHUSTER are best known for creating Superman, and with him spawning the entire genre of superheroes. Although the Man of Steel was their most popular creation, he wasn't Siegel and Shuster's first collaboration, and neither was he their last—that honor goes to Funnyman.

By 1948, Superman-related licensing had made a fortune for its publisher, and Superman's creators felt undercompensated. With a lawsuit pending against their employer, Siegel and Shuster were forced to temporarily look elsewhere for paying work. Approaching Magazine Enterprises publisher Vincent Sullivan—who, as an editor with National, had been responsible for purchasing the first published Superman story—Siegel and Shuster decided to try a slightly different direction with their new hero.

Superman had always contained comical elements—the impish Mister Mxyztplk, the villainous Prankster, and so on—Funnyman put comedy on par with crime-fighting. Armed with an arsenal of classic gags, from hand buzzers to squirting flowers, and disguised by a putty nose, the "Daffy Daredevil" was secretly Larry Davis, a popular television comedian (in the early days of the medium) with a yen for acting out in public.

Davis's manager, agent, and occasional love interest June Farrell arranged a publicity stunt wherein Davis, in the costume he'd soon wear as Funnyman, would foil a staged crime. Crossed wires lead Davis to confronting and defeating a real-life criminal, and at that moment the comedian is hooked on do-gooding. Unlike Lois Lane in the Superman books, June was fully aware of Larry's dual identity. And she hated it, preferring to keep the comedian performing in venues with a chance of a payday. Meanwhile, Funnyman padded out his prop department with an eye toward even more efficient (and absurd) crook-catching. Not only was he well outfitted with a portable armory of practical jokes, he bolted around town on his gadget-loaded Trixcycle, invented a flying "Jet Jallopy," and even maintained a massive "Funny Manor," each room packed with crook-nabbing traps.

Funnyman didn't catch the public imagination in the same way as the pair's earlier collaboration, but this time around Siegel and Shuster made sure to secure their intellectual property. Their names appear boldly not only on the first page of every story but also on the cover of every issue, which was all but unheard of in those days. Less permanent was the tagline that topped the masthead of their first issue: "The creators of SUPERMAN present their NEW HERO." DC objected to its trademark being used by the competition. →

Created by:
Jerry Siegel and
Joe Shuster

Debuted in:
Funnyman #1
(Magazine
Enterprises,
January 1948)

Weapons:
Seltzer bottle of
justice, exploding
cigar of virtue, the
banana cream pie
of right

© 1948 by
Magazine Enterprises

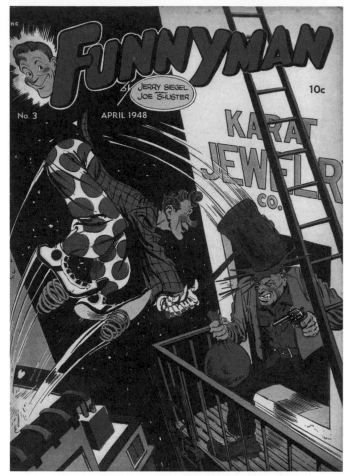

Funnyman managed to eke out a half dozen comic books and a brief run as a syndicated newspaper strip. But the character packed a lot into that brief existence. His rogues' gallery included no shortage of villains, such as the gadget-happy Doc Gimmick, the elusive jailbird Slippery Slim, the high-speed Lazar and his Crime Car, the sword-wielding Monsieur Cheval, Timido the Timid Menace, Leapin' Lena, Noodnik Nogoodnik, and many more. Funnyman even had to contend with a couple of hecklers, Comicman and Laffman, copycat superheroes looking to steal the slaphappy hero's thunder.

The collapse of Funnyman coincides roughly with Siegel and Shuster's court case, which was resolved in favor of Superman's long-time publisher. It's possible that even if their new character had caught on, neither creator would have felt the high spirits necessary to keep the collaboration going.

EDITOR'S NOTE...

Funnyman never returned to a title of his own, but he made a cameo of sorts in DC Comics' Super Friends #5 (June 1977), in which writer E. Nelson Bridwell and artist Ramona Fradon arranged for a "funny man" comedian named, and resembling, Larry Davis to make an appearance on a televised fund-raiser. The event was staffed by such heroes as Batman, Wonder Woman, and, of course, Superman. In the 1990s, Funnyman almost found a whole new audience when comedian Richard Belzer attempted to develop the character as a motion picture.

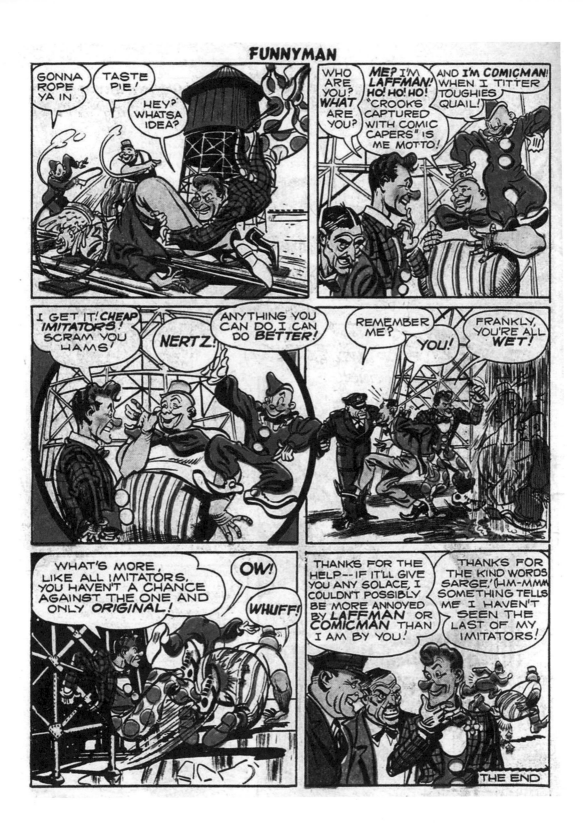

GHOST PATROL

"Funny thing! To know you're ... er ... dead ... an' still be able to talk about it! Well-l-l, we had it comin' ... "

Created by:
Ted Udall,
Emmanuel Demby,
and Frank Harry

Debuted in:
Flash Comics #29
(DC Comics,
May 1942)

Alternate unused identities:
The Lifeless
Legionnaires,
the Departed
Do-Gooders

© 1942 DC Comics

THE GHOST PATROL WEREN'T the only characters in comic books who started their superheroic careers post mortem (see Kid Eternity, page 73, and Nemesis, page 177). But few other resurrected super-do-gooders seemed to have as much fun.

In life, the men who would eventually become the Ghost Patrol were lantern-jawed Fred, handsome (and vain) Pedro, and the ironically named Slim. Professional soldiers of fortune, these friends and fellow pilots had the bad timing to enlist in the foreign legion just prior to France falling under Nazi control. Now taking orders from Germany's military commanders stationed in northern Africa, the trio is sent on all manner of unsavory missions, against their better judgment, including a bombing raid targeting helpless civilians.

But their consciences get the better of them in midflight. Underlining their moral quandary, Fred drawls resentfully, "We never joined this outfit to kill women and children!" Deciding to dump their deadly payload harmlessly in the middle of the empty desert, the pilots discover too late that Henri (their mechanic, who had tried to warn them against flying this mission) had sabotaged the planes. Rather than see them used for wholesale slaughter, Henri would see them destroyed by time bombs. An explosive airborne moment later and Fred, Pedro, and Slim have all shuffled off the mortal coil.

But they're not gone long. The reason for the resurrection is never fully explained, but the pilots find themselves standing above their own broken bodies. Even more alarmingly, they can see right through one another!

Near-invisibility isn't the only power the newly dubbed Ghost Patrol picks up. Besides the power of flight, they can also pass through solid objects, stretch and even separate their body parts, turn to smoke, summon storms, and call down lightning. Better still, they can become completely visible and solid. In fact, death doesn't seem to be much more than a minor inconvenience for the men, who are happy to turn their powers to bedeviling Nazi aggressors throughout Europe.

Reuniting with Henri, whom they seem to have forgiven for his deathly shenanigans, the Ghost Patrol's first mission is to direct the full complement of their supernatural powers at their evil former commander. Once the local bad guys are sorted, the spectral soldiers aim higher and closer to Berlin. That's right, they spend their second appearance hassling Hitler! Indeed, the Ghost Patrol frequently makes the top Nazi a special priority throughout their career. A stand-out adventure from early in the run involves the men swiping Hitler's →

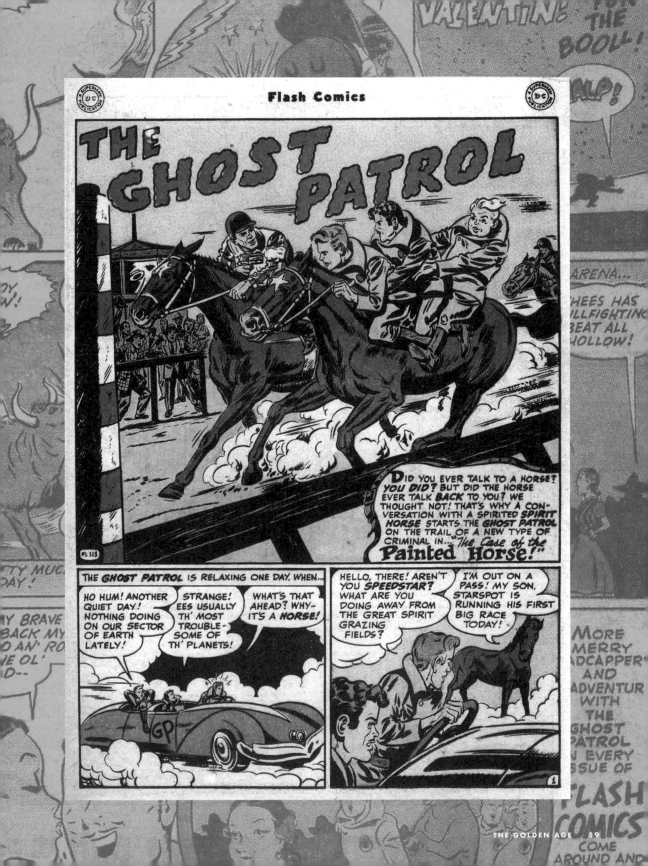

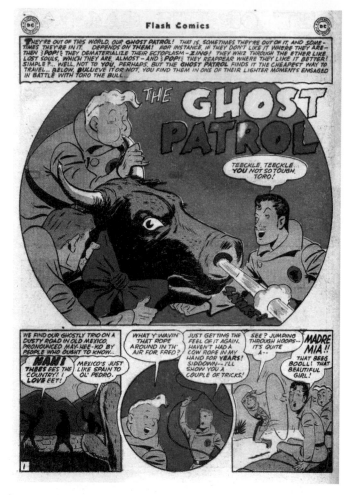

false teeth. "Midout mein teesh I cannot shcream . . . und if I cannot shcream, how can I be der Feuhrer?" cries a gum-toothed Hitler into a full-length mirror.

After World War II wrapped up, the Ghost Patrol eked out another half decade of adventuring, shifting their focus from Axis armies to everyday mobsters. In 1949 the group vanished—for real, this time—and the Ghost Patrol has been AWOL from comics ever since. But the nice thing about a concept like this: you can never fully write off any characters who have already beaten death.

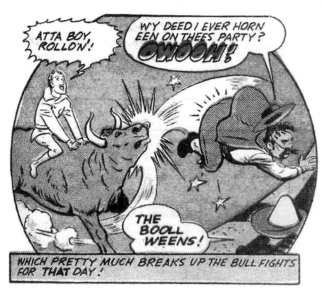

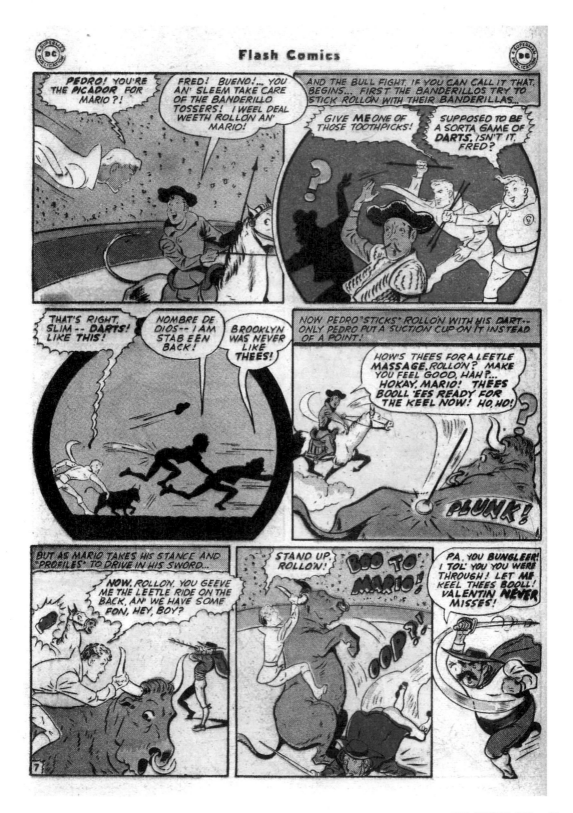

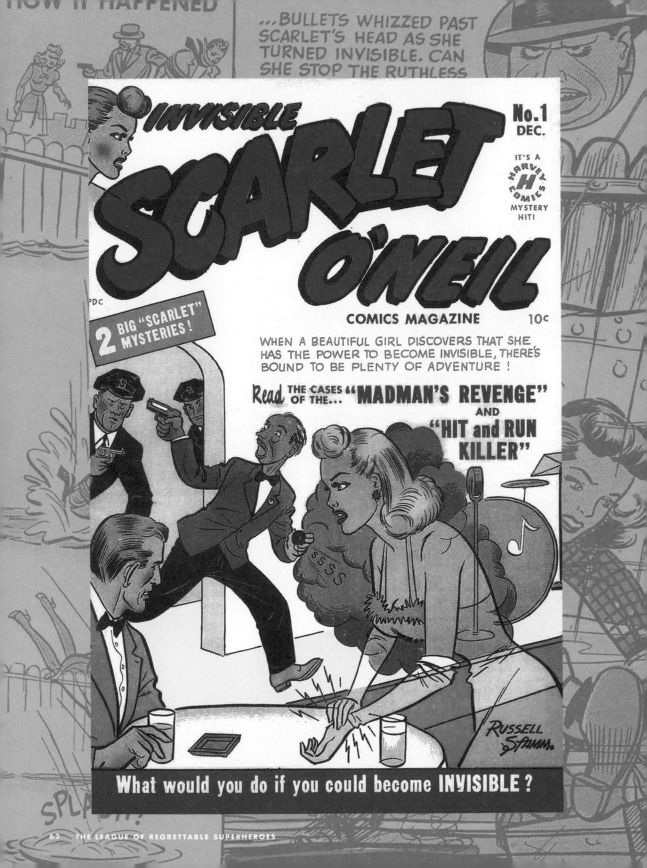

INVISIBLE SCARLET O'NEIL
"I'd better remove my clothes so I can swing freely in the ring."

T'S NOT EXACTLY A name that strikes terror into the hearts of criminals. But in the early anything-goes days of superheroes, the rules were still being written, and Invisible Scarlet O'Neil helped write them.

The eponymous Ms. O'Neil missed out on being the first female superhero in comics only because her initial appearance was in newspaper comic strips before she made her comic book debut. (Fantomah, page 50, is generally considered the first.) Many of her few contemporaries, like the Woman in Red and Lady Luck, had little but their wits and fists to rely on. Scarlett may have lacked a superheroic alias or costume, but as her nickname implies, she had the advantage of invisibility.

One in a long line of costumed crime-fighters who gain powers from having an ingenious inventor for a father (e.g., son of Supermind, page 100), Scarlet O'Neil acquired her ability to turn transparent when, as a young girl, she poked a curious finger into a ray beam in her father's laboratory. The result: she could now render herself invisible at will. Whenever our heroine needed to pass unseen, the change was triggered by a discreet application of gentle pressure at a specific spot on her wrist.

Scarlet was the creation of Russell Stamm, a former assistant on Dick Tracy who abandoned the hard-boiled, guns-blazing sensibilities of the popular cop strip that gave him his start. As if presaging the parental concern over comic book violence, Scarlet solved her cases without much in the way of bullets or bloodletting; she got by on wits and her innate kindness. Even promotional material boasted of her relative nonviolence: "Action—without blood and thunder!" read one, and "Adventure—exciting but human! Fantasy—but with a humorous twist!"

Not that O'Neil avoided trouble. Her adventures included challenges any superhero would be proud to face, from raging wildfires to gun-happy crooks, even a little time-traveling. But for all its variety, her career wasn't a long one. As superheroes' popularity began to wane, I.S.O. faded with them, though slowly. In 1950, the "invisible" was dropped from her title, and Scarlet's unusual ability was put on display with increasing rarity. After a few more years as just "Scarlet O'Neil," the strip was renamed after a popular, recently introduced character, "Stainless Steel." A year later, it was canceled altogether.

Created by:
Russell Stamm

Debuted in:
Chicago Times
(June 3, 1940)

No relation to:
Imperceptible
Crimson O'Leary,
Undetectable
Alizarin O'Shea

© 1940 by
Chicago Sun Times

THE IRON SKULL

"I can't say I'm sorry I had to wreck your floor with my head!"

Created by:
Carl Burgos

Debuted in:
Amazing Man
#5 (Centaur
Publications,
September 1939)

Name sounds like:
A decent heavy
metal band;
something Indiana
Jones might be
looking for

© 1939 by
Centaur Publications

THE IRON SKULL MAY have the privilege of being the second robot superhero in comics (after Bozo, page 23). Or possibly the first cyborg superhero in the medium. It's hard to say for sure what accolade he's most deserving of because the stories themselves are awfully unclear on what exactly the Iron Skull is. At least we know this much: his skull is made of iron.

Although the Iron Skull never receives an origin per se, readers are introduced to a sketch of his backstory in one introductory caption, which highlights the essential points: a former soldier, badly wounded, has most of his body (and specifically his skull) replaced with metal equivalents. The result of the surgery is a man who looks exactly "like a living image of a skeleton"—not quite true, although the grim-visaged Skull did cut an imposing figure—but whose body houses the terrific powers bestowed upon him by his mechanical parts.

The Skull's metallic nature was disguised by a "lifelike" rubber mask whose manufacturers clearly cut a few corners. With a triangular cutout where his nose was supposed to be, the stern figure resembled a blonde-haired jack-o-lantern in a blue suit as much as he did a robot. The resemblance was enhanced when, in later appearances, the Iron Skull traded in his suit for a snazzy superhero costume, complete with skull-and-crossbones insignia, and sported a completely shaved head.

The Iron Skull's adventures took place in the far future of 1970, a pessimistic twenty years after the end of World War II. The depictions of this distant era had a habit of changing from one story to the next, so that the Iron Skull's future world had a touch of Buck Rogers one issue, and seemed indistinguishable from contemporary 1940s America the next. Eventually, all references to the future setting were dropped; a new writer began to pen the Skull's adventures, and he apparently didn't get the memo about where the action was taking place.

As for powers, the Skull briefly developed the ability to communicate mentally with New York's district attorney, the better to be on the lookout for crime. And he somehow acquired the ability to fly around the same time he picked up a distinctive costume. For the most part, his power was smashing his head through things. In any given story, the Iron Skull might take three or four distinct opportunities to validate his nom de guerre, bashing through walls, busting up machinery, knocking out twenty-foot-tall women, even drilling through floors and ceilings using only his reinforced noggin!

Not that he was above using his metal fists and feet to wreak a little havoc →

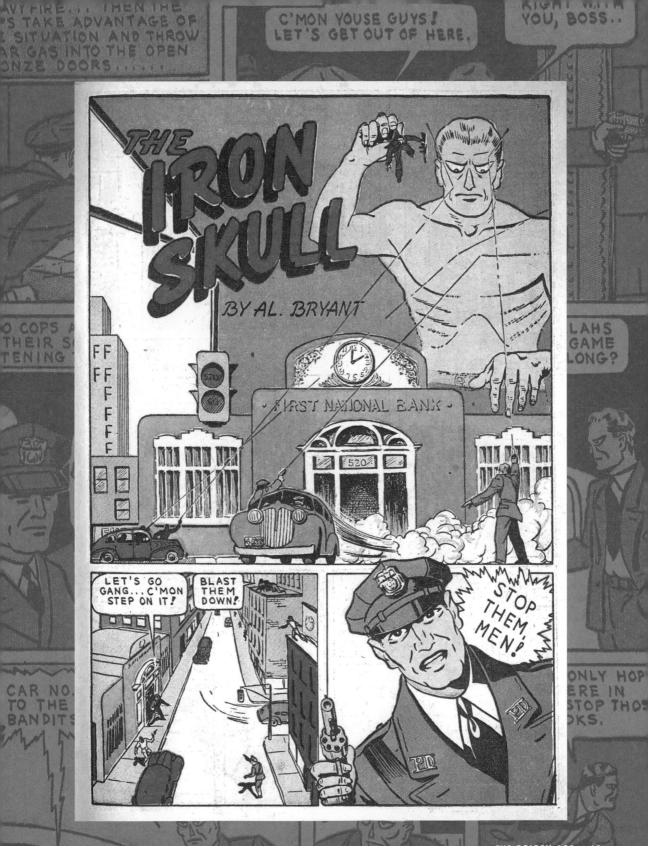

now and again, too. The Iron Skull didn't discriminate about his means of destruction; he just had an image to maintain. Though literally hard headed, the Iron Skull wasn't stubborn enough to stick around after his series ended. A revival attempted in the 1990s fizzled, possibly because it was difficult to find an audience for such an oddball character.

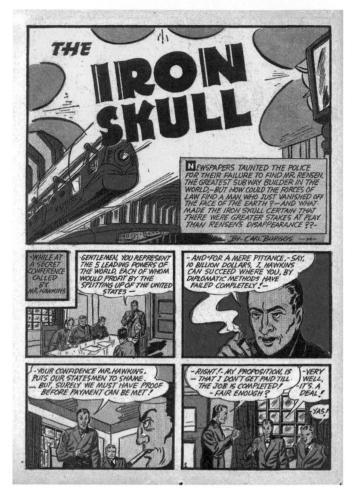

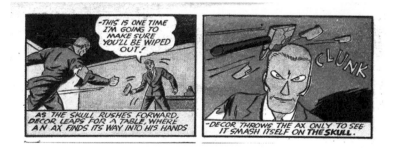

EDITOR'S NOTE...

For a while, the Iron Skull possessed a ring that would leave a skull-shaped impression on any crook he slugged, a gimmick he may have picked up from that purple-clad jungle hero, the Phantom.

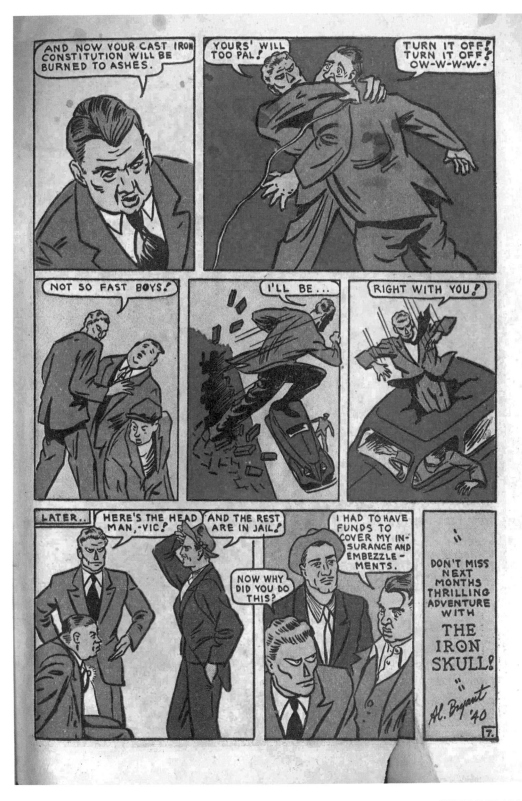

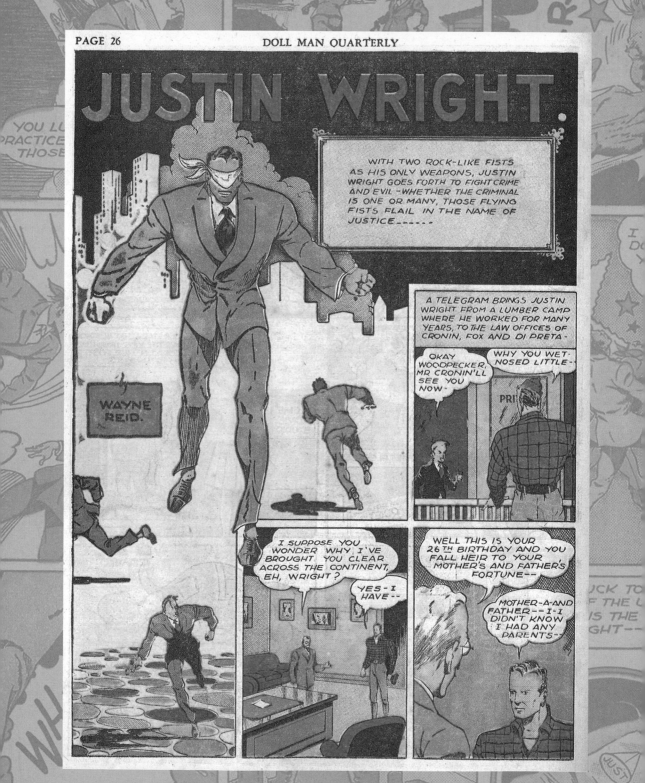

JUST 'N' RIGHT

"Crime robbed me of parental love—something's got to be done to stamp out crime—something will be done!"

IT'S AN UNFORTUNATE TRUTH in comic books that many crime-fighting careers begin with the death of one's parents. Superman's mom and dad sacrificed their lives so that their only son might live on. Batman saw his parents gunned down before his very eyes. Even Spider-Man is an orphan. And then . . . there's Just 'n' Right!

On his twenty-sixth birthday, lumberjack Justin Wright is called to the law offices of Cronin, Fox, and Di Preta. There, the burly young man is made aware that he's the sole inheritor of the vast fortune of his late parents—parents he never knew anything about. As an orphan who was handed off from one foster family to another, Justin was also unaware that his parents were murdered by criminals.

Left unsettled by this bittersweet inheritance, Justin goes to explore the humble home left to him. In a small box of mementos he finds his mother's scarf—the same one she was wearing at the time of her murder—and discovers that it possesses a curious one-way translucence. From one side the scarf can be seen through clearly, whereas from the other it's completely opaque. Taking this as a sign, Justin opts to wear the scarf "like a blindfold mask," recalling the likeness of blind justice, as he wages a one-man war on crime.

As aliases go, Justin Wright's baddie-bashing alter ego "Just'n'Right" probably shouldn't leave crooks scratching their heads about his real name. Nonetheless, he manages to make it work. Decked out in a sharp suit and his mother's scarf, Just'n'Right is armed with "two rock-like fists as his only weapons," setting upon criminals while "those flying fists flail in the name of justice."

Just 'n' Right enjoys a brief but effective career. In his first outing, he manages to put an end to the nefarious affairs of an elf-eared gangster, Pety Dirk, and top mob boss "Skizone." Part of Just'n'Right's success may lie in relentless self-promotion. Before we first see him in action, the underworld is already alarmed by "that new menace that's popped up—Just'n'Right!" Perhaps they'd seen his calling card, a sticker affixed to the foreheads of his unconscious targets depicting a balanced scale and his nom de guerre. The blindfolded baddie-basher doesn't stop at pummeling mooks. To summon the authorities, he hurls a signed note and a bundle of evidence—tied to a brick—through the police chief's office window.

Just 'n' Right made only that single appearance, and his ultimate fate was never revealed. Conceivably, the police picked him up outside the chief's office and put him away on a vandalism charge.

Created by:
George Brenner
(as Wayne Reid)

Debuted in:
Doll Man #1
(Quality Comics, 1941)

Existential dilemma:
Why not become a lumberjack-themed superhero?

© 1941 Quality Comics

KANGAROO MAN

"I couldn't have done a thing without Bingo! Here, pal, have a dose of your favorite candy—cod liver oil pills!"

Created by:
S. M. Iger and Chuck Winters

Debuted in:
Choice Comics #1 (Great Comics Publications, December 1941)

Notable characteristics:
No pouch, no tail—hey, is this guy even really a kangaroo?

© 1941 Great Comics Publications

THE COVER OF CHOICE COMICS billed Kangaroo Man's debut as "the most unusual feature in comics." That's a difficult claim to defend, but it's clear this was an atypical sort of superhero. For one thing, Kangaroo Man wasn't even really the star of his own feature. That honor fell to his marsupial sidekick, a crime-smashing, Nazi-bashing, and wise-cracking kangaroo named Bingo!

The saga commences as Jack Brian—the eponymous Kangaroo Man and "daredevil American explorer"—returns to his native country from a tour of Australia, arriving with a trained kangaroo in tow. "I found Bingo on the Australian plains two years ago," he explains to an old friend. "He's trained now so he's practically human. He understands my commands and signals like a soldier."

That description of Bingo's responsiveness is blatantly underselling his potential. Gifted with an apparently unlimited understanding of human speech, Bingo also seems to possess a human intelligence and wry tough-talking personality. Although the 'roo's own speech is limited to a series of hiss-like rasps—variations on "Rssp!" and "Rsp!"—Bingo's often quite complicated thoughts are translated for the readers. "Trust me pals, Bingo won't let you down," he silently reassures his human friends in a moment of peril. "Who says kangaroos can't master strategy," he ponders while making short work of a deadly mountain lion. "Can't say I enjoy this kind of transportation," thinks Bingo while riding a motorcycle.

In addition to his human intelligence and nonstop patter, Bingo masters some pretty impressive skills. Besides possessing top-notch hand-to-hand (and foot and tail) fighting techniques and knowing his way around a motorbike, Bingo walks the wings of a plane in flight and hops away unharmed after his tail is run over by a German tank. On the cover of his second appearance, he's mopping the floor with a trio of presumably superpowered masked hero-types. "These silly zooming 'super guys' amuse me!" thinks the cantankerous kangaroo while effortlessly batting his super-powerful opponents like rag dolls.

As for Jack Brian, so-called Kangaroo Man, he's almost a supporting character in his own feature—but then again, how do you compete with a wisecracking kangaroo? Kangaroo Man is hard-pressed to offer much more than a roundhouse punch and the occasional bit of gunplay when trouble comes calling. In fact, the most important contribution Kangaroo Man seems to make is to reward Bingo with a tidbit of cod liver oil.

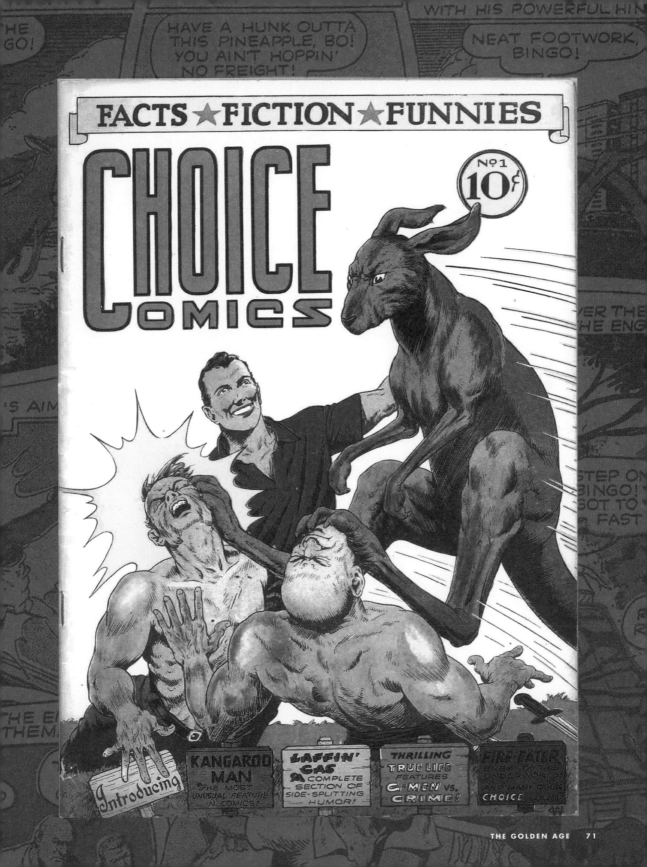

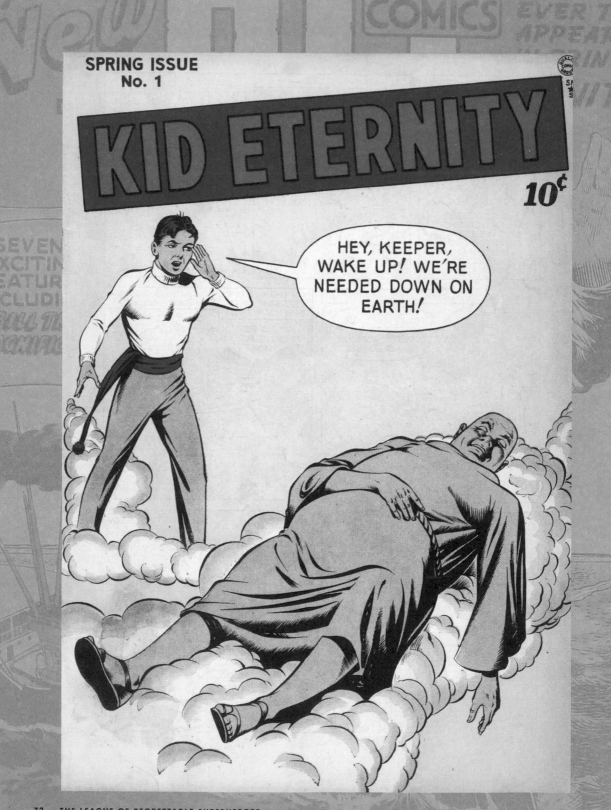

KID ETERNITY
"Eternity!"

EW SUPERHEROES GAIN THEIR powers as the result of a clerical error. But then there's Kid Eternity! While still a boy, "Kid" (his real name is never revealed) becomes the victim of Nazi aggression when a U-boat sinks his grandfather's ship—heavy with its cargo of rubber and crude oil—taking with it all hands. Their bodies are recovered by a patrolling American destroyer, but the next time we see the Kid and his "Gran'pa," they're among the Elysian fields of "Eternity."

Concerning Gran'pa and the rest of the crew, there's no problem. In the fatalistic universe of Kid Eternity, the dates and methods of every human death are preordained, so the recently snuffed sailors were expected. Not the Kid, though. Thanks to a celestial bookkeeping error (the first in two million years!), the Kid passed away before his time. He wasn't scheduled to shuffle off the mortal coil for another seventy-five years.

It's disheartening to imagine that bureaucratic errors persist into the afterlife, but at least the powers-that-be make it up to the Kid, in spades. First, they return him to his human body (no mean feat, considering he has to be recovered from a burial at sea). And their largesse doesn't end there. The Kid is granted tremendous supernatural powers! With a shout of his magic word—"ETERNITY!"—he can switch between his mortal and ghostly forms, perform feats of pure magic, and summon the greatest figures of history, myth, and fiction to his beck and call.

Guiding the underage superhero in his mission against crime is "Mr. Keeper," the portly desk-jockey whose error resulted in the Kid's unscheduled kicking of the bucket. Together, the pair proved popular enough to score the Kid a title of his own, in addition to his appearances in *Hit Comics*. Over the course of his solo run, the Kid's powers narrow in scope: his magic word originally gave him nearly limitless abilities, but eventually his power set was limited to transitioning between mortal and ghost, and summoning of notable shades (including fictional ones).

Still, the latter ability served him well, and when he was in a jam, Kid E summoned everyone from Paul Bunyan and Hercules to Knute Rockne and Robin Hood. Unexpected choices include prohibitionist Carrie Nation (always an asset when you have to throw down with a gang of hoodlums) and fellow Quality Comics character Blackhawk (page 129). Kid Eternity's opposite number was Master Man, a reform school thug who could summon the most evil figures of myth and history by hollering his own magic word, "Stygia" →

Created by:
Otto Binder and Sheldon Moldoff

Debuted in:
Hit Comics #25 (Quality Comics, December 1942)

Notable shortcomings:
Wears white after Labor Day; is dead

© 1942 Quality Comics

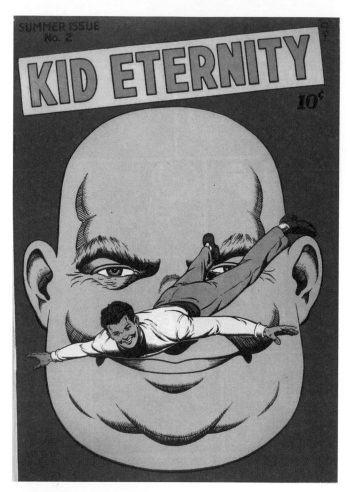

(apparently the infernal alternative to this cosmology's divine Eternity). Among KE's more dangerous foes—like the sinister Kali or the wretched Doctor Pain—was a pair of lady con artists called Her Highness and Silk, who became so popular that they graduated to a feature of their own.

By the early 1950s, Kid Eternity's popularity faded, bringing him (or at least his book) the death he'd evaded years before. Although he's been resilient enough to survive a few revivals since, none of the Kid's reappearances have earned him superstardom. If Kid Eternity wants a second life as an A-list hero, he'd better hurry up—his seventy-five-year reprieve is almost over!

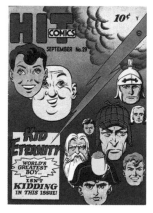

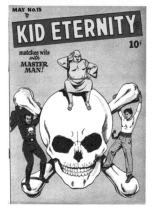

ROLL CALL...

Other superheroes who worked their mojo by way of magic words include the second Blue Beetle ("Khaji Da!"), Johnny Thunder and his Thunderbolt ("Cei-U"), and father–daughter magicians Zatara and Zatanna (who cast their magic spells by speaking words backward, i.e., "sdrow sdrawkcab"). Not to mention, of course, the entire Captain Marvel extended family ("Shazam!").

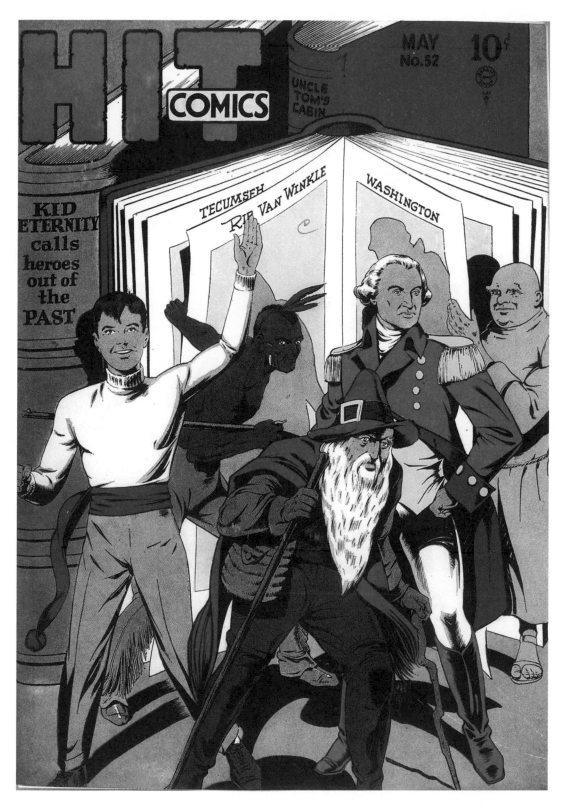

LADY SATAN

"Burn, drinker of blood!
Burn, werewolf master!"

Created by:
George Tuska

Debuted in:
Dynamic Comics #1
(Harry "A" Chesler
Publishing,
December 1941)

**Alternate unused
identities:**
Madame
Mephistopheles,
Dame du Devil

LADY SATAN MAY HAVE an infernal edge to her name, but her supernatural side was late in coming. "A strange, mysterious woman dedicates her life to ferret out the secrets of the enemies of democracy," begins the caption to her introductory story, "and to turn these secrets over to the nations engaged in a death struggle to keep the light of liberty aglow."

It's with no light responsibility that Lady Satan has chosen to saddle herself, but she's motivated. The sole survivor of an Atlantic passenger ship sunk by Nazi bombers, the soon-to-be-redubbed Lady Satan (real name unknown) is already vowing revenge while clinging for life to an errant piece of driftwood. She is soon hard at work subverting Nazi war plans, uncovering spies and saboteurs, and generally looking fabulous while doing it—while dining in a chic Parisian café, she's decked out in a blood-red evening dress and matching domino mask.

Lady Satan starts off powerless but not helpless—she's deadly with a garrote, handy with a handgun, and a real pip behind the stick of a fully loaded fighter plane. She relies heavily on her knives, one of which possesses a retractable blade and contains a reservoir for fake blood, in case she needs to simulate a suicide. Her primary weapon, though, is a gun that shoots clouds of chlorine gas. "A dose of chlorine won't hurt them" Lady Satan opines, quite incorrectly, as she fills an entire room of baddies with the deadly stuff.

Lady Satan disappeared for a few years, returning in the mid-1940s after having benefited from a little extracurricular study. Still decked out in her domino mask and crimson eveningwear, Lady Satan picked up some magic tricks—specifically, black magic! Armed with obscure arcana like "Xanda powder" (handy for discouraging overattentive werewolves) and a Tibetan gadget capable of summoning helpful "shadow people," the now-supernatural superheroine finds herself taking on cases of evil mystical forces that threaten innocent people.

A few of her enemies turn out to be merely mortal ne'er-do-wells who use rubber costumes and ghostly gadgets to simulate sorcery. Lady Satan dispatches them just as quickly and mercilessly as she does the legitimate spooks. But she seemed to have given up the chlorine gun, despite its inarguable convenience in dispatching an entire room full of criminal jerks.

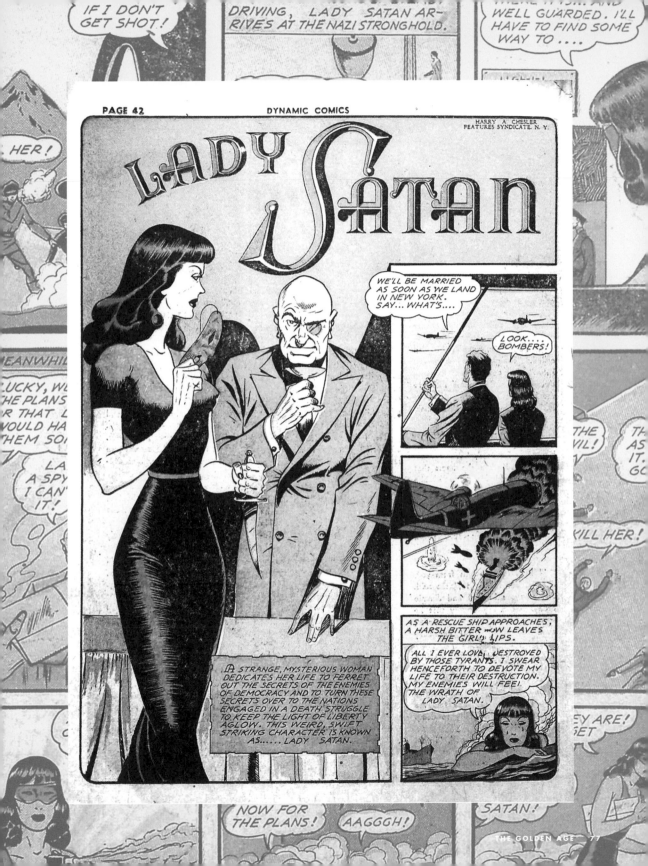

MAD HATTER

"I'm really not so bad as I'm painted!
By all means let's get better acquainted!"

S THE 1940S DREW to a close, the popularity of superheroes began to wane. Future decades would prove there were still novel ideas to be had in the genre, but the boom that had immediately followed the publication of Superman made novelty a victim of plenty. Young readers were beginning to clamor for westerns, humor, and gory mystery books over the familiar cape-and-cowl types flooding the racks.

Nonetheless, new superheroes were being introduced with the intention of catching the jaded eye of the veteran comic book reader. Among these stood the Mad Hatter, a blonde-haired crime-fighter decked out in lurid purple, under a masthead declaring, "A new kind of comic book."

What exactly was "new" about this comic book is a question for the ages. The adventures of junior law partner Grant Richmond—alter ego of the crime-smashing Mad Hatter—resembled the familiar adventures of any dozen other heroes. Richmond maintained a put-upon alter ego, had a hardnosed girl reporter as an inamorata, and faced off against a colorful coterie of baddies and menacing goons. You know, the usual.

Which is not to say that the Mad Hatter didn't have a few unique things going for him. For one: his costume, a violet one-piece accessorized with the cape, gloves, boots, and briefs tricked out in white fur. Also notable was his insignia, proudly emblazoned against a golden circle on his chest: a top hat. It's hard to suggest what sort of figure the Mad Hatter cut in his crusade against the underworld, but "menacing" doesn't seem to fit.

The Hatter also adopted a habit of speaking in rhyme, at least when he was mopping up the bad guys. He'd drop the affectation when talking with non-crooks (or sometimes when the author just forgot or couldn't be bothered). The rhyming gimmick was employed on the Mad Hatter's calling cards as well, which were emblazoned with such timeless doggerel as "Though I dream of sweets and stuff, Kings and cabbages aren't enough—I must have danger too!" Signed, "The Mad Hatter."

A few intriguing criminals lingered among the Hatter's otherwise typical parade of racketeers and mobsters. Keeping with the children's literature theme, for instance, was the corpulent Humpty Dumpty, a criminal genius hobbled by his overpowering laziness. More striking, however, was the Gargoyle—in reality, a mobster named Frank Faro whose brain had been transferred into the body of a gorilla. Donning a man's suit and a lifelike rubber mask, the super-crook embarked on a combination crime wave and revenge spree that sorely tested the Hatter's resolve.

Created by:
Bill Woolfolk and Mort Leav

Debuted in:
Mad Hatter #1 (O. W. Comics Corp, January/ February 1946)

Does he wear a hat?
Actually, no.

© 1946 O. W. Comics Corp

\rightarrow

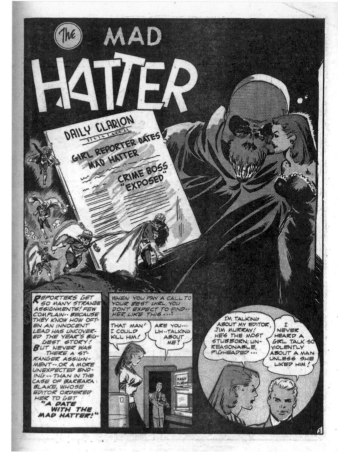

Yet, the obvious question about this hero is, why did he call himself the Mad Hatter? Was he possessed of hat-related gimmicks or crime-fighting chapeaus? (No.) Was he in some way based on the Lewis Carroll creation of the same name? (Possibly.) We he mad? (Very likely. Did I mention the fuzzy white briefs?) Whatever the case, with only a handful of appearances over a mere two issues, the Mad Hatter wasn't around long enough to answer these questions, either in rhyme or in prose.

EDITOR'S NOTE...

The Mad Hatter carried a signal device of some sort that allowed him to shine his insignia in the path of terrified crooks. The device, however, is never shown. How exactly the Hatter accomplished the trick, and where he kept the gadget, will forever be a mystery.

MADAM FATAL
"A very touching farewell— clever acting I call it!!"

Created by:
Art Pinajian

Debuted in:
Crack Comics #1
(Quality Comics,
May 1940)

Alternate possible aliases:
Old Lady Mortality,
Grandma Death,
that nice Mrs.
Vengeance from
next door

© 1940 by Quality Comics

HEN ACTOR RICHARD STANTON'S wife passes away and his daughter is kidnapped, the heartbroken but critically acclaimed character actor and master of disguise simply vanishes from public life. Eight years later, Stanton is only a memory. In his place stands Madam Fatal, the little old lady who became comicdom's first cross-dressing superhero!

Resembling something like a mix of the films *Taken* and *Mrs. Doubtfire*, Madam Fatal represents one of the truly unique characters in comics. Women who disguised their gender in superhero identities were uncommon but not unheard of. However, America's macho culture frowned on the opposite arrangement, making Madam Fatal a singular character, to say the least.

Stanton's commitment to his alter ego was more than passing. As explained in his debut appearance, he built a comprehensive second life for his elderly, red-clad senior citizen identity. To Stanton's neighbors, Madam Fatal was a kindly old lady who occupied a quiet apartment with her pet parrot Hamlet, not a superhero vigilante itching for action. Even after Stanton/Fatal confronts his daughter's abductor, he chooses to keep the disguise of Madam Fatal alive. "John Carver is dead," he says of the crook, "and the actor's disguise of Madam Fatal has served its purpose—but this is not enough, for I've decided that, as Madam Fatal, I'll go on fighting crime and lawlessness as long as I can!"

"As long as I can" ended up being another twenty-one issues of *Crack Comics*, during which Madam Fatal never scored a cover appearance (except for a headshot in the sidebar of the first issue, jammed between such timeless names as "Wizard Wells" and "Ned Brant").

Lest readers fear that Stanton was in any way dainty, he was portrayed as an all-around athletic marvel in both of his identities; Stanton was an ex-soldier, a deep-sea diver, and an expert swimmer, whereas Madam Fatal swung from rooftops, fought like a lion, and wielded a ferocious cane. As the series progressed, Carver found himself with more frequent opportunities to appear out of uniform; eventually he was set up in the "Sure-Fire Detective Agency" with his pals Tubby White and Scrappy Nelson (although it was Madam Fatal who did most of the two-fisted sleuthing).

After almost two years, the character had exhausted the shock value inherent in an apparent octogenarian knocking thugs around like rag dolls, and Madam Fatal hung up her wig and cane.

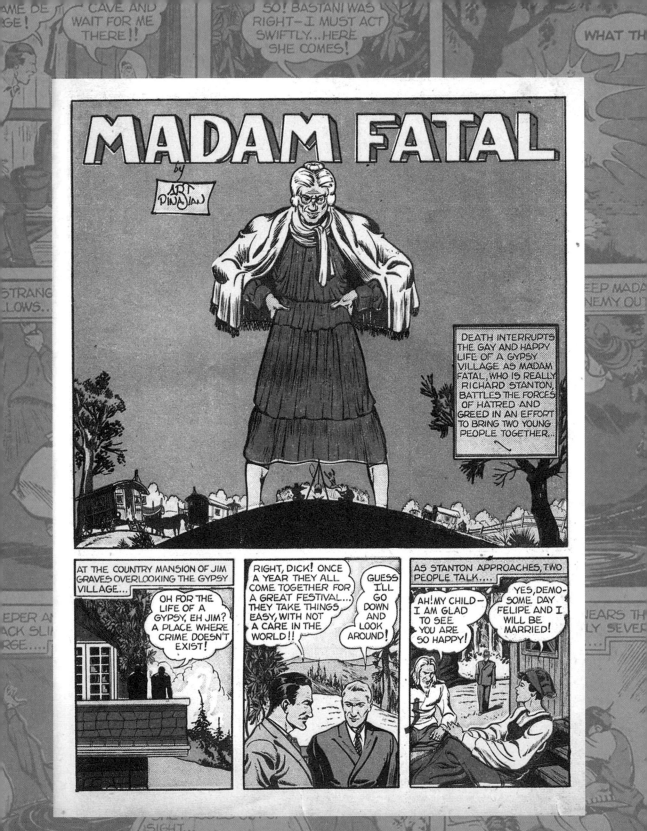

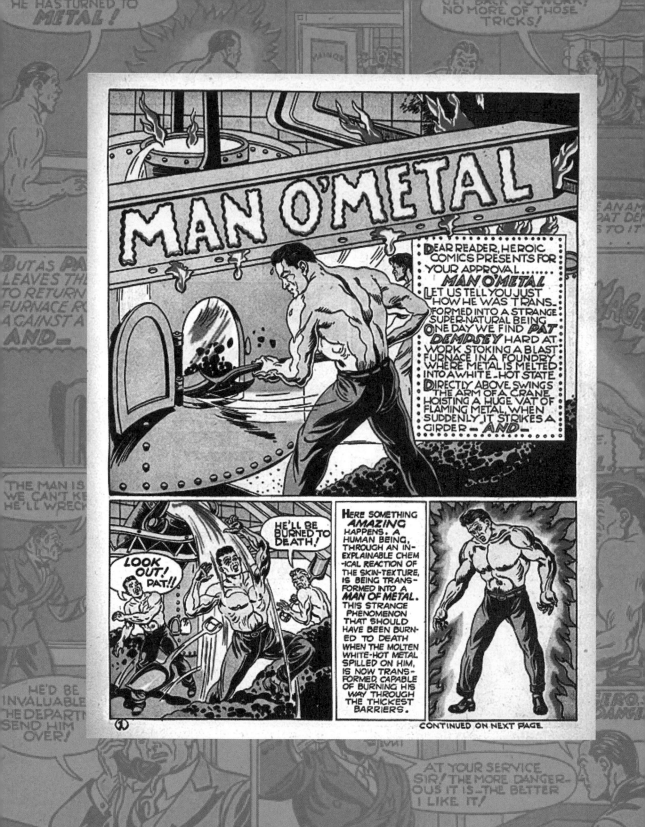

MAN O'METAL

"Sorry, Senorita, the bullets ignited me!"

NOT ALL SUPERHEROES ARE secretly multimillionaire playboys. Quite a few of crime-fighting's caped-and-cowled crusaders punch the clock as newspaper reporters, beat cops, and the like. But for a genuine blue-collar superhero we don't get a much better example than Pat Dempsey, a.k.a. Man O'Metal!

Created by:
H. G. Peter

Debuted in:
Reg'lar Fellers Heroic Comics #7 (Eastern Color Printing, July 1941)

Alternate unused identities:
Fella O'Fire,
Superhero McSteel

© 1941 by Eastern Color Printing

Although he sounds like a brand of silverware polish, Man O'Metal is in fact a steelworker who is accidentally caught under a shower of molten steel. Rather than dying in the terrible accident, Dempsey undergoes a startling transformation. "A human being," explains a caption in his introductory adventure, "through an inexplicable chemical reaction of the skin texture, is being transformed into a man of metal." That's just basic science; any school child knows that.

The molten-steel shower transforms Pat's skin to sleek, sky-blue metal and encases him in powerful flames, imparting immense strength and rendering him "capable of burning his way through the thickest barriers." Seizing the opportunity, Pat's bosses at the foundry connect him with the F.B.I., and soon Pat Dempsey becomes a superpowered agent for the U.S. government (and an occasional private eye).

Man O'Metal's amazing powers require the occasional recharge. Any contact with flame, significant heat, or electricity is sufficient to send Pat's skin blazing and effect his transformation into living steel. Once he cools again, he reverts to his human state. You might think Pat would carry a lighter at all times; instead, he typically relies on happenstance and luck to trigger his powers. Over his roughly two dozen adventures, Pat manages to sneak a lucky spark from a downed power line, a hot radiator, a lit cigarette, a passing car's unexpected backfire, an acetylene torch, a frying pan (full of bacon and eggs), a shovel full of hot coal, and a matchbook luckily ignited by a bullet. Oh, and also by rubbing the soles of his feet along a wall.

Man O'Metal is likely based on the legend of Joe Magarac, the subject of several urban folk tales that popped up among Pittsburgh steelworkers of in the early 1900s. Something like a Paul Bunyan of the steel industry, Magarac was a tremendously strong man—made of pure metal—who emerged fully formed one day from a vat of molten metal to serve as a protector of the city's steelworkers.

Man O'Metal was the creation of H. G. Peters, the cocreator of Wonder Woman. Presumably, when the latter series took off, Peters had less time to concentrate on his steel-jacketed creation, which explains why the unique-looking hero vanished after a few years of waging a blazing battle against crime.

MOON GIRL

"You have no right to command me in anything!"

Created by:
Max Gaines,
Gardner Fox, and
Sheldon Moldoff

Debuted in:
The Happy Houlihans
#1 (E.C. Comics,
1947)

Current phase:
Eclipsed

© 1947 by E. C. Comics

N COMICS, FEMALE SUPERHEROES have always been fewer in number than their male counterparts. But not so few that the creators of superheroines wouldn't copy an already-proven formula.

Moon Girl was the sole costumed hero published by EC Comics, the company that would become notorious for the gory horror comics targeted in Frederic Wertham's excoriating book *Seduction of the Innocent.* Founded by Max Gaines after his departure from All-American Publications (home of Green Lantern, Flash, and, most relevant to Moon Girl, Wonder Woman), Educational Comics was intended to be a comics publisher that eschewed superheroes in favor of religious and didactic stories.

But after Gaines's untimely death in 1947, his son William picked up the reins, steering EC toward the horror, war, and humor comics that became its mainstays. Along the way the company tried its hand at superheroes. Moon Girl's story featured a fairly familiar origin: Clare Lune is princess of an isolated civilization of warrior women. In possession of powers that make her "superior to any man," Clare takes off for America, where, assuming the identity of Moon Girl, she battles evil in her telepathically controlled airship (or, to be more precise, moonship).

Her natural superiority is enhanced by a mystic "moonstone" she wears on a choker. Similarities to Wonder Woman aside, Moon Girl melded adventure with a touch of romance. Part of her mission in America was to locate her former suitor, the rugged Prince Mengu. Finding the dusky hunk teaching school, she adopts a civilian identity in the same institution, pairing up with "The Prince" to fight a parade of primarily female menaces, from the horn-headed Satana to the Invaders from Venus (which apparently, just as the famous self-help book suggested, is where women come from).

Moon Girl had a troubled publishing history. Her comic debuted in the late 1940s, when the shine was already dulling on the superhero craze, and was produced by a publisher for whom costumed adventurers held little interest. When the original title *Moon Girl and the Prince* began to flag in sales, the book was rebranded as simply *Moon Girl*, then the more descriptive *Moon Girl Fights Crime*, then—dropping the superheroic trappings altogether—it was repackaged as a primarily romance comic under the masthead *A Moon, A Girl…Romance!* This last iteration saw a five-issue run, in which Moon Girl eked out only a single appearance.

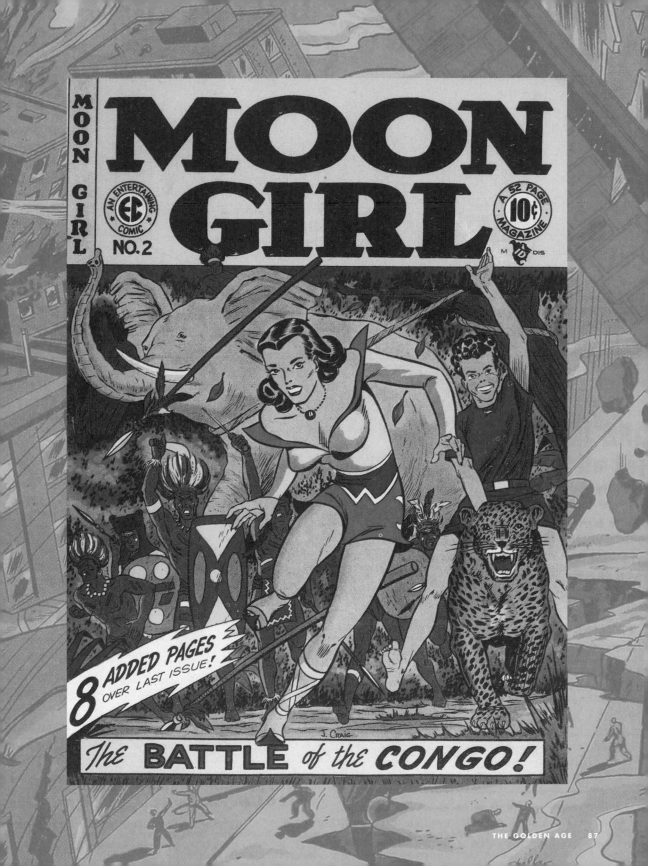

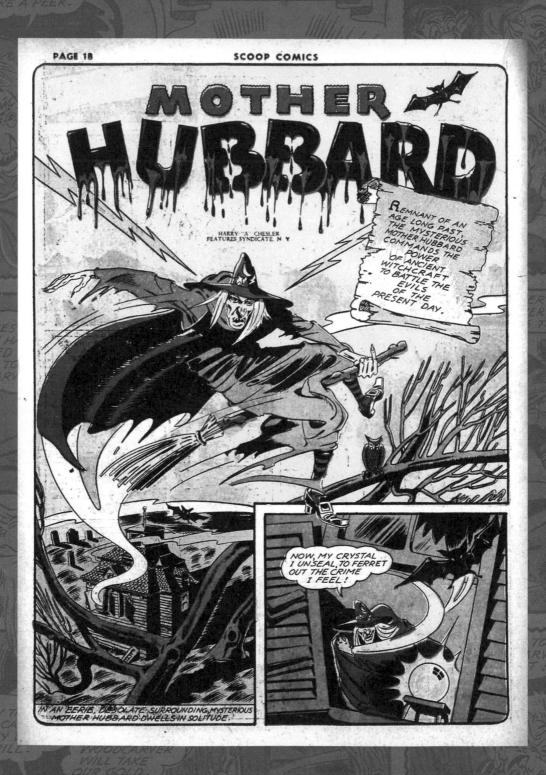

MOTHER HUBBARD

"Loosen eyes from out of head, no more children you'll be fed."

ESPITE BEARING A NAME with origins in a children's nursery rhyme (admittedly, a somewhat bleak one), Mother Hubbard's trio of adventures in the early 1940s may have been the most flat-out terrifying superhero stories in the entire genre. Back then, everyone in a cape and cowl fought a few Nazi masterminds. Only Mother Hubbard confronted a race of gnomes who pried the eyes out of children's heads with a crowbar!

Mother Hubbard was part of a small sorority of magical superheroines (sorcerous do-gooders were not uncommon, but male magicians outnumbered their female counterparts by far), but she stands out from the rest by being a genuine witch—crone-like appearance, peaked hat, flying broomstick, and all. Headquartered in a dilapidated house located somewhere inside a morose swamp, bordering a graveyard and a forest of barren needle-like trees—evidently on the indistinct boundary between the real world and a world of mystical horrors—Mother H turned the tools of witchcraft against the forces of evil, both human and supernatural.

"A remnant of an age long past," begins the caption to her introductory tale, "the mysterious Mother Hubbard commands the power of ancient witchcraft to battle the evils of the present day." Her occult armory was a cupboard that wasn't bare but, rather, full of ominously labeled bottles of "bat's claws," "siren's lure," "madman's blood," and the like. With these, she worked her "idle black magic." She was also in possession of a crystal ball, and Mother Hubbard could tell when evil was afoot via a built-in series of biological early-warning systems. As she once explained, in the rhyming speech that was her trademark patter: "My nose is twitching, my blood runs cold, 'tis sign of pending crime that I must unfold." She could also count on her creaking bones and curling hair to alert her to imminent wrong-doing, although for most folks such bothersome symptoms just mean it's going to rain.

Although she debuted fighting Nazis, Mother Hubbard more often fought bizarre supernatural menaces whose targets were children. In one adventure, work-avoidant gnomes steal the souls of sleeping kiddies and use them to animate tireless wooden dolls to labor on their behalf. In a subsequent adventure, Mother Hubbard blinds a trio of baby-eating ogres and disrupts a subsequent black market for stolen human child's eyes (the gnomes were also responsible for that horrifying operation).

Created by:
Unknown

Debuted in:
Scoop Comics #1
(Harry "A" Chesler
Publishing, 1941)

Sidekick:
Technically,
shouldn't she have
a dog?

© 1941 by Harry "A"
Chesler Publishing

→

Our heroine appeared in a few more comics, but thsoe stories were reprinted from her original run in *Scoop*. No new Mother Hubbard stories have popped up since. Maybe she's busy restocking her cupboards.

EDITOR'S NOTE...

Harry "A" Chesler's comics were known particularly for publishing wild and weird stories. Allegedly, when asked what the "A" stood for, Chesler replied, "Anything." Formerly employed in the furniture business and advertising, he oversaw a packed studio of high-quality comics creators. His employees churned out stories that were then sold to other comics publishers; Chesler also oversaw a chain of publishing houses under variations of his own name, where heroes like Lady Satan (page 76) and the Black Dwarf (page 19) debuted. Chesler claimed at one point to have supplied superhero adventures for 300 comics titles.

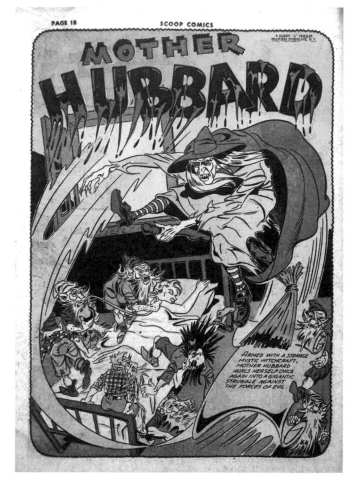

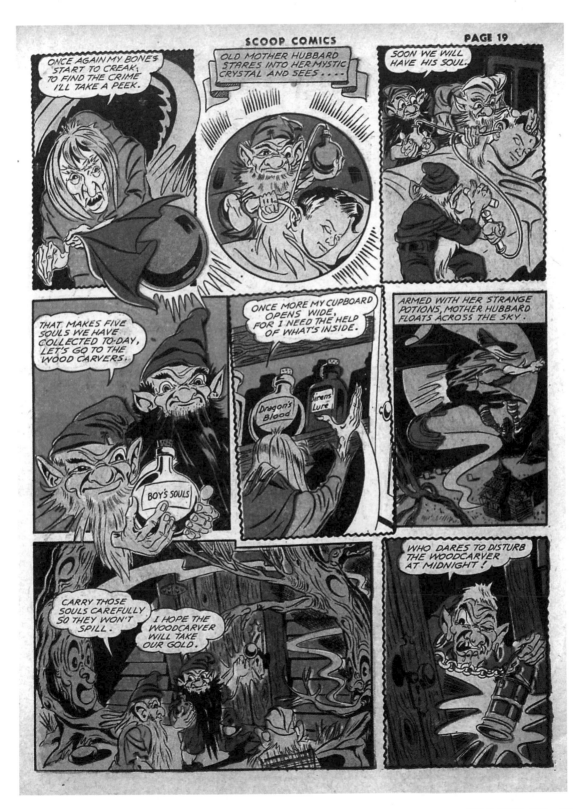

MUSIC MASTER

"What is this strange melody I feel running through my body?"

Created by:
Stephen A. Douglas

Debuted in:
Reg'lar Fellas Heroic Comics #12 (Eastern Color Printing, 1942)

Primary weapon:
The Pipes of Death

© 1942 by Eastern Color Printing

MUSICIAN JOHN WALLACE WAS gainfully employed as a music teacher and symphony performer when destiny gave the violinist the means to strike a blow against crime. "Flung into a series of amazing adventures by his impetuous nature and intense hatred of injustice," so begins a caption at the beginning of his debut adventure, "John Wallace finds himself the possessor of the wonderful Pipes of Death and becomes the Music Master!"

It's a concise summary that skips some of the finer points. Leaving the symphony one evening, Wallace rescues an elderly street fiddler from a well-dressed assailant. Discovering the old man is Antonini, the famous violin maker, Wallace is called on again to defend the artisan—this time from kidnappers, one of whom inventively stabs Wallace through the chest with a violin bow. Dragged back to Antonini's shop, the wounded rescuer is revived by the so-called Pipes of Death. Though they look like ordinary pan pipes, "The secret of this ancient Egyptian instrument," explains Antonini, "is a song which creates sound waves that match exactly the life vibrations of the human body!" The science is a little shaky, but a once-again healthy Wallace can't argue with the results.

Antonini isn't so lucky. While looking to steal the famous artisan's secret varnish formula—the same one Antonio Stradivari used on his famous violins—crooks kill Wallace's wizened benefactor. Hungry for justice, Wallace dons the dead man's frock coat, arms himself with the Pipes of Death, and launches into action as the Music Master.

More than merely reviving the Music Master from near death, the pipes also grant the hero strange musical—and magical—powers. The gifted Wallace can now disappear and reappear in a flurry of musical notes, fly through the air along the path of any musical sound, and even use music as a force field, a weapon, or a bind to tie his enemies. On several occasions, he is even capable of ordering musical notes to do his bidding, sending them wandering off like sentient soldiers.

With the Pipes of Death at his side, the Music Master promptly apprehends Antonini's murderers. Continuing on to fight crooks, Axis agents, and assorted bad guys for more than a dozen adventures, the Music Master even picks up a sidekick. "Downbeat," a hep-talking rich kid, bleats out "all reet" and "daddio" at the drop of a hat. As a truly unusual comic book hero, Music Master reached a coda in 1945, one from which not even the Pipes of Death could revive him.

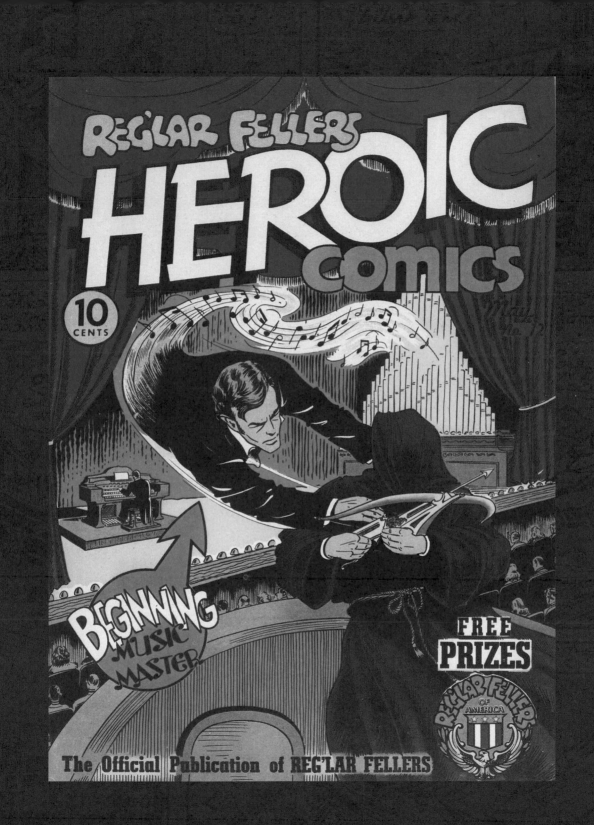

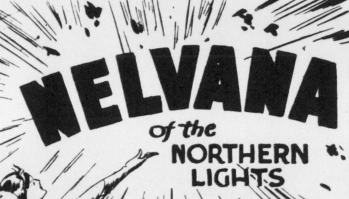

NELVANA OF THE NORTHERN LIGHTS
"In the name of Koliak, destroy the Etheria!"

COMIC BOOK SUPERHEROES, by and large, began as a uniquely American phenomenon. But it didn't take long for other countries to come up with caped crusaders and dynamic do-gooders all their own. When wartime supply embargoes shut down the shipping of American comic books across the U.S.-Canadian border, Canuck publishers came through with heroes of their own invention and with local flair.

Nelvana wasn't the first superhero to hail from the Great White North. She was preceded by a pair of super-Canucks: the original Iron Man (no relation to Bozo, page 23, or Marvel's armored hero) and the seemingly unpowered Freelance. Other Canadian superheroes from the Golden Age of comics include Captain Wonder, Speed Savage, Commander Steel, Sergeant Canuck, and Mr. Monster. But Nelvana was the country's first female superhero, and she even preceded Wonder Woman by several months.

Decked out in a winged headdress and fur-trimmed costume, Nelvana cut an unmistakable figure, dashing through the arctic air and often framed by the aurora borealis. Peculiar to this first class of Canadian superheroes, Nelvana was distinctly tied to the culture and mythology of the land she protected. The demigoddess daughter of "Koliak" and the embodiment of the northern lights, Nelvana, along with her brother Tanero, is charged with protecting the Inuit peoples (whom Nelvana calls "Eskimos," in the parlance of the time) from any and all assorted evils.

Among the abilities shared by Nelvana and her brother are the powers of flight (at light-speed, even), invisibility, telepathy, and weather control. Tanero has his sister beat on one front—he often accompanies her in the form an enormous mastiff-like dog. He exists under a curse that prohibits him from being seen in his human form by "white men." Nelvana suffers no such indignity.

Nelvana has her real-world origins in mythology. Creator Adrian Dingle was inspired by the stories of native Inuit myths told to him by his far-travelling friend Franz Johnston. The result was a popular character whose adventures took her from battling the armies of hidden kingdoms to smashing the Axis to a stint as a secret agent, and finally as Earth's defender against an alien armada. Aside from having to take her brother out for a walk, Nelvana's most regrettable aspect is that she remains largely unknown south of the border. But perhaps her time has come: a small but dedicated legion of fans in her native country are now encouraging the character's revival.

Created by:
Adrian Dingle

Debuted in:
Triumph Adventure Comics #1
(Hillsborough Studio, August 1941)

Favorite bacon:
Canadian

© 1941 by Hillsborough Studio

NIGHTMARE AND SLEEPY
"First you get Sleepy, see?"
"Then you get a Nightmare!"

Created by:
Alan Mandel and
Dan Barry

Debuted in:
Clue Comics
#1 (Hillman
Periodicals,
January 1943)

Day job:
Wrasslin'!

© 1943 by Hillman
Periodicals

YOU MIGHT THINK THAT the life of an itinerant professional wrestler would be sufficiently exciting for any individual, traveling from town to town, testing your strength and skill in the squared circle, competing for honors and prizes awarded only to the greatest in the sport. For career grappler Bob White and his teenaged manager Terry Wake, however, wrestling is only the prologue to adventure. Because outside the ring they are, in secret, the outlandish costumed heroes Nightmare and his kid sidekick Sleepy!

Decked out in a garish skeleton costume—which was doused in phosphorescent paint, so as to lend him additional creep factor—the burly Nightmare became a symbol of terror to an assembly of weird and often seemingly supernatural foes, such as the Undertaker, an alleged medieval spirit known as the Robber Baron, and most terrifying of them all, the Corpse That Steals Living Men's Faces!

Despite appearances, neither Nightmare nor his whimsically adorned junior partner Sleepy (decked out in what appears to be footie-pajamas and a red riding hood) boasted any supernatural or superhuman powers. In fact, the duo were all too human; life on the road sometimes left them without money, food, or a place to sleep. Such problems Batman never had!

Halfway through their abbreviated existence, Nightmare and Sleepy lightened the tone. The elder partner dropped his skeleton suit for a more traditional skintight Spandex superhero uniform, complete with encircled "N" insignia on the chest and a pair of "horns" on his cowl (these were more than slightly reminiscent of the "bat-ears" on another grim avenger of the night). Likewise, the light dose of mysticism that shrouded their earlier foes dissipated, leaving Nightmare and Sleepy slugging common thugs, mugs, and the occasional Nazi in lieu of corpse thieves and sundry spirits.

By way of a truly unusual climax to his story, Nightmare's final (and solo) appearance strips the hero of his backstory and reimagines him as a crime-fighting genie summoned by the smoking of a homemade cigar, hand wrapped by slaphappy would-be private detective "Nosey" McGuiness. It's a weird conclusion, but with one last puff, Nightmare and Sleepy were no more.

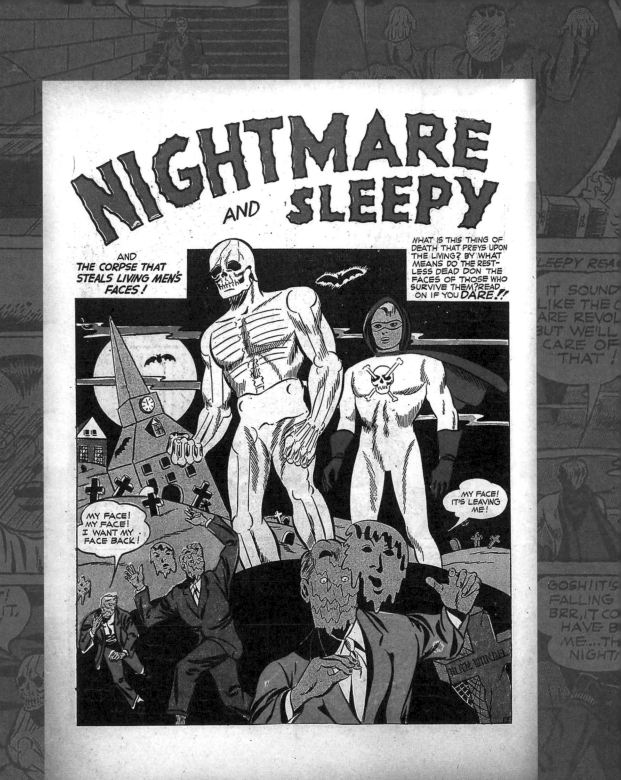

PAT PARKER, WAR NURSE

"We haven't got Cossack horses, but we have got our Yank duck! Let's go!"

OMIC BOOK CRIME-FIGHTERS work in all sorts of courageous careers, from police and private eyes to attorneys and journalists (not to mention the occasional bored wealthy playboys, the bravest heroes of them all). But nursing is a relatively underutilized day job for superheroes—even today, decades after the debut of Pat Parker's costumed identity, War Nurse.

Parker began her comics career as a (lowercase) war nurse, a native London lass whose earliest adventures had her busting up Nazi spy rings when she wasn't providing aid to injured soldiers, all without benefit of a costume or a pseudonym. But when original publisher Brookwood collapsed and Harvey Comics bought the rights to its characters, Nurse Parker received an upgrade to become a fully costumed Axis smasher.

At first so rare as to be nearly nonexistent, female superheroes were soon popping up with increasing regularity after the introduction of Wonder Woman over at Max Gaines's All-American Publishing. Harvey already had a high-profile and popular superheroine in the Black Cat, "Hollywood's Glamorous Detective Star," and the War Nurse would become a secondary lady adventurer. Pat Parker never scored her own series and rarely made cover appearances, whereas the Black Cat was always a popular draw and scored her own series beginning in 1946.

Like her more successful Harvey colleague, Nurse Parker battled crime without the aid of superpowers, relying instead on unexplained fighting skills and an overdose of pluck to see her through. Operating secretly as the mask-wearing War Nurse while holding down a day job as an actual war nurse, Pat maintained possibly the least well-protected double identity in comics history. Perhaps it was her costume that kept people from deducing the truth. Decked out in a midriff-baring boots-and-shorts ensemble—complete with a cowl based on her nurse's hat—her alter ego was certainly an attention getter.

Pat Parker had another crime-fighting career change before her exploits ended. She abandoned her war nurse identity to form the Girl Commandos, a five-girl gang of freedom fighters decked out in identical blue outfits who inserted themselves in the paths of Nazi and imperial Japanese hostilities. Pat stuck with the Girl Commandos until the end of her series, eventually switching out her black hair for blonde and at some point relocating her hometown from London to New York.

The group kept at it for almost two dozen adventures and helped fend off a Japanese invasion of Los Angeles. The onetime War Nurse's shift outlasted the war itself, but not by much—her run officially ended in 1946.

Created by:
Jill Elgin

Debuted in:
Speed Comics #13
(Harvey Comics,
May 1941)

**Not to be
confused with:**
Bob Barker, game
show host; Ma
Barker, gangster

© 1941 by Harvey Comics

PROFESSOR SUPERMIND AND SON

"Dad! I can feel it! I can move mountains!"

Created by:
Maurice Kashuba

Debuted in:
Popular Comics
#60 (Dell Comics,
February 1941)

**Odds that
Supermind will one
day electrocute son:**
Better than even

© 1941 by Dell Comics

ONE OF THEM SPENDS all day in the field, doing the heavy lifting and putting his neck on the line. The other spends all day at home, watching television. It's either a new casting of *The Odd Couple*, a metaphor for how the comic book industry really works, or it's Supermind and Son!

The brilliant Professor Warren (we never learn his first name) has created an amazing invention by which he transforms his adult son, Dan Warren, into a superhuman dynamo of justice known as . . . well, "Supermind's Son." The "ultra frequency apparatus" known as the High Frequency Energy Builder is capable of imparting superhuman energy into Dan's otherwise mortal form. "Enough to kill 100 men" adds the professor ominously. Additional ominousness isn't needed, for the device resembles nothing less than an electric chair surrounded by looming tesla coils. On more than one occasion, Dan mentions how nervous the setup makes him. "I still don't see why I don't get electrocuted," he admits to his father after one session has filled him with "a strength equal to a thousand horse-power."

In the course of the pair's abbreviated existence, Supermind locates trouble for Dan to smash, observing and advising him via another invention: the Televisoscope, an electronic screen roughly the size of a basketball mounted on a monolith of metal and wires larger than a truck. The Televisoscope can pick up images from anywhere in the world—from deep inside secret military bunkers to the middle of the ocean. It also permits Supermind to impart consistent moral guidance to his spawn. Whenever Dan begins enjoying his newfound power a little too much, the professor reminds him that it should only ever be used for good—and that it can be taken away. Maybe that's why Dan doesn't get a code name or much of a costume. They'd only encourage super tomfoolery.

The only recurring foe faced by Supermind and Son was "Sorel," a red-helmeted genius who managed to hijack the pair's High Frequency Energy Builder, giving himself powers equal to Dan's. (Imagine being able to say "Stand back! I am as powerful as . . . Dan!") For the most part, the senior partner rarely participates directly in the action. As the adventures continue, Supermind does find occasion to join his son in the field, traveling by means of an invisible dirigible. Perhaps their aerial camouflage worked too well, because after a dozen adventures, the duo of Professor Supermind and Son was never seen again.

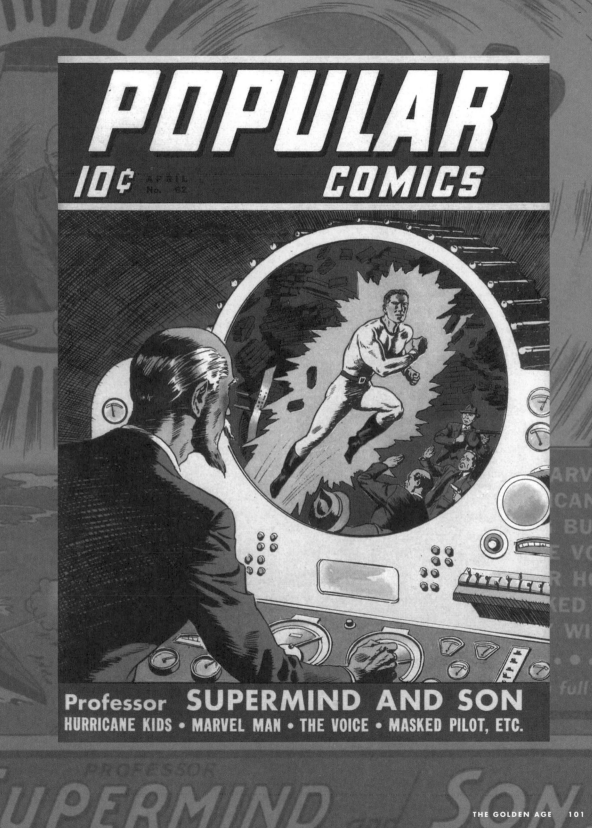

THE PUPPETEER

"A Hindu with an Irish brogue and his turban tied wrong! I don't like the looks of it!"

PATRIOTIC SUPERHEROES ARE a dime a dozen, but few can claim to pack quite as much confusing errata into their modus operandi as the Puppeteer, possibly the most baffling such superhero of them all.

Decked out in a red, white, and blue costume—itself loaded down with stars and stripes and a prominent white "V" across the chest—professional puppetmaker Alan Hale looks like a natural for any number of flag-waving alter egos. He could be Victory Man, he could be the American Victor, he could be—and even was once called—Captain V. Instead, his superheroic pseudonym is taken directly from his civilian profession, puppeteering.

Naming your superheroic identity after your day job seems to be lending one's foes a pretty valuable clue as to one's identity. Bruce Wayne never took to the streets of Gotham disguised as "The Avenging Millionaire," and Peter Parker was sure to adopt a disguise other than "Shutterbug Science Whiz." But such caution is not for the Puppeteer!

One might think that puppeteering figured somehow into the this hero's powers or origin. Well, it didn't. In fact, in one adventure, the Puppeteer becomes the *victim* of puppeteering: Doc Eerie, a criminal mastermind, manages to turn the Puppeteer (temporarily) into a "life-size puppet." As for his amazing powers—primarily the ability to fly along a red, white, and blue shaft of light called a "V-Beam"—they're granted whenever the opening notes to Beethoven's Fifth Symphony are played on the special, possibly supernatural organ he keeps in his workshop. The Puppeteer can play the notes himself or send his sidekick to do it.

The aforementioned associate is a highly intelligent talking animal, in this case, a bald eagle called "Raven" (that is, inexplicably, repeatedly referred to as *being* a raven, despite all physical evidence to the contrary). Even Raven's powers of speech are baffling. On some occasions, the bird speaks flawless English and can be understood not only by the Puppeteer but by anyone in earshot. In other circumstances, it's reduced to loudly and repeatedly cawing in an attempt to make itself understood.

So, the Puppeteer, who has nothing to do with puppets, wears a "V" on his chest, owns a talking eagle-raven, and gains his powers from a magic pipe organ. Not surprisingly, he didn't last long. More to the point, he never held down a recurring spot in any single book, appearing sporadically in more than a half dozen comics before sputtering out of existence. It was likely impossible to decide what to do with a costumed hero whose identity was all over the map.

Created by:
Alec Hope

Debuted in:
All Top Comics #1
(Fox Features, 1944)

Sidelines:
Puppeteering, bird training, organ playing

© 1944 by Fox Features

RAINBOW BOY

"Time for Rainbow Boy to see what's cookin'!"

Created by:
Unknown

Debuted in:
*Reg'lar Fellers
Heroic Comics* #14
(Eastern Color
Printing, September
1942)

No relation to:
Rainbow Brite,
Skittles candy

© 1942 by Eastern Color
Printing

HE GOLDEN AGE OF comics had no shortage of heroes sporting the good old red, white, and blue. But one costumed champion beat them all. Sporting the colors of his namesake, it's Rainbow Boy!

As the name suggests, this junior superhero's powers revolved around that colorful arc in the sky, although his origin leaves a lot to the imagination. In his debut appearance, Rainbow Boy explains that he discovered, while experimenting with light while at home, that he could supercharge his body with powerful energy. What sort of experiments isn't clear, but the results couldn't be more bold.

When powered by the sun—or any sufficiently bright light, including flashlights and glowing magma—Rainbow Boy was capable of flying at "the speed of light" while producing a prismatic display in his wake. He could also extend the Roy G. Biv effect at will, using it to form barriers, shields, bridges, even temporary prisons. Though his plain white costume was mostly a blank canvas, his powers more than made up for the monotony with brilliant displays, not to mention the rainbow crest on his helmet.

In his private life, Rainbow Boy was Jay Watson, a boy genius who appears on the Wizard Kid Radio Program, some sort of quiz show for juvenile geniuses. He often teamed up with Eastern's big hitter, the soggy superhero HydroMan, who could turn himself into clear liquid and mentally control bodies of water on command. In fact, Rainbow Boy debuted in HydroMan's feature.

On the few occasions when HydroMan would summon or encounter Rainbow Boy, the pair refused to sit still. With trails of water and rainbows flashing behind them, they would hold impromptu airborne strategy sessions, resembling a dancing-fountains display. (The duo could have made a mint appearing in Las Vegas.)

Rainbow Boy's multihued crusade against crime didn't last long, however. With only nine appearances under his belt, he finally hung up his rainbow-crested hat. There's always a chance he could be revived if the right venue opens up, say, as mascot for a breakfast cereal or greeting card company.

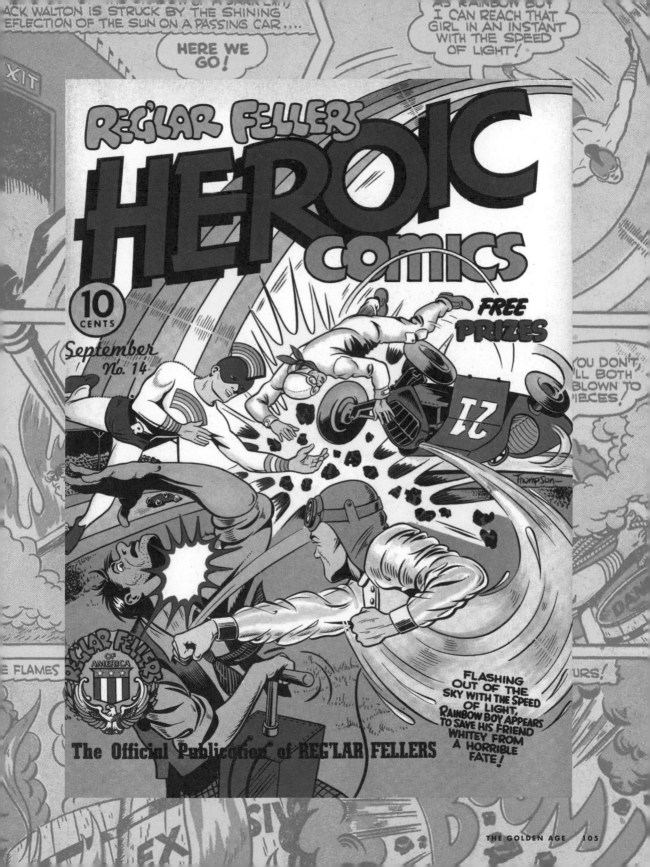

THE RED BEE

"You've not met my little friend Michael before!"

IN THE EARLY DAYS of comics, creative code names based on avenging predators or eerie creatures of the night were quickly scooped up. From Batman and the Ferret (page 203) to the Black Owl and the Black Cat, it wasn't long before the most intimidating animal-based aliases had been assigned. The shortage of suitably dramatic pseudonyms may explain why Assistant District Attorney Richard Raleigh, on deciding to don a costume and stem the rising tide of crime, adopted a colorful insect-inspired sobriquet: the Red Bee.

Although his adventures were played for straight life-or-death, good-versus-evil thrills, the Red Bee's creation seemed a little tongue-in-cheek. Creators Toni Blum and Charles Nicholas (a pen name for several different creators) crafted the feature under the pseudonym "B. H. Apiary," the "B. H." likely standing for "Bee Hive."

Unlike other superheroes who took their names from the animal kingdom, the Red Bee wasn't particularly bee-themed (contrast him with, for example, Bee-Man, page 126). Aside from the striped leggings he wore in his earliest adventures, A.D.A. Raleigh didn't incorporate any specifically bee-y elements into his costume. He also didn't have the proportional powers of bee, or deploy bee-themed gadgets, or drive a bee-mobile (although he did have a bright red sedan, which one imagines would draw attention on the streets of Superior City).

Where the young prosecutor made his connection with his namesake is that he possessed a remarkable rapport with his arthropod friends, keeping several in little hidden compartments inside his belt. When trouble was overwhelming and throwing a punch wouldn't solve the problem, the hero would free one of his tiny flying helpers. His favorite was "Michael," which implies that he actually named all of his pet bees.

How exactly the Red Bee maintained such comprehensive control over his buzzing buddies was never explored. Yet, the bees seem not only to respond to his verbal commands but also to read his mind. When not terrifying criminals by humming about their heads, the Red Bee's barbed band could sting a gun out of a crook's hand. On one occasion, they even transported *a single razor blade* to a bound Red Bee so that he could cut his off ropes. (What, you thought they'd bring an axe?)

The Red Bee also claimed an impressive collection of gadgets and vehicles that seemed a little beyond the budget of a civil servant. Besides his bright red car—which was, by the way, capable of driving itself on command, almost like a bee—Raleigh also owned an autogyro (which he kept on a nearby rooftop, for

Created by:
Toni Blum and Charles Nicholas (as "B. H. Apiary")

Debuted in:
Hit Comics #1 (Quality Comics, July 1940)

Commitment to his own motif:
Halfhearted

© 1940 by Hit Comics

→

easy access) and something called the "Alto-Gainer," a box-shaped catapult he could use to launch himself from street level into top-floor skyscraper windows, presuming they were open.

After managing a modest career without getting splattered across the exterior of a closed window forty-five stories high, the Red Bee entered a long hibernation from which he's been awakened only rarely—and usually for a joke. If nothing else, the Red Bee deserves recognition for defying expectations. In any story, you wouldn't normally expect the man with a belt full of bees to be the hero, right?

EDITOR'S NOTE...

During his twenty-five consecutive appearances in Hit Comics, *the Red Bee was slugged in the noggin or otherwise knocked unconscious more than a dozen times. That might explain a lot of things, including why they called it* Hit Comics.

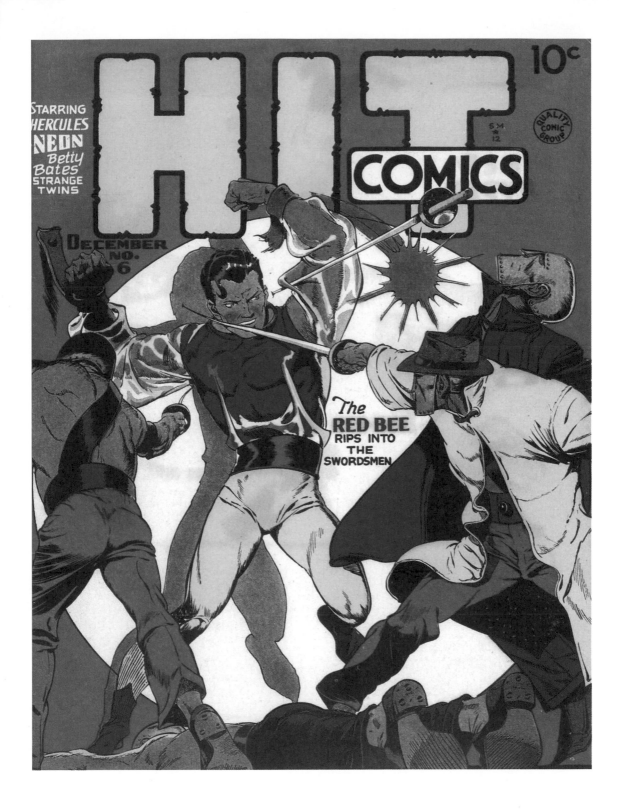

THE RED TORPEDO
"I don't know what I'm in for, but here goes!"

Created by:
Henry Carl Kiefer
(as "Drew Allen")

Debuted in:
Crack Comics #1
(Quality Comics,
May 1940)

Mistresses:
The sea; Queen
Klitra of the
Mermazons

© 1940 by Quality Comics

THE VAST MAJORITY OF comic book superheroes have made their headquarters on land and, on a few rare occasions, in the air. But the oceans, which cover almost three-quarters of the planet, have hosted only a handful of protectors.

Add to this coterie the Red Torpedo, formerly U.S. Navy captain Jim Lockhart, who resigns his commission when he fails to receive military support for his new invention. The Navy can probably be forgiven for turning its back on Lockhart's engineering marvel, a "self-navigating torpedo" that can be piloted like a submarine. Torpedoes explode on contact, and ranks might be thinned considerably if we started putting enlistees inside them.

Undeterred, Lockhart works with his fiancée, Meg (sometimes called "Peg"), to build his fantastic one-man sub in a hidden workshop in a secret cove. He dubs the finished product—and himself, in his signature red costume and mask—the Red Torpedo.

Apparently unworried by any potential confusion (when his enemies cry, "Look, it's the Red Torpedo!" do they mean the ship or the man?), Lockhart takes to the oceans of the world. In twenty consecutive adventures, the Red Torpedo finds himself facing, and sinking, submarines and seagoing warships, from both the Axis nations and individual oceanic rogues. Armed with "energy beams," the high-speed torpedo is also capable of smashing right through enemy vessels.

The Torpedo's adventures are generally played as straightforward action stories, although by his seventh appearance the temptation to employ a little innuendo had apparently become too strong to resist. A man in a giant, red, cigar-shaped object seems to cry out for Freudian analysis. For example, the Red Torpedo discovers a race of mermaid amazons (called, unsurprisingly, "Mermazons") and is asked for help by their queen, Klitra. Naturally, aiding Klitra involves the Red Torpedo's signature tactic: "Avoiding the entangling seaweed," reads the captions, the Red Torpedo "crashes the cavern . . . "

After that, it's back to less coy adventures. Although routinely dubbed "The Robin Hood of the seas" in captions accompanying his adventures, the Red Torpedo was never seen to rob the rich or give anything to the poor. In fact, unless the story of Robin Hood involves smashing a horse through the side of enemy garrisons, it's difficult to see the comparison.

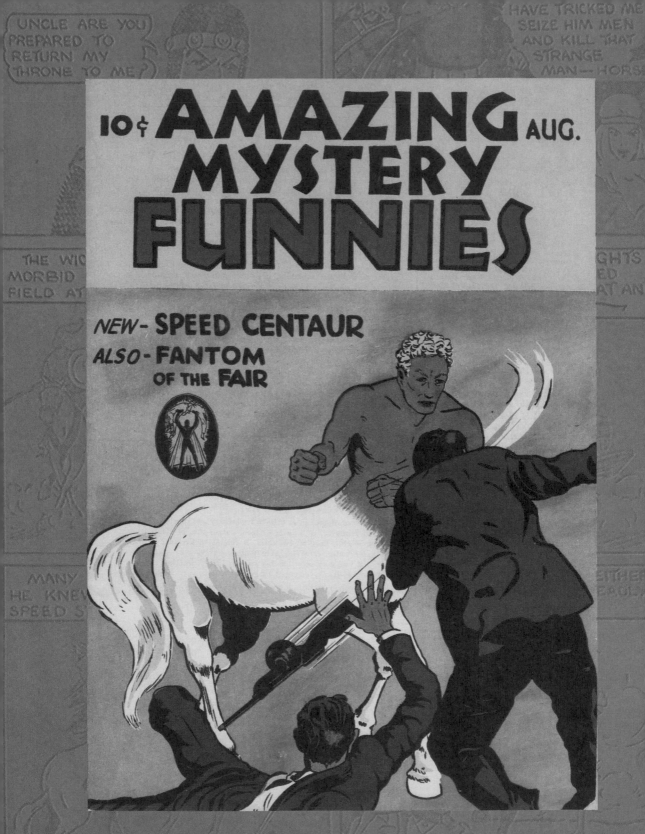

SPEED CENTAUR

"Yes, I've always talked. I'm a talking horse—the only one there is."

ALF THE BATTLE IN coming up with a new superhero is finding a way to make the costumed crime-fighter stand out from the legions of superpowered types competing for a kid's dime (or, these days, four bucks). Well, standing out was no problem for Speed Centaur because he is exactly what his name advertises—a crime-fighting centaur!

Born in a mysterious city somewhere in the Arctic Circle, Speed is the sole survivor of a catastrophic earthquake that destroys his homeland and all of his people. Found orphaned and wandering around by a kindly (human) trapper, the young creature is educated, trained, and raised "to hate evil and crime." On his deathbed, the trapper gives Speed his mission: to clean up the nearby urban center, dubbed "The City of Rackets"!

Well, a trip to the big city is just what every young centaur dreams of, and soon Speed has foiled the plans of his very first crook, "Killer" Diller. For good measure, he's also saved the life of his soon-to-be pal and partner, newsman Jerry "Reel" McCoy.

Speed has an impressive array of powers. As if being a centaur didn't make him unusual enough, he also is a mental and physical giant capable of flinging mighty boulders like pebbles, can apparently fly, and, as his name implies, moves as quickly as lightning. Though he can do much of what other superheroes do, he doesn't have a strong chance for a secret identity, a civilian career, or a romance, despite looking like a matinee idol from the waist up (and also from the waist down, if you count Roy Rogers's horse Trigger).

Speed does have a handy disguise when called on to pass unnoticed in the city: a lifelike equine "mask" with which he covers his upper body, allowing him to pass as a (talking but otherwise unremarkable) urban horse. Disguised in this way, Speed and Reel are able to pass as a street vendor and his innocuous pack animal, thus making Speed the only hero with a nonhuman secret identity.

When not fighting crime, Speed resides in his secret headquarters inside a titanic cave on Nob Nose Mountain, overlooking the city. On the off chance there isn't enough crime and injustice to keep the pair busy in town, the cave is also home to weird monsters. In one its hidden chambers, Speed and Reel face something that resembles a hairy green rhinoceros. They also find the entrance to a lost medieval kingdom, where Speed is able to clean up as the only all-in-one horse-and-rider competitor in jousting history.

Created by:
Martin Kildale

Debuted in:
Amazing Mystery Funnies vol. 2, #8 (Centaur Publications, August 1939)

Weakness:
Well, he likes the occasional sugar cube

© 1939 by Centaur Publications

SPIDER QUEEN

"Ah ah ah, won't you ever learn not to pick on me?"

Created by:
Else Lisau (believed to be Louis and Arturo Cazeneuve)

Debuted in:
The Eagle #2
(Fox Features,
September 1941)

Ironic twist:
She still gets squicked out by spiders

© 1941 by Fox Features

A MASKED RED-AND-BLUE figure appears, using web-shooting wrist devices to swing from the rooftops. An outlaw mistrusted by authorities, the spider-inspired crime-fighter uses scientific powers to defeat evil in its myriad forms. If all that sounds familiar, it should . . . though we're not talking about everyone's favorite neighborhood Spider-Man. This is Spider Queen, a different arachnid-themed do-gooder. Even more significant, she precedes the famous wall crawler by twenty years.

A short-lived superheroine whose few adventures were crammed into the back pages of a comic featuring the patriotic do-gooder known as the Eagle, the woman who would eventually become Spider Queen was research assistant Shannon Kane. After her husband, Harry (a "brilliant young government chemist on a special assignment"), is killed by enemy agents of a foreign government, Shannon discovers his notes for "spider-web fluid." Following the recipe, she creates a thin and durable adhesive that sticks like glue and, as Shannon discovers to her delight, is "actually strong enough to swing on!"

"Ingeniously devising a set of special bracelets to contain the fluid and release it as needed," Shannon effectively invents Spider-Man's trademark web shooters a full two decades before Peter Parker was bitten by his radioactive namesake. Pledging vengeance against the murderers who left her widowed, Shannon declares: "This stuff is going to help me put a damper on some of these gay fellows who make a business out of crime and murder." She then takes to the skyline as Spider Queen.

Like more than a few other costumed crime-fighters in the early days of comics, Spider Queen is considered an outlaw by the local authorities. However, that doesn't stop the hard-hitting police detective Mike O'Bell and the Queen's civilian identity from striking up a flirtatious relationship that runs the length of her three adventures. While hot on the trail of the elusive Spider Queen, Detective O'Bell pays repeated visits to the beautiful young widow. "Gee that's not a bad little doll," he says of Kane, adding, "I like that cute, fluffy type!" He thinks she's not around to hear him . . . but she is. Outside the window, as a matter of fact. Smooth move, O'Bell.

The relentless and cunning Spider Queen was anything but cute and fluffy, but she wasn't particularly long-lived. After three appearances, she vanished from comics, leaving room for the more famous web swinger to take the stage, two decades later.

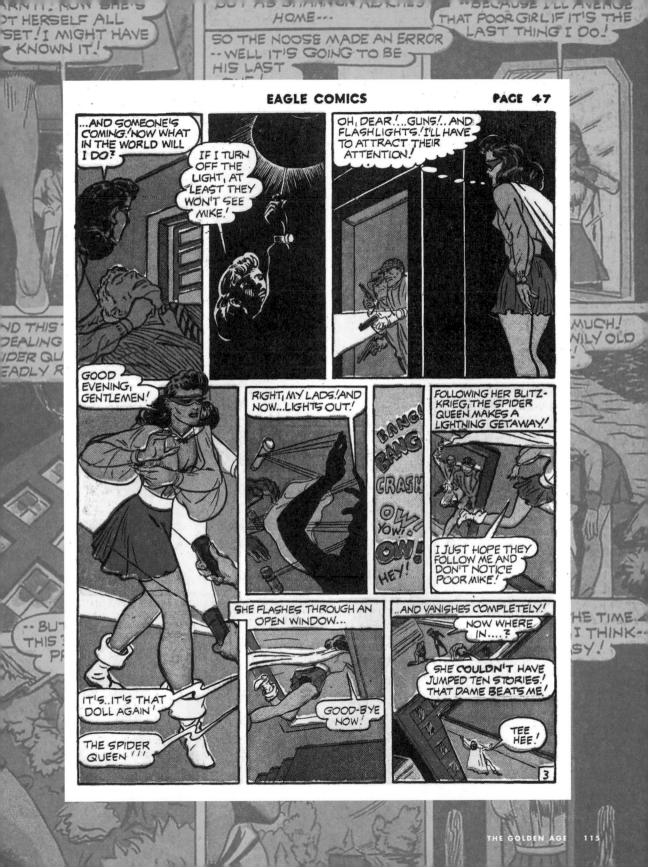

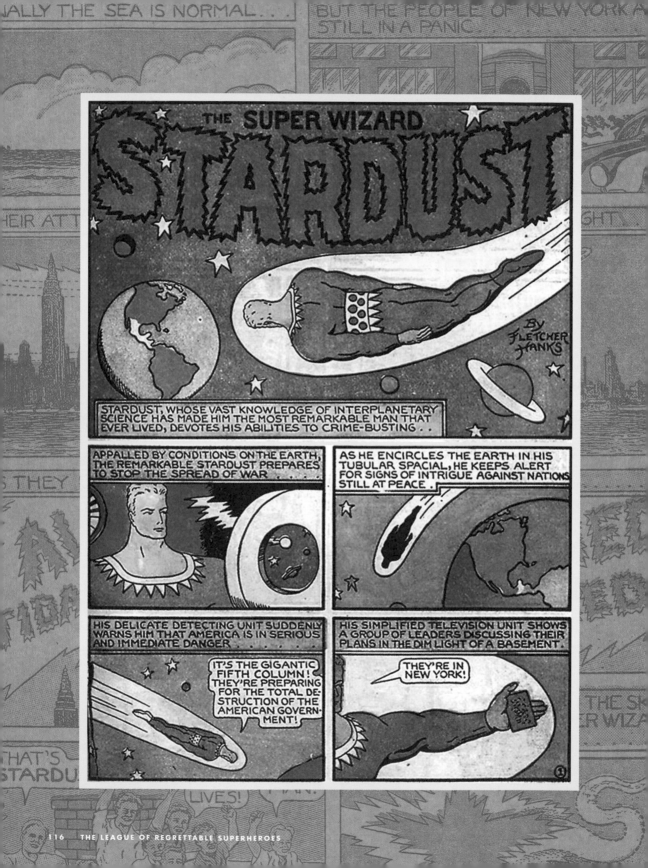

STARDUST THE SUPER-WIZARD

"You are now in the power of Stardust!"

A GOOD SUPERHERO IS the product of a robust imagination, and if Stardust the Super-Wizard had nothing else going for him, he certainly sprang from an abundance of ingenuity.

The best-known creation of Fletcher Hanks—whose brief career in comics secured his legacy as one of the most singularly unusual creators in the field—Stardust ran as a backup feature in the aptly titled *Fantastic Comics*. First published in the year after Superman's debut, Stardust appeared on the heels of a cavalcade of Man of Steel imitators. At first glance, he might've even seemed to be just another all-around *Übermensch* in a blue suit.

But even a cursory glance at an average Stardust story—although it's a stretch to call any Stardust story "average"—quickly reveals the differences between the Super-Wizard and all the other super Johnny-come-latelies. Like Hanks's famous creation Fantomah (page 50), Stardust was omnipotent and seemed to delight in crafting bizarre, even surreal, punishments to foil his enemies.

The closest thing to a Stardust origin story occurs in his first appearance, when criminal and spy organizations operating within the United States listen to an ominous news broadcast announcing the Super-Wizard's imminent arrival on earth. Besides warning of "a merciless clean-up of spies and grade-A racketeers," the program fills in the reader on Stardust's bonafides in advance of his arrival: "His scientific use of rays has made him a master of space and planetary forces," begins the report. "The gas of a certain star has made him immune to heat or cold."

The announcer next describes how Stardust "carries artificial lungs that enable him to breathe safely under any condition; he uses new spectral rays that can make him invisible or as bright as the sun; he wears a flexible star-metal skin, controlled through rays from a distant sun and rendering him indestructible . . . "

An intriguing combination of colorful descriptions and outright nonsense, this list is only the tip of the iceberg. Finally landing on earth, the towering Stardust manipulates a sheet of falling missiles, hangs crooks motionless in midair, and summons the bones of the dead to leer at their killers. And that's only the beginning! Battling such gory characters as the Emerald Men of Asperus, the crooks Rip-the-Blood and Wolf-Eye, and the planet-murdering Mad Giant, Stardust rarely revisits the same punishment twice. He condemns a gang of thieves to a planet of gold and diamonds on the cusp of "a black night that will last for centuries," turns fifth columnists into ice or rats, and causes crooks to hover in the air so that he can fly into them at a speed sufficient to turn them to ash. →

Created by:
Fletcher Hanks

Debuted in:
Fantastic Comics
#1 (Fox Features,
December 1939)

Hobbies:
Cruel and unusual
punishment; neck
exercises

© 1939 by Fox Features

A fine example of Stardust's punishments is the one he arranges for "Mastermind De Structo." Stardust inflates the head of the would-be murderer to the point that his body withers away, then he throws the head through "the space pocket of living death," where the Headless Headhunter ("The hugest giant in the universe") resides. Affixing De Structo's severed noggin to the unoccupied space between his own shoulders, the giant absorbs the still-living fiend whole.

For a Super-Wizard whose missions often took him to deep space and strange worlds, Stardust had a particular affinity for the United States, often rooting out spies and saboteurs and paying particular attention to the nation's economy. The final panel of his adventures depicts a world-spanning broadcast announcing that "Stardust saves the U.S. Government from financial ruin!" This he accomplished by feeding a crook named "Slant-Eye" to a golden octopus monster.

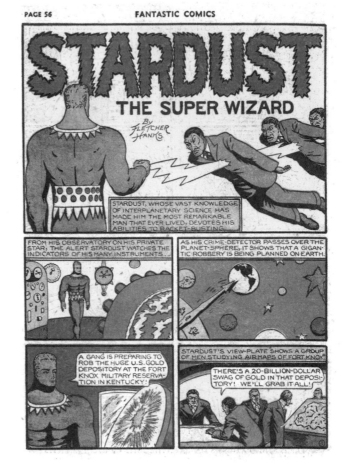

EDITOR'S NOTE...

Junior partners have always been the rage in superhero comics, but Stardust took the idea a few steps further by establishing "Stardust Sixth Column Clubs" across the country. The organization's young members received pills that gave them a fraction of Stardust's strange powers, metal-repelling ray belts for flight, and Super-Wizard costumes to aid in their defense of America.

VAGABOND PRINCE

"A hasty foot is a dangerous thing ... it is first to feel trouble's sharp sting!"

Created by:
Joe Simon and
Jack Kirby

Debuted in:
Black Cat #7
(Harvey Comics,
August/September
1947)

**Could be
mistaken for:**
A doorman, a
nutcracker, a
hamburger chain
mascot

© 1941 by Harvey Comics

MONG THE CROWDED COMICS racks, the best way for a new superhero to compete is to make sure he stands out. And if the Vagabond Prince did anything, particularly in that costume of his, *he stood out*.

A creation of the acclaimed team of Joe Simon and Jack Kirby, the Vagabond Prince ended up being one of their lesser but most unusual collaborations. Perhaps first among the qualities that distinguished the character from his competitors was his mode of dress. Decked out more like a bandleader than a crime-fighter, the unpowered royal slugged his way through a pair of adventures while wearing something resembling a doorman's uniform, accentuated with a domino mask.

Pairing his strange getup with peculiar patter, the Vagabond Prince made a habit of speaking in a cod-Elizabethan manner peppered with terrible doggerel. "Did ever yon moon glow so bright to shine upon such a sight?" he asks on one occasion, between such archaic oaths as "Odd's Bodkin!" and "By my dagger!" (Fact-check: the Vagabond Prince did not carry a dagger.)

Also unusual: while other superheroes typically got along with a single sidekick, the prince was known to pal around with two. The team's junior partner, donning a less dressed-up version of the prince's unconventional outfit, was the Chief Justice; its third member was the sometimes-bumbling Jester, who dressed accordingly. The Jester wholeheartedly subscribed to the same pseudo-Shakespearian dialogue that the Vagabond Prince occasionally employed, but the Chief Justice was having none of it. "Aw, wet potato chips, Prince!" he utters on one occasion, signifying his distaste.

For a civilian career, the Vagabond Prince—in his unmasked identity of Ned Oaks—was far removed from the typical superhero day jobs in journalism, law, or science. He was a writer for a greeting card company, and unlike the bored playboys who traipsed across rooftops foiling crime, lived in a tenement slum.

Poverty was at the root of the saga. It is revealed in his belated origin story (unseen until a recent collection; the strip was canceled before the tale could be published) that Ned Oaks is the legal owner of the land on which is built all of Esten City, his hometown. Crooks discover this fact ahead of Ned and try to force him to sign over the land. They leave him badly beaten and abandoned in skid row, where local bums christen Oaks with his superhero moniker. A slum kid named Roger believes his story, and the pair teams up to punish the crooks. It is that conflict from which the Vagabond Prince and Chief Justice are born.

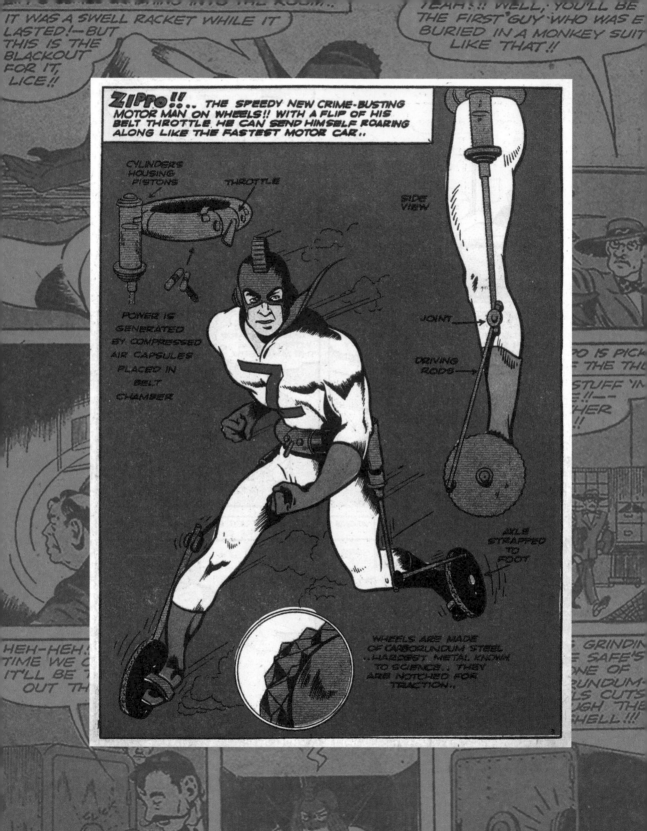

ZIPPO

"I'll need my full speed to climb this pit ... just like the motorcycles in carnivals!"

T o MAKE YOUR MARK in the highly competitive field of superheroics, you need a gimmick, particularly if your primary power is super-speed. The ability to move at jetlike velocity is such a common characteristic among the cape-and-Spandex set that it's generally appended to a hero's overall abilities. If being fast is your only thing, you'll have to put your own spin on your speed or else become just another Johnny-quick-come-lately.

Which is exactly what private investigator and part-time inventor Joe Blair does when he creates his high-speed alter ego Zippo, "the motor-man on wheels" (according to his own press). Balancing on carborundum wheels and equipped with a below-the-belt exoskeleton outfitted with a powerful compressed-air engine, Zippo turns into a veritable human meteor, traveling at ground speeds of as much as 65 miles an hour. What a rush!

Although he might seem better suited for the extreme-sports circuit, Zippo manages to carve out an impressive eight-issue crime-fighting streak in the pages of *Clue Comics*—practically a lifetime, compared to some other short-lived heroes. It's worth noting, though, that his adventures are always conveniently solved by the clever application of his high-horsepower gizmo. Along with the inevitable high-speed chases, Zippo seems to always find a smooth, flat surface upon which his wheels make of him an exceptional opponent, whether on a high network of steel girders, the side of a massive concrete dam, or even train tracks or telephone wires. And when confined in a space that constrains his movement, Zippo has an additional trick up his pants leg: his durable wheels can whizz fast enough to cut through steel!

Also helping Zippo's batting average is that, defying the usual comic book formula, he never fought foes who claimed super-speed of their own. Typically, he pitted his spinning wheels and pumping pistons against garden-variety crooks and thugs, occasionally turning his attention to the only kind of super-powered foe he tended to fight: weird beast-men. Between the scientist-turned-caveman and would-be world conqueror Professor Schooner, the hulking hairy dwarf called "The Fly," the tubby but catlike "Lynx," and a horrifically ugly "Goblin," Zippo claimed an ugly rogues' gallery that he could literally run rings around.

One character at a time, *Clue Comics* began to cycle out its original lineup of superheroes and replace them with spy, war, and horror features. As if in reverse alphabetical order, the first character shown the door was Zippo. One can imagine the high-speed hero crouched in his signature traveling posture, vanishing into the sunset, unable to outrace his own cancellation.

Created by:
Pierce Rice

Debuted in:
Clue Comics #1 (Hillman Publications, January 1943)

Performance:
40 mpg highway, 28 mpg city

© 1943 by Hillman Publications

THE SILVER AGE
1950-1969

AFTER THEIR INITIAL WAVE OF SUCCESS IN the 1940s, superheroes began to fall out of favor. An overstuffed marketplace may have been the primary cause. At one point, literally hundreds of costumed do-gooders campaigned for readers' attention (and money) every month. Changing social mores also contributed to the decline, with books like Fredric Wertham's *Seduction of the Innocent* (1954) excoriating comics for an alleged negative influence on children. Even a Senate subcommittee hearing on juvenile delinquency took the material to task. As westerns and space adventures moved in to the public imagination to occupy the spot where caped crusaders once resided, it seemed that superheroes were a fad whose time had come . . . and gone.

But then came the Silver Age! A renewed sense of national optimism—brought about by economic prosperity, leaps in technology, and the drama of the space race—made this a perfect time to bring back the colorful and exciting world of costumed crime-fighters. Inspired by the high-fashion, high-camp spirit of the '60s, superhero comics were infused with a new energy and plenty of strange quirks, aided in no small part by a particular Dynamic Duo's much-celebrated television treatment in 1966. The rise of Marvel Comics changed how superhero stories were told, injecting the medium with much-needed wit and characterization and drawing a new audience of high school and college-age readers. As the '60s gave way to the '70s, it was clear that superheroes were here to stay (even if some of them were too strange to stay in print).

NOTE: By some accounting, the Silver Age of comics started in the mid-1950s, separated from the Golden Age by a few years of artistic stagnation.

BEE-MAN

"We double-dare you to resist the attacking bees!"

Created by:
Otto Binder and
Bill Draut

Debuted in:
*Double-Dare
Adventures* #1
(Harvey Comics,
December 1966)

Headquarters:
The Hive
(a giant hive)

© 1966 by
Harvey Comics

ITH THE ARRIVAL OF Batman to the nation's television screen in 1966, Bat-Mania soon followed. Pop culture went bananas for all sorts of costumed crime-fighters, no matter the flavor. Comics enjoyed a surge of popularity and renewed creativity, and the freshly fertile earth produced literally dozens of over-the-top campy characters. If a premise could be beaten into the ground, comics were there to do it.

Take, for example, Bee-Man. His story begins as disgruntled mission-control technician Barry E. Eames (note the initials) sabotages the landing of a remote-controlled rocket ship, intending to rob the sample-gathering space vessel of whatever wonders it has collected from beyond the surly bonds of earth. Unfortunately, what Eames finds inside the vessel are mutant space bees, which mercilessly savage him and drag his broken body to their distant world.

After an interlude in outer space, Eames returns to earth, decked out in technologically advanced armor from the Bee People's impressive new fall collection of comfortable casualwear for would-be space thieves. The unstoppable Bee-Man occupies himself by stealing gold, radium, and life-giving honey. He stores the loot in his secret, hidden Houston Astrodome–sized beehive headquarters. Surely no one would ever be able to find such a structure, particularly if they were suffering from "Giant Hive Blindness."

Yes, Bee-Man begins his career as a super-crook. By the second issue, however, he's turned himself around, pointing his supersonic wings, honey grenades, and nose-mounted stinger for the cause of justice. Shocked and unsettled by the Bee People's plans to enslave the minds of all humanity (you might even say he was bee-side himself), Bee-Man turns on the Bee Planet's beautiful but cruel "Queen Bea" and aligns himself with the Federal Bureau of Investigation. Officially serving as a superpowered defender of the planet, Bee-Man gains the additional honor of a position as a government operative—yes, he's awarded special-agent status in the one-man "F-Bee-I"!

Bee-Man's career on the side of right was sadly abbreviated. (Or should we say a-bee-viated? No, we probably should not.) After just two appearances, Double-Dare Adventures was canceled and Bee-Man was forced to turn in his wings.

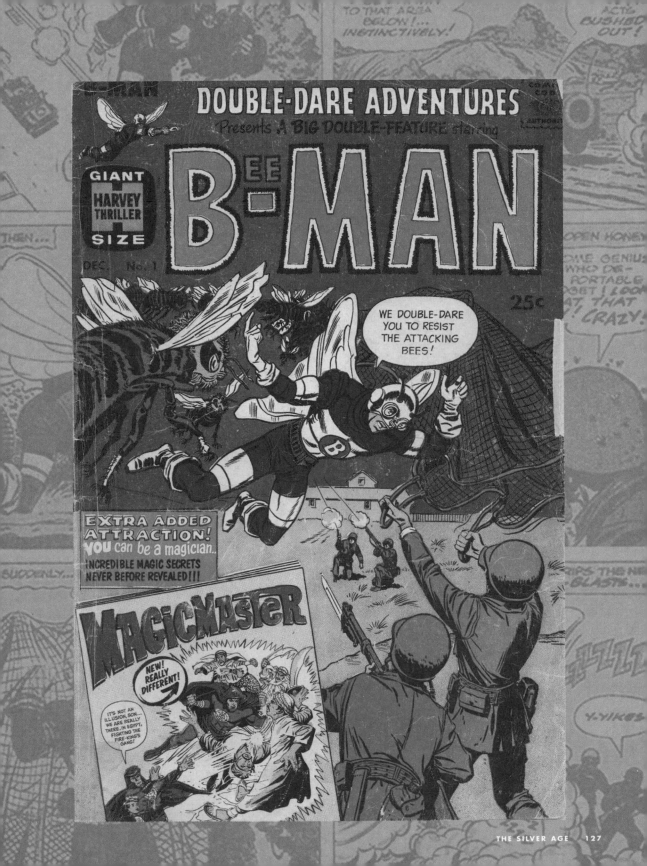

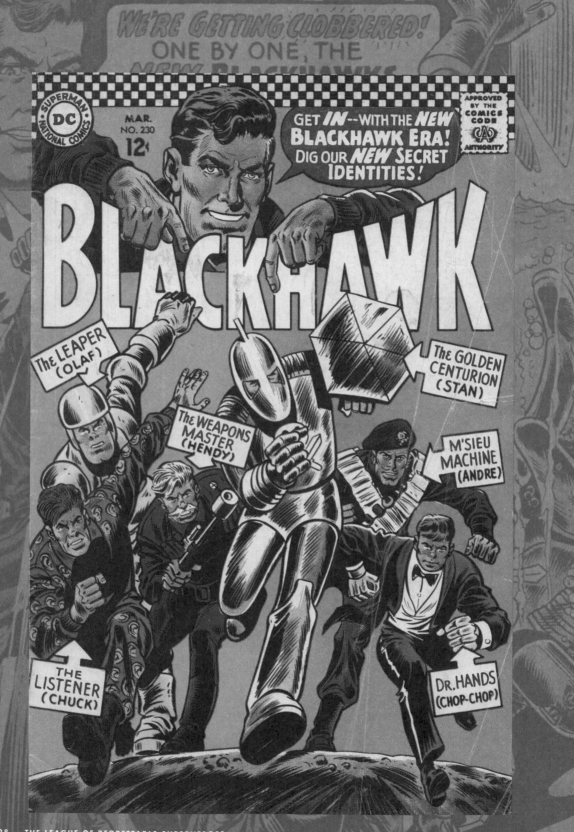

THE "NEW LOOK" BLACKHAWKS
"HAWK-A-A-A-A!"

THE BLACKHAWKS, A SEVEN-MAN international team of World War II fighter pilots, were big shots during the Golden Age of comics. They starred in two different books and they even had their own weekly radio show. They graced the silver screen in a fifteen-chapter Columbia movie serial. Daring aerial aces, they defended Allied forces against airborne Axis threats and ended every mission with a rousing sing-along.

But by the late 1960s, some of the luster had worn off. Nazi-related menaces were now old hat. The new generation preferred their aerial adventurers to fight enemies of the Cold War, flying shiny new jets rather than archaic twin-engine bombers.

A late-1960s storyline in the team's long-running comic confronted this obsolescence head-on. The Blackhawks were judged and found wanting by a panel of government officials and Silver Age superheroes, including Batman, Superman, and the Flash. (Batman, on the Blackhawks: "To put it bluntly . . . they just don't swing!") The U.S. government assigned the pilots new identities, ensembles, and modi operandi:

ANDRE, the team's French lothario, was decked out in a purple union suit with pockets full of high-tech tools. His new name: M'SIEU MACHINE.

OLAF, formerly an acrobat with a Swedish circus, was wrapped in rubber rings and encouraged to bounce around as THE LEAPER.

CHUCK, the demolitions expert, was given an absurd pair of light-blue pajamas decorated with cartoon ears and became THE LISTENER, the team's communications officer and, perhaps, therapist.

Polish strongman STANISLAUS found himself covered (expensively) in solid gold armor, which granted him the power of flight as THE GOLDEN CENTURION.

HENDERSON, the team's elderly Dutch sharpshooter, became their weapons master as, wait for it, THE WAEPONS MASTER.

Once portrayed as a highly objectionable ethnic stereotype, the team's Chin-ese member CHOP CHOP was handed beryllium-covered gloves (and, for some reason, a tuxedo) and redubbed the deadly DR. HANDS.

The eponymous leader BLACKHAWK got off easy, being allowed to keep his existing uniform.

The new Blackhawks become operatives for a government peacekeeping force bearing the unlikely acronym G.E.O.R.G.E.—the Group for the Extermination of Organizations of Revenge, Greed, and Evil. They gamely pit their newfound powers against a few deadly robots, enemy agencies, and outlandish killers. After fourteen uninspiring issues the Blackhawks were returned to their original airborne garb, for better or worse.

Created by:
(Original)
Chuck Cuidera, Bob Powell, Will Eisner

("New Look")
Bob Haney, Chuck Cuidera, Dick Dillin

Debuted in:
(Original)
Military Comics #1 (Quality Comics, August 1941)

("New Look")
Blackhawk vol. 1, #228 (DC Comics, January 1967)

Uniforms:
At first, totally sweet matching aviation outfits; later, ill-fitting pajamas from the superhero clearance bin

© 1941 by Quality Comics and 1967 by DC Comics

BRAIN BOY
"I'll just take a look into his mind."

Created by:
Herb Castle and
Gil Kane

Debuted in:
Four Color Comics
#1330 (Dell Comics,
April/June 1962)

Affiliation:
The Good Ol'
Red, White, and
Telepathic Blue!

© 1962 by Dell Comics

SUPERHEROES TEND TO BE a flamboyant lot, what with their colorful sobriquets, dynamic powers, and fanciful costumes. The absence of such trappings may make Brain Boy unique in comics history.

Brain Boy's fate is determined when his parents, Matt Price and his pregnant wife, Mary, collide with an electrical tower after their car loses a tire. Dad perishes in the accident, but mother and fetus survive, and two months later young Matt Junior is born, speaking fluent English! You guessed it: exposure to fatal levels of electrical power has given the future Brain Boy a tremendous intellect and, more than that, the power of "telepathy" (which in this case includes telekinesis, mind control, and a few other fantastic mental abilities).

Matt keeps his telepathic talents a secret, but is nevertheless approached by agents of the American government, who induct him into their service to fight alongside other patriotic telepaths (against, of course, *un*patriotic telepaths). Adopting the nickname "Brain Boy," Matt studies anthropology by day, but by night he's an agent of freedom protecting the West from the Red Menace of Communist ESP!

A product of Dell Comics, Brain Boy was one of the publisher's rare forays into the superhero genre, which could explain his lack of heroic accouterments. Dell produced comics primarily based on the characters of Walt Disney and Warner Bros., as well as dry adaptations of television programs like *Bewitched*, *Maverick*, and *Mission: Impossible*. Brain Boy preceded more colorful Dell super-attempts, like the explosive Nukla and superhero versions of Dracula (page 146) and Frankenstein.

Brain Boy's style was fundamentally more quotidian than these later efforts. He wore normal street clothes during his adventures and answered to his given name more often than his nom de guerre; even his superpowers manifested themselves plainly. There were no force-beams, explosive bolts, flames, or visible psychic shields—he would simply raise a hand to his head or visibly concentrate to flex his telepathic muscles. Despite facing giant dinosaurs and communist armies, the plainclothes Brain Boy lacked the dynamism of your average superhero, which may explain why his initial outing lasted only a half dozen issues.

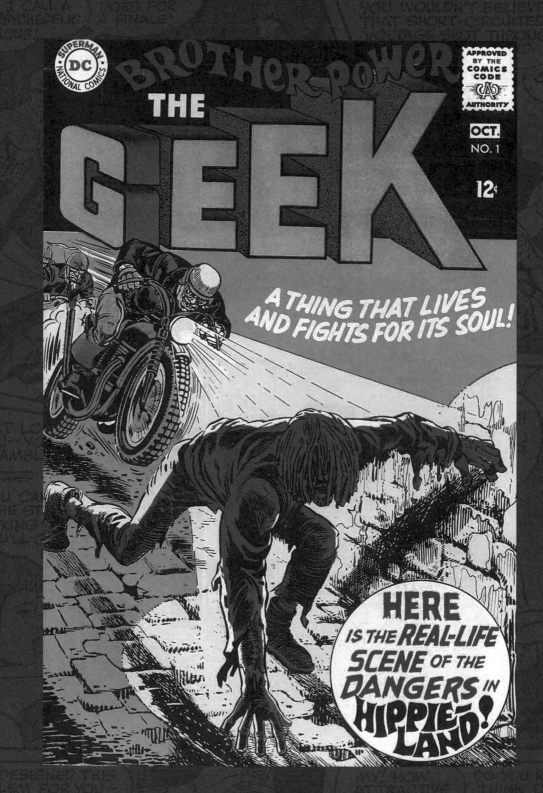

BROTHER POWER THE GEEK

"Man, I tell it like it is now! The sound is groovey! It blows my mind!"

A THING THAT LIVES and fights for its soul" is how the enigmatic Brother Power is described on the cover of his debut appearance in late 1968. As leather-clad bikers bear down on his shabby fleeing form, the cover blurbs go on to promise, "Here is the real-life scene of the dangers in Hippie-Land!"

It's unclear how much Joe Simon—who'd cut his teeth on Captain America in the heyday of World War II—truly knew about the realities of hippie culture, aside from what he'd read in the newspaper and seen on TV; by the time he created Brother Power, the comics veteran was fifty-five years old. Still, Simon had a long history of inventing youthful characters. In addition to creating (with partner Jack Kirby) the crime-fighting kid gangs the Newsboy Legion and the Boy Commandoes, he was also the mind behind the pimple-faced protagonists known as the Green Team and the barely shaved chief executive Prez (page 231).

Brother Power's origin is certainly steeped in contemporary touchstones. After a pair of pacifist hippie youths are assaulted by a belligerent biker gang and given a dunk in a nearby river, they dry their clothes on an old tailor's mannequin resting on a radiator. One fortuitous bolt of lightning later and—shades of Frankenstein's monster—the mannequin comes to life and the Geek is born!

Although he hangs out with his hippie pals (and, well, wears their clothes), the creature they dub Brother Power doesn't share their lackadaisical lifestyle. He talks a convincing boho patois, but while his "brothers" are happy to navel-gaze the day away, the Geek has ambition! Before long, Brother Power is hustling up the career ladder and setting his sights on institutional power—Brother Power for Congress! Between job hunting, the Geek uses his surprising strength and fortunate resilience to complicate the schemes of corny criminals, like the wicked bean counter Lord Sliderule.

This troubled title lasted only a pair of issues. Besides suffering from a meandering and genuinely confusing plot, it was rumored that the high-ranking DC Comics editor Mort Weisinger had actively petitioned to kill the hippie-friendly book. Brother Power was unceremoniously fired via rocket into permanent orbit (although he's managed to make a handful of earth-bound appearances in various DC comics since then).

Created by:
Joe Simon

Debuted in:
Brother Power the Geek #1 (DC Comics, October 1968)

Resume:
Tailor's mannequin, student, circus freak, factory-line worker, political candidate, unwilling astronaut

© 1968 by DC Comics

B'WANA BEAST
"Ki-ki-kuuuuuueeeee!"

Created by:
Bob Haney and
Mike Sekowsky

Debuted in:
Showcase #66
(DC Comics,
February 1967)

**Cat or dog
person:**
Both, at the
same time

© 1967 by DC Comics

JUNGLE HEROES HAVE BEEN a staple of comics ever since the medium's beginning. But blonde blue-eyed heroes striding through the jungle almost always evoke unlikable constructs of colonialism and imperialism. So it's a wonder that B'wana Beast received such a relatively high-profile debut in the late 1960s. His superheroic pseudonym employs a term that was, even fifty years ago, a relic of uncomfortable race relations. He also attempted one of the most questionable "looks" in comics history: leopard-trim boots, a loincloth, and a bullet-shaped hat.

The man behind the Beast is game warden Mike Maxwell, trapped on the top of Mount Kilimanjaro when a storm disables his private twin-engine airplane (he's one of those wealthy game wardens). He and his college buddy Rupert Zambesi Kenboya take refuge in a nearby cave. In short order, Maxwell gulps down a restorative cup of water fortified by unknown minerals, develops a massive physique and tremendous strength, is set upon by a talking mutant ape (whom he quickly subdues), and is then presented by the ape with a helmet that allows Maxwell to control animals with his mind.

And that's not all (though maybe it should be). B'wana Beast has the singular ability to combine any two animals into a single creature embodying the properties of both. For example, he merges a water buffalo and a rhinoceros into a super-sized battering ram monster (and afterward returns the animals to their regular forms, unharmed). When not blending faunae, he can still count on the wild creatures of Africa to aid him, making use of helpful giraffes, alligators, and bats throughout the story.

B'wana Beast's introduction is told through an interesting device: his friend Kenboya narrates from his position as police commissioner of a developing nation. Rupert's "Zambesi" tribe stands on the cusp of modernization, as were many African nations in the 1960s. What role an animal-mixing, bare-chested American in a fur-lined helmet could play in such a delicate state of cultural affairs is anybody's guess; the narrative fizzled after two issues. B'wana Beast did make some notable guest appearances in the 1980s, showing up in more sophisticated DC titles such as Grant Morrison's *Animal Man* (in which the political implications of the character were frankly addressed).

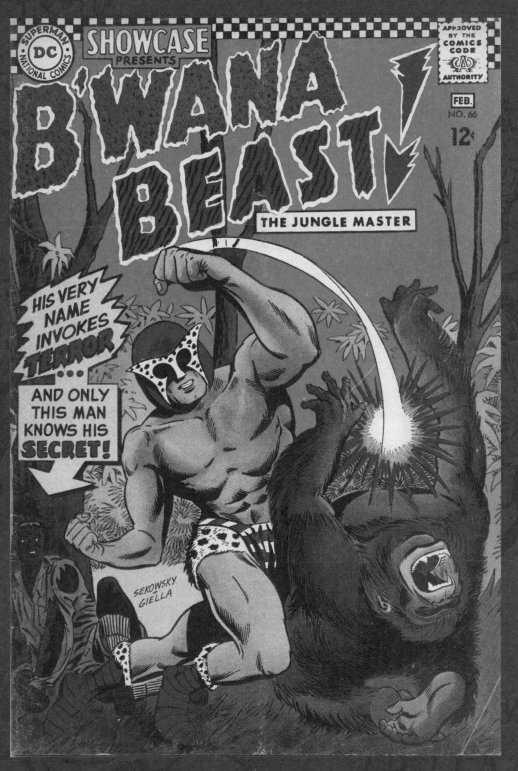

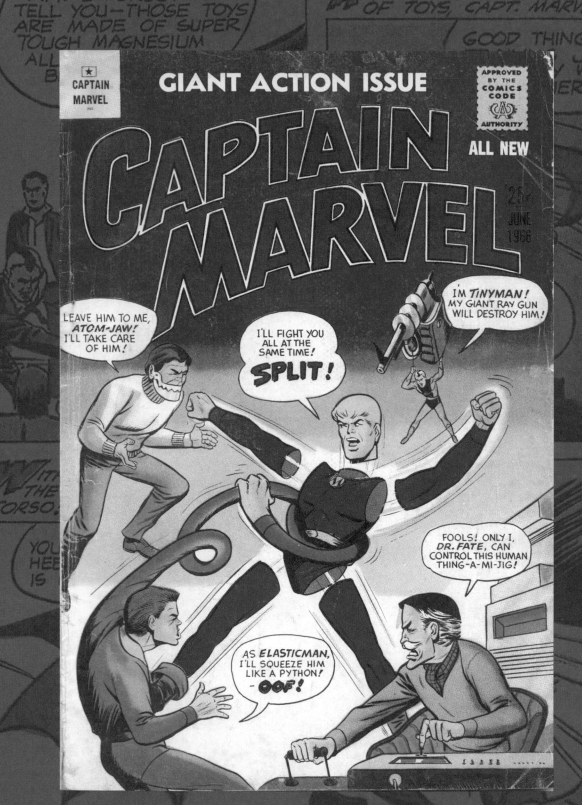

CAPTAIN MARVEL
"SPLIT!" "XAM!"

MORE THAN A FEW superheroes have taken to the skies using the name "Captain Marvel." Most, naturally enough, have been published under the auspices of the Marvel Comics Group, which is intent on preserving its corporate identity in an often crowded marketplace. The original, of course, was the red-suited, lightning-bolt-emblazoned hero whose magic word "Shazam!" echoed in the ears of fans, from comic pages to movie serials to Saturday morning TV.

The Captain Marvel shown here, however, was a short-lived sound-alike from publisher Myron Fass's fly-by-night comics company, eponymously titled M. F. Enterprises. He was crafted by Carl Burgos, whose "Human Torch" creation was one of the three key superheroes published by Timely Comics (primogenitor of Marvel Comics). This new Captain Marvel was something of an amalgam of the two: he bore the first Captain Marvel's name and, like him, was powered by a shouting a magic word. Additionally, like the so-called Human Torch, this Captain Marvel was an android.

Captain Marvel—who was also an alien from another world, just to ensure all bases were covered—possessed possibly the most unique and disturbing superpower in comics history: his limbs fell off. With a cry of "SPLIT!" the good captain's arms, legs, and head would fly free of his torso to tackle a multitude of foes, flip distant switches, or generally create a sense of profound unease. When the individual body parts had achieved their collective goal, the head would holler "XAM!"—not a far cry from the original Captain Marvel's magic word—and the pieces would reunite.

The Captain wasn't the only character in his book to borrow a name from a more popular superhero comic. His kid sidekick was a young fellow named "Billy Baxton" (not dissimilar from the original Cap's secret identity, Billy Batson), and his foes included such familiar super-sobriquets as Plastic Man, Dr. Doom, and Dr. Fate. In fact, his most dreaded enemy was originally called "The Bat," but a cease-and-desist order from DC Comics reminded M. F. Enterprises that it was treading dangerously close to a certain caped crusader. The villain's name was changed to "The Ray" (also the name of a onetime popular superhero).

Ultimately, the troubled Captain M lasted for only a handful of issues. The publisher folded after less than a year, with a measly three titles to its name.

Created by:
Carl Burgos and
Roger Elwood

Debuted in:
Captain Marvel #1
(M. F. Enterprises,
April 1966)

Personal existential dilemma:
If mine eye offend me, should it fly away and fight crime?

© 1966 by M. F. Enterprises

CAPTAIN SCIENCE

"There are times when good old American fists are better than an atom gun!"

Created by:
Walter Johnson

Debuted in:
Captain Science
#1 (Youthful
Magazines,
November 1950)

No relation to:
Lieutenant
Humanities, Colonel
Metaphysics

© 1950 by Youthful
Magazines

IS NAME MAKES HIM sound like the host of a children's educational television program. But Captain Science is in fact the two-fisted defender of the planet Earth, protecting us from such intergalactic menaces as the Cat People of Phobos and the Deadly Dwarfs of Deimos. What would we do without him?

Captain Science is Gordon Dane, an "eminent physicist and researcher" who—in the midst of a camping trip in New Mexico with his young, orphaned, oddly named protégé Rip Gary—witnesses a damaged flying saucer whiz overhead and crash into the nearby mountains. Saddling up, the duo rides to the wrecked space ship, where a strange force overcomes the youngster, causing him to pass out and leaving Dane alone to face the ship's occupant.

Trapped in the wreckage and dying from earth germs, a blue-skinned alien named Knur introduces himself to Dane and charges him with an important mission: protecting the world from the imminent invasion of murderous aliens— the Beast-Men of Rak! Supplementing Dane's "keen mind" and all-around earthling get-up-and-go is Knur's gift of a "Mechanical Brain," a triangular metal box capable of imparting to Gordon all the knowledge necessary to battle the menace from beyond the stars.

While Dane's scientific prowess may be strong, his ethics could use some shoring up. He happily goes along with Knur's plan to brainwash young Rip into becoming the future Captain Science's devoted sidekick. "When he wakes," Knur explains, "his mind will be conditioned to help you." In addition, Knur explains that Rip has been mentally commanded to hand over his inheritance to Dane. "The vast wealth left to him by his father will build for you the laboratory . . . which will make you Captain Science of Earth." Dane is fine with all of this. As is Rip, but then why wouldn't he be? His mind was conditioned, remember?

While not wearing any particular costume, Gordon takes the nonetheless superheroic nom de guerre Captain Science and becomes our planet's number one defender against alien threats. Operating out of his super-scientific laboratory headquarters in the New Mexico desert—a futuristic building resembling a Frank Gehry design—the Captain's first outing against the alien Beast-Men involves routing their agents on earth. Said agents are cloaked figures whom Gordon identifies as "the leaders of aggression in World War II who escaped and were never found." Naturally, their most prominent member sports a toothbrush moustache.

→

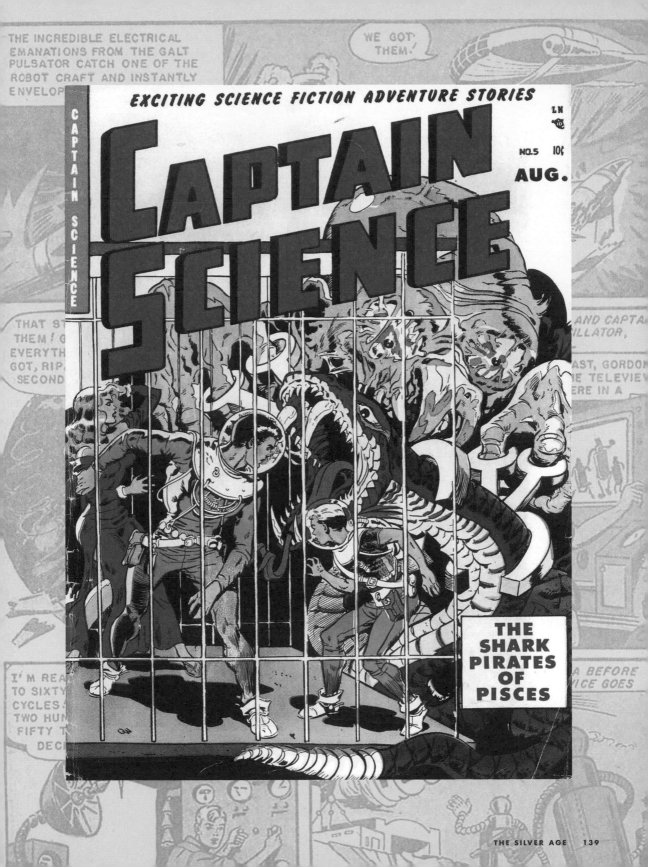

Along the way, Gordon and Rip pick up a third partner, Luana, whose father is one of the aforementioned Axis baddies. Nonetheless, she's as dedicated to staving off earth invasions as her partners, so she doesn't blink when Gordon is forced to blow her pop and his insidious pals to kingdom come. It's all in the name of science, after all! With each passing issue, the "science" referred to in the book's title grew increasingly dubious, as the Captain and his crew battled everyone from neighboring Martian Slavers to conquering colonists from the planet Pathor.

Despite increasingly garish covers and a rotating art team that included legends Joe Orlando and Wally Wood, the mission came to a premature end after seven installments. Captain Science never even faced the Beast-Men he was originally recruited to quash. We can only hope they're not still out there, planning that long-threatened invasion.

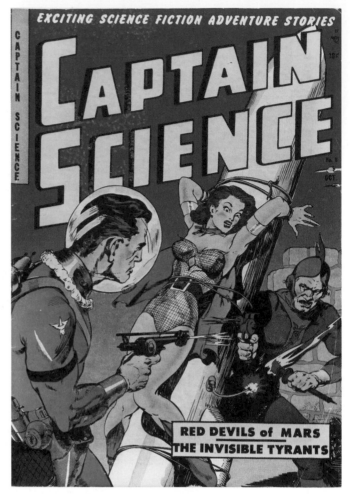

EDITOR'S NOTE...

Captain Science's adventures tended to be loosely built around a single quasi-scientific solution. For instance, in one tale, he demolishes an entire robot army using ultrasonics, "like those dog whistles that humans can't hear." Despite that these same robots had earlier withstood a direct assault with hydrogen bombs. . . .

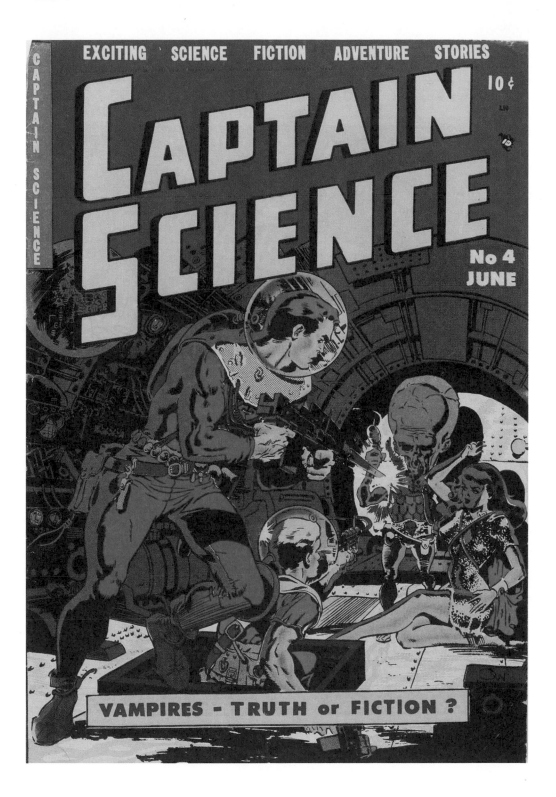

EXCITING SCIENCE FICTION ADVENTURE STORIES

10¢

CAPTAIN SCIENCE

No 4
JUNE

VAMPIRES - TRUTH or FICTION ?

CONGORILLA

"M-my head's spinning! Something's happening to me! S-some ... GROOOOWRR! GRRROOOWRRR!"

Created by:
Whitney Ellsworth and George Papp (Congo Bill); Robert Bernstein and Howard Sherman (Congorilla)

Debuted in:
More Fun Comics #56 (DC Comics, June 1940)

No relation to:
Saharattlesnake, Japanda, Minneapolizard, Arctic Ice Capybara

© 1940 by DC Comics

B Y SOME RECKONING, CONGORILLA—that is, his human alter ego "Congo" Bill—is one of the oldest characters in American comic books. The jungle adventurer debuted in 1940 and was a recurring backup feature in a handful of DC Comics titles, including a long-running stint in *Action Comics*, alongside Superman, from 1941 through 1959. The pith-helmeted hero's series was only moderately popular, but it still managed to earn Bill his own Columbia Pictures movie serial in 1949.

Congo Bill even managed to briefly occupy his own eponymous title, in a staggered seven-issue run that continued his jungle adventures over twelve months. Eventually, the safari motif ran its course, and Bill's star was fading fast. Not even the addition of a kid sidekick—Janu the Jungle Boy, a wild orphan with whom Bill started to pal around in 1954—could reverse his fortunes.

As jungle explorers were on their way out, superheroes were on their way back in. Caped crusaders were staging a comeback, and Congo Bill wasn't to be excluded. Bill's superpowers were, appropriately enough, rooted in the jungle magic of Africa. In January 1959, he attended the deathbed of his beloved native pal Chief Kawolo, who gifted Bill with a magic ring. When rubbed, the ring transferred the mind of its wearer into the body of whoever wore its twin, and vice versa. The present owner of the matching ring? A gigantic, extremely powerful, and exceptionally intelligent golden ape!

In a wild twist on the Dr. Jekyll/Mr. Hyde formula, Bill would exchange minds with the golden gorilla—dubbed Congorilla—whenever danger struck. His boy assistant Janu would take precautions to cage Bill's human body beforehand so that the ape's primitive mind would not inadvertently damage its human host. Unfortunately, Congo Bill's reincarnation as a crime-fighting gorilla didn't extend the life of his feature. After a few more years of body-switched baddie bashing, both Congo Bill and Congorilla were retired.

It's hard to keep a good gorilla down, though. Over the years, Bill and his simian alter ego have continued to make cameo and guest appearances in assorted DC Comics, with Congorilla briefly earning a turn as a member of the Justice League of America.

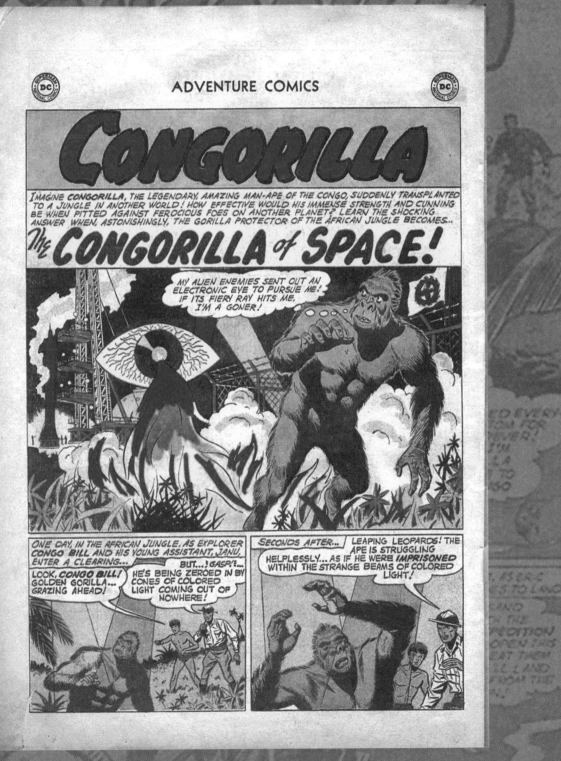

DIAL H FOR HERO
"Sockamagee!"

SUPERHERO COMICS WERE ENJOYING a boom in the mid-1960s, and for a brief period the multitudes of costumed crime-fighters were nowhere more abundant than in the pages of *House of Mystery*. Formerly an anthology comic focusing on horror, science fiction, and fantasy stories, the title was briefly converted into a superhero book to accommodate the expanding market.

It was in this environment that bespectacled young science whiz Robby Reed found himself stumbling into a secret cave on the outskirts of Littleville, U.S.A. Discovering an alien device (resembling something like a phone dial attached to a golden tuna can) hidden deep within, Robby gives the machine a tentative spin. Spelling "H-E-R-O" on the dial, the boy finds himself transformed—not just into a single hero, but into a succession of superheroes, each one stranger than the last!

In a typical issue, Robby would transform into as many as three unique and never-before-seen superheroes, each with distinct names, powers, and costumes. Some of the more traditional heroes created by the "H-Dial" included the titanic Giant-Boy, the dazzling Cometeer, and the bewildering Hypno-Man. Its weirder inventions seemed to imply that the alien device possessed something of a wicked sense of humor. On various occasions, Robby found himself transformed into such unlikely super-characters as the sweets-themed King Kandy, the unsettling Human Starfish, and Mighty Moppet, a cape-wearing baby who fought villains with a magic milk bottle. Even existing superheroes were fair game. In one adventure, using the dial changed the youngster into a duplicate of Plastic Man, a once-popular character who'd recently been acquired by DC Comics.

Dial H for Hero didn't quite make it through twenty issues before the tank began to run dry. The demand in every issue for weird new superheroes led to the reappearance of earlier characters and the creation of some memorably infamous incarnations (including Whozit, Whatsit, and Howzit, who were essentially superpowered shapes). The concept returned in the 1980s; this time, the writers lightened their burden by inviting readers to submit their own ideas for heroic transformations. Fans rose to the occasion and generated such agreeably entertaining identities as Teleman, Captain Electron, Vibro the Quakemaster, Puma the She-Cat, and Glass Lass.

Since then, H-Dial has been mostly dormant, although it periodically pops up in an occasional new series, always in the hands of a new user.

Created by:
Dave Wood and
Jim Mooney

Debuted in:
House of Mystery
#156 (DC Comics,
January 1966)

In case of misdial:
Please hang up and
dial again

© 1966 by DC Comics

DRACULA

"By changing into my Dracula costume, I will be prepared for anything once I board that lead dirigible."

Created by:
Don Segall and
Tony Tallarico

Debuted in:
Dracula #2; issue #1
was an adaptation
of the film (Dell
Comics, November
1966)

Issue oddity:
Dracula the
superhero appeared
in issues 2–4, then
his adventures were
reprinted in issues
6–8; there was no
Dracula #5

© 1966 by Dell Comics

ELL COMICS ONLY INFREQUENTLY dabbled in original superheroes; their bread and butter was a line of comics licensed from popular television shows, cartoons, and films. So perhaps it's only natural that when they created their own thematically united superhero "universe," they stuck with what worked: repurposing existing characters.

Dracula was part of a trio of superhero titles produced by Dell and based loosely (and therefore legally) on the popular Universal Monsters franchise. The company had already published successful adaptations of several monster movies, including *The Mummy* and *The Creature from the Black Lagoon*. For their line of superheroes, however, Dell stuck with the classic monster trinity, creating superheroic versions of Dracula, Frankenstein, and Werewolf (the name "Wolf-Man" was legally owned by Universal, so Dell opted for the next best nomenclature). Frankenstein was elevated from rampaging brute to crook-crushing superhero—sort of a cross between Superman, the Hulk, and a morgue full of stitched-together body parts—while the Werewolf became a masked government agent operating in secrecy to save the free world.

As for Dracula, he ended up clothed in a skintight purple bodysuit, with a broad red belt and some sort of bat-eared bonnet. This Dracula was the direct modern-day descendant of the historical King of the Vampires and a research scientist who sets up in the ancestral castle home of his forebears. This contemporary version is seeking a chemical cure for traumatic brain injuries, and the secret ingredient to his sanity-restoring serum is, of course, bat blood.

Accidentally consuming an extra-large dose of his still-untested liquid, in a sort of superheroic equivalent of the old "You got chocolate in my peanut butter" routine, young Doc Dracula is shocked to discover that he has suddenly developed a host of superpowers reminiscent of legendary vampires. He acquires superhuman strength, enhanced senses, and the ability to transform himself into a bat. (Which begs the question: Were the bats he used for his serum transformed vampires, caught in a moment of vulnerability?)

Abandoning his research, young Dracula devotes his newfound powers to the cause of clearing the ol' family name, which has been tainted by the atrocities of his famous ancestor (why can no one ever recall all the *good* things the Draculas have done?). Designing a costume and setting off for America, the newly rechristened Dracula makes this oath:

"I pledge by the strange powers which have become mine to fight against the injustice, corruption, evil and greed which fills this Earth in the hopes that →

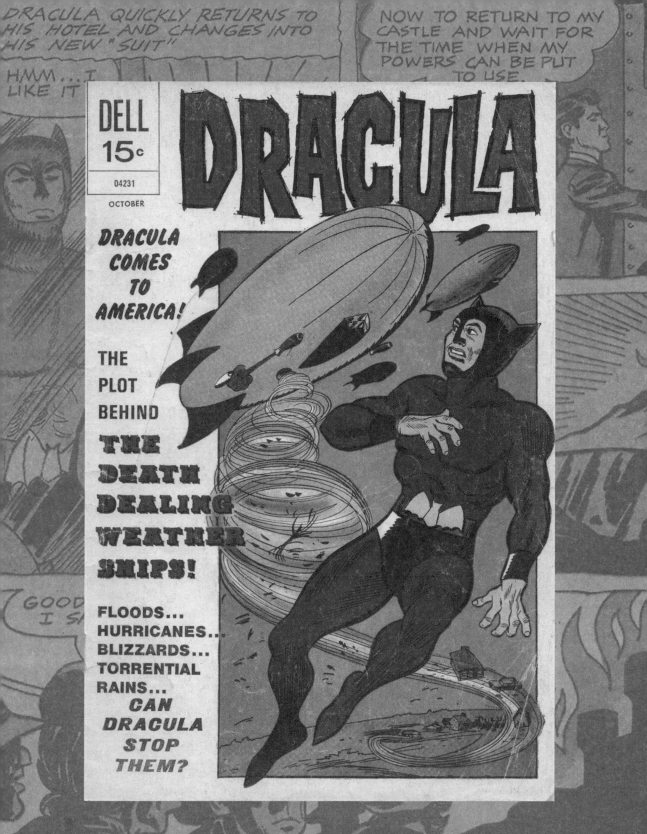

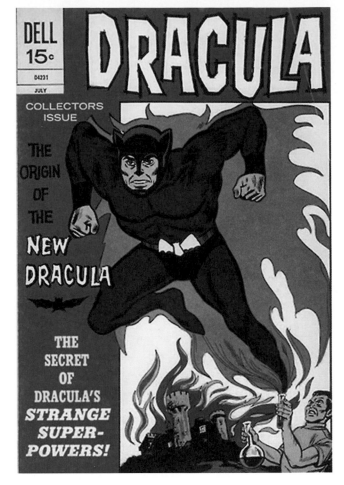

somehow my example will be an example to all men."

Despite his mission to restore honor to the family name, Dracula adopts a pseudonym, "Aloysius Ulysses Card," a.k.a. "Al U. Card," an impenetrable alias, providing that no one ever reads his business card backwards.

As if to mimic the better-known bat-based superhero who preceded him, Dracula procures a "bat-cave" of his very own (an underground government installation and bomb shelter hidden under the grounds of an expansive family estate) and a sidekick "Fleeta" (short for "Fledermaus"). What he couldn't replicate was the longevity of either his superheroic predecessor or his gothic namesake. Despite his return via reprints, Dracula's short-lived superhero career never made it past three adventures.

EDITOR'S NOTE...

Vampires make their presence known among the superhero set with some frequency. Examples include Spider-Man's sometimes-foe/sometimes-ally Morbius the Living Vampire, the vampire-hunting Blade (himself half vampire, on his father's side), the Teen Titan called Nightrider, and the Outsiders' hypnotic Looker.

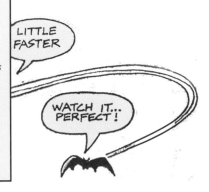

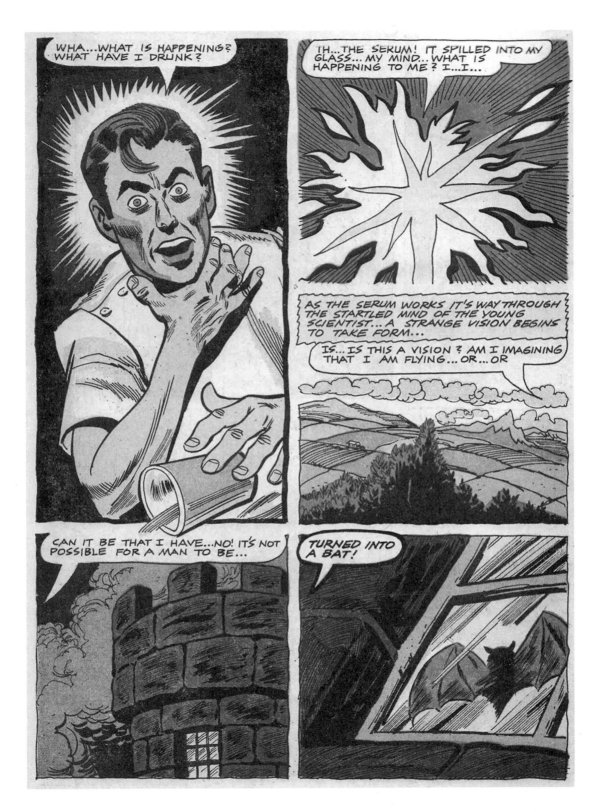

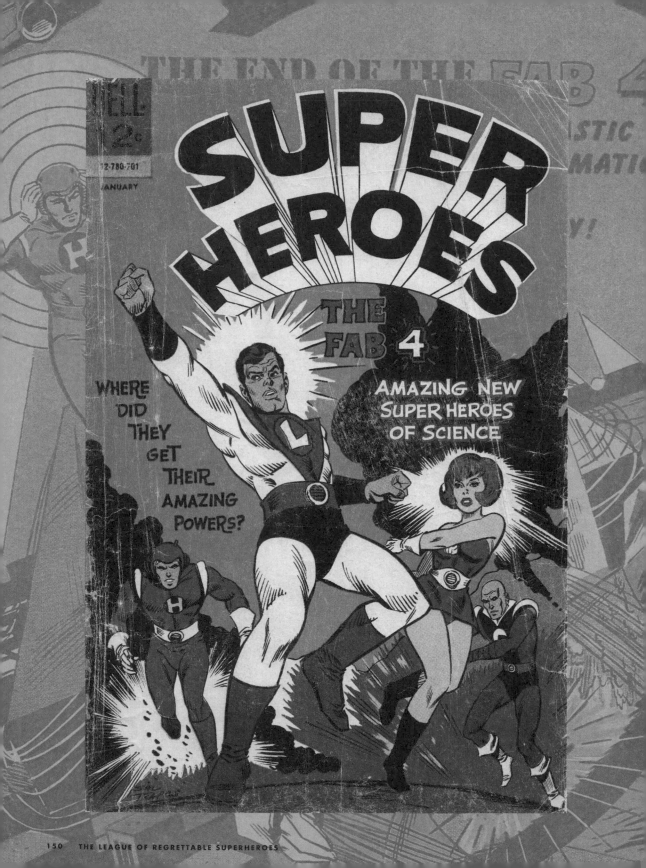

THE FAB FOUR

"Golly, Polly, girls worry about the silliest things!"

HE NAME "THE FAB FOUR" conjures images of a certain well-known Liverpudlian rock quartet. But during the brief existence of Dell Comics' plainly titled *Super Heroes* comic, it was also the moniker of that publisher's sole super-team.

Effecting an unusual twist on the old Captain Marvel formula—in which a child is transformed into an adult superhero—the Fab Four were sightseeing teens who happened to visit the Dell Hall of Heroes. That's right, these Dell Comics characters visited a museum dedicated to the shallow roster of superheroes from Dell Comics (specifically, the nuclear-powered pilot Nukla; Toka the Jungle King; and Kona, Monarch of Monster Isle).

The titular foursome are made up of young Southerner Reb Ogelvie, nervous nellie Tom Dennis, stalwart Danny Boyd, and Polly Wheeler, the group's sole female member. Before the friends can make it to the museum's gift shop, they're caught in a weird science explosion emanating from a nearby laboratory. The explosion somehow gives the kids the powers to transfer their minds into a quartet of android superheroes currently on display in the Hall of Heroes. Why those four android superheroes were on display is unrevealed, but it's possible they were being exhibited as examples of the worst superhero code names in history. Danny takes over the powerful robot body "El," so named for the letter on his chest (which stands for "laser"). Tom finds himself possessing the hypersonic "Hy." Forever-chilly Reb becomes the cryogenic "Crispy," and Polly becomes the frictionless "Polymer Polly," able to weave nearly unbreakable polymer strands.

A lot of questions are left unanswered. . . . Who invented these superpowered robots in the first place? Why aren't these kids in school? And where the heck *is* the Dell Hall of Heroes, anyway? During their short-lived series, Danny, Tommy, Reb, and Polly go sightseeing around America, in the course of one issue traveling from northern Pennsylvania to the Florida coast. Yet they're never so far from the Hall of Heroes that they can't immediately summon their heroic android selves when trouble arises.

It's also left to the readers' imagination to decide what happens to the teens' bodies while their minds are occupying the androids. The kids seem to be leaving their human shells in considerable danger.

The Fab Four debuted and disappeared in the short span of four issues, but they packed a lot of enemies into their schedule: the Clown, Johnny Boom Boom, the mad modernist architect Mister Nutt, Nepto the shark man, a brutal and ever-burning giant called the Coal Man, and more.

Created by:
Don Arneson
and Sal Trapiani

Debuted in:
Super Heroes #1
(Dell Comics,
January 1967)

Headquarters:
A superhero
museum that's
somehow close to
everywhere

© 1967 by Dell Comics

FATMAN THE HUMAN FLYING SAUCER

"Sorry boys ... but the scales are weighted in my favor!"

Created by:
C. C. Beck and
Otto Binder

Debuted in:
*Fatman, the Human
Flying Saucer* #1
(Lightning Comics,
April 1967)

**Possible
unused IDs:**
Capt. Corpulent
the Living UFO,
Tubby Titan the
Anthropomorphic
Alien Vessel

C. BECK AND OTTO BINDER were two of the key personnel responsible for making the original Captain Marvel, the lightning-empowered, "Shazam!" spouting World's Mightiest Mortal, one of the most popular superheroes not only in comics but around the world. (Not to be confused with Captain Marvel the self-dismembering android, page 137). Unfortunately for this dynamic duo, in 1951 the long-running lawsuit between Captain Marvel's publisher Fawcett and rival comics publisher National Comics (home of Superman, and now known as DC Comics) was ultimately decided in favor of the Man of Steel. Beck and Binder found themselves jobless when Fawcett subsequently shut down its comics-creating wing.

The 1950s were lean years for superhero comics across the board. But in the late 1960s, the popularity of the Batman TV show revitalized interest in superheroes. It was at this point that Beck and Binder chose to reunite for another attempt to catch lightning in a bottle, as it were.

The result of their collaboration was the absurd Fatman, a plump but athletic character named Van Crawford who was happy to spend his idle time indulging his many and varied hobbies and collections. When a spaceship—also a shape-changing alien—crashes within sight of his daily constitutional, Crawford rushes to its aid. He is rewarded for his efforts with the power to transform himself into a UFO.

Decked out in a suit resembling a verdant version of Captain Marvel's famous duds, Fatman battled a roster of foes that included the titanic Anti-Man, the hideous Brainman from Mars, underground gnome Grollo, Syntho the Patchwork Man, and the lovely but evil Lunita, the Moon Witch. He was well served by both his athletic bulk and his unusual alternate persona as a living, thinking spaceship. Along the way, Fatman picked up a fellow crime-fighter, Tin Man, an unusually skinny teenager who gained himself a robot body thanks to a chemical concoction of his own invention.

Fatman, the Human Flying Saucer and partner title *Tod Holton, Super Green Beret* constituted the only output by publisher Lightning Comics, which folded after a few scant months. Since then, sightings of Fatman, like the flying saucers he emulated, have been scattered and unreliable. Lightning Comics promised one more superhero title, which it never delivered. The lawyer-baiting title of this never-made book: *Captain Shazam!*

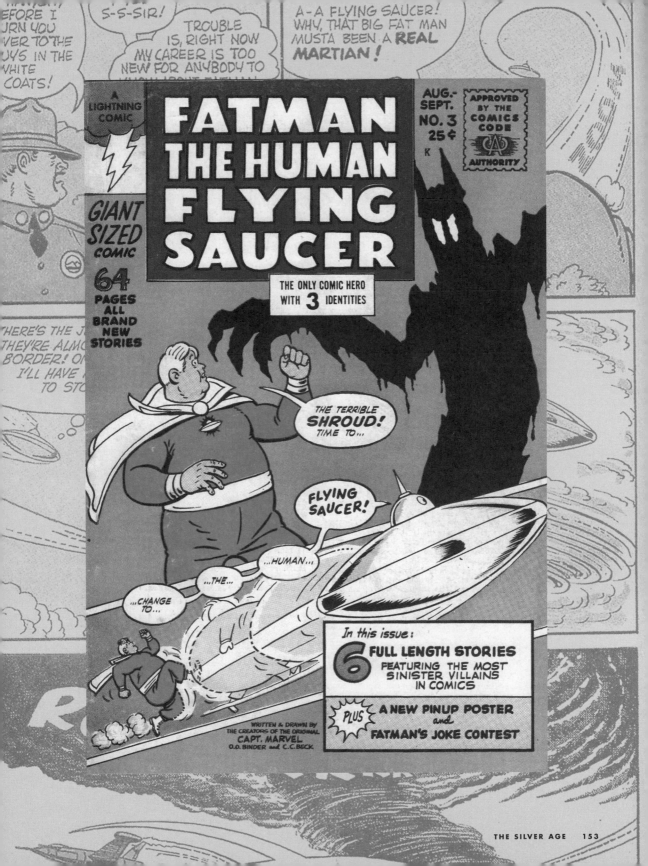

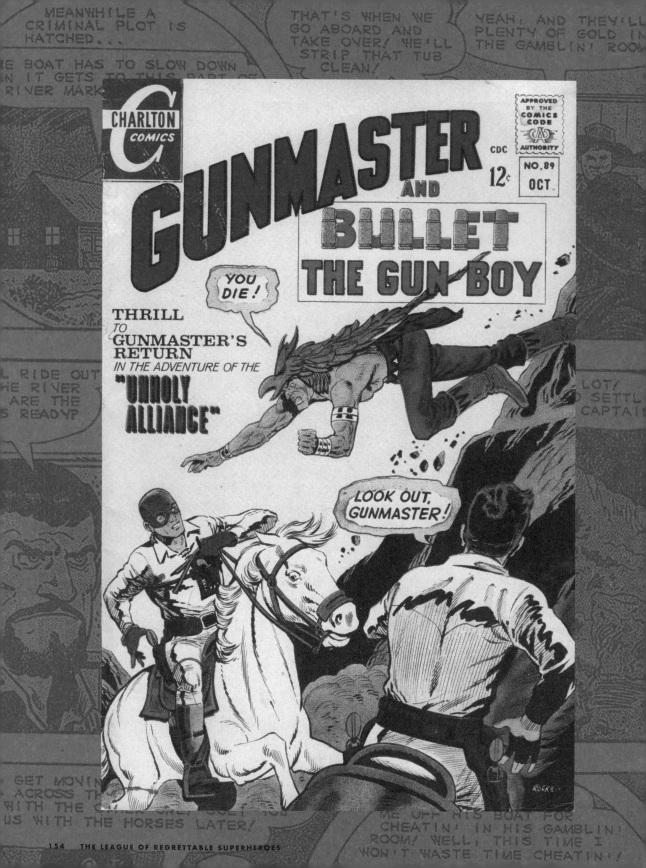

GUNMASTER

"Get back in the train, President Grant! They're after you!"

IMID, BESPECTACLED CLAY BOONE is despised by the woman he loves because of his cowardice. If only he could be more like that daring, masked stranger who appears in the tiny Old West town of Rawhide in times of danger!

Unbeknownst to his would-be lady love, Clay Boone—spoiler alert—*is* that masked hero, the daring duelist known as Gunmaster. Hiding behind his seemingly telling civilian career as an apprentice gunsmith, Boone is actually an avowed pacifist who only unholsters his shooters when all other attempts at peacemaking fail.

Shy on superpowers, Gunmaster gets by with an increasingly inventive arsenal of guns and gunlike gimmicks, all of his own creation. When a gun that shoots gas bombs or flares fails to solve the problem, Boone's unerring eye for trick shots makes him an admirable enemy of evil.

With the quick resolution of a shootout solving most of his problems, no small amount of the average Gunmaster adventure is spent on Boone justifying his seemingly contradictory lifestyle. When his civilian identity is accused of cowardice, he thinks to himself, "She may be right! I'm too cowardly to live by the principles I think are right."

But then he goes on to insist, "If I MUST resort to guns as they do, then I will be master of the weapon! My enemies have guns, I have better ones! They have skill … I will match that and better! If I MUST fight, then I will win!"

Gunmaster's torturous only-if-I-gotta position is a little harder to buy when Boone decides to take his gun shop on the road, seemingly seeking out trouble across the still-wild Wild West. Along the way, he picks up a kid sidekick. Bullet, the Gun Boy who, in his civilian guise of Bob Tellub (read it backward for a mediocre surprise), becomes Boone's apprentice. He also comes across a few colorful supervillains, like the wild Apache warrior Hawk, the corpulent criminal genius known as "Brains," and the hypnotic menace called "The Barker."

Despite acquiring a fledgling rogues' gallery, a kid sidekick, and a graduation to his own title, Gunmaster's guns a-blazin' faded away after a couple dozen appearances. Here's hoping he ended up in a place where he could abide by his peaceful beliefs.

Created by:
Dick Giordano

Debuted in:
Six-Gun Heroes #59
(Charlton Comics,
October 1960)

How many guns does he own?
So many guns

© 1960 by Charlton Comics

→

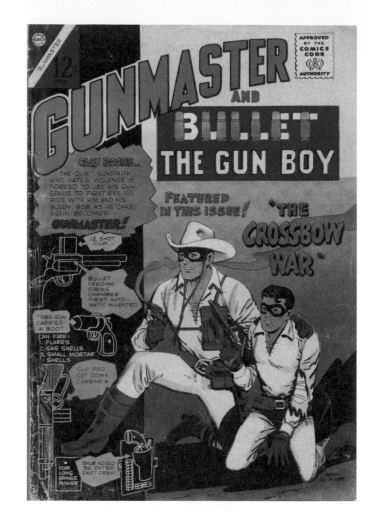

ROLL CALL...

Most superheroes seem to prefer Spandex long johns and capes, but a few wild and woolly types have traded those in for lariats and ten-gallon hats. Some superheroes who've opted for the cowboy look include the motorcycle-riding "prairie troubadour" known as the Vigilante, Dennis Yee's super-strong Chinese American cowboy hero called the Canton Kid, and the Texas Twister, that cyclone-spinning saddle tramp. Marvel Comics' original Ghost Rider was an Old West gunslinger possessed of the clever idea to douse his costume (and his horse) in eerie phosphorescent paint to appear ghostlike to crooks. Awkwardly, it turns out that tactic, as well as his all-white costume and his briefly adopted alternate alias "The Night Rider," were all ideas also employed by the Ku Klux Klan.

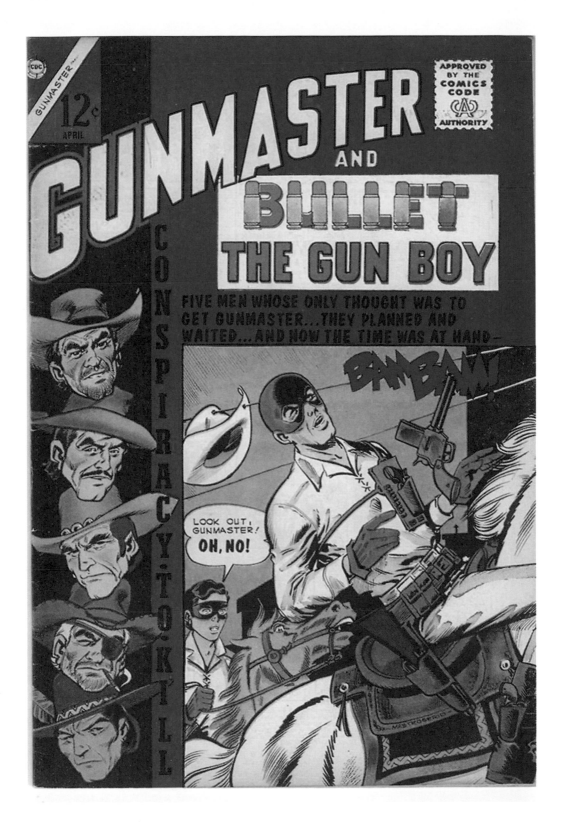

JIGSAW

"I'm lucky to be alive ... I guess."

Created by:
Joe Simon,
Otto Binder, and
Bill Draut

Debuted in:
Jigsaw #1 (Harvey
Comics, September
1966)

Level of difficulty:
Hundreds of pieces,
ages 8 and up

© 1966 by
Harvey Comics

A S THE BLURB ON the cover of this hero's debut appearance warns: "Don't laugh at the Jigsaw Man!" Well, if they didn't want us to laugh, they probably shouldn't have made the Jigsaw Man look like that.

The "Man of a Thousand Parts" whose "mechanical parts make him the greatest crime-fighter on Earth" begins his career in outer space. Colonel Gary Jason (having two first names is almost a guarantee that one will become a superhero of some sort), astronaut with the Earth Space Force and pilot of the exploratory orbital vessel *Stargazer One*, is caught up in a "magnetic cone" that is stealing rocks, trees, and animals from remote Siberia and depositing them on the moon. Battered and bruised by fast-moving space debris, left teetering on the edge of death, Colonel Jason is rescued by the rock-stealing but otherwise well-meaning aliens behind the phenomenon.

Eager to ensure that earthlings view them as friendly, the metallic extraterrestrials make up for their cosmic faux pas by rebuilding the badly broken astronaut (for better or worse). During a hasty operation—a sort of reverse alien autopsy—the human's broken body is replaced with gaudy multicolored plates that interlock around his limbs and torso in jigsaw fashion.

Even more alarming than Colonel Jason's new form is his exponential increase in strength and sudden stretchability. The "Moon-mile of synthetic tendons" that replaced Jason's shattered limbs are also limitlessly elastic, granting Jigsaw the power to dramatically telescope parts of his body.

Stretchy superheroes are not particularly uncommon in comic books, but Jigsaw is one of the few whose ability to elasticize his body is manifested in a genuinely unsettling manner. Rather than smoothly expanding like a rubber band, the interlocking plates on Jigsaw's body separate, allowing his ropey alien tendons to swing free. It's appropriate that Jigsaw's origin seems to borrow so much from 1960s-era sci-fi suspense programs—*The Twilight Zone* and *The Outer Limits*, for example—given that the manifestation of his power is utterly terrifying.

The Space Force is convinced that Jason has been replaced by an alien monster, while his girlfriend responds to his newly elastic existence with a prolonged shriek of horror. So, Jigsaw spends most of his subsequent adventures puzzling about in outer space. He enlists in a cosmic Cold War battle against the sinister Pulots, a conquering alien empire. Once fully assembled, Jigsaw stymies the Pulots' plans and competes in the Interplanetary Olympics. After that, Jigsaw evidently fell to pieces and hasn't yet been put back together again.

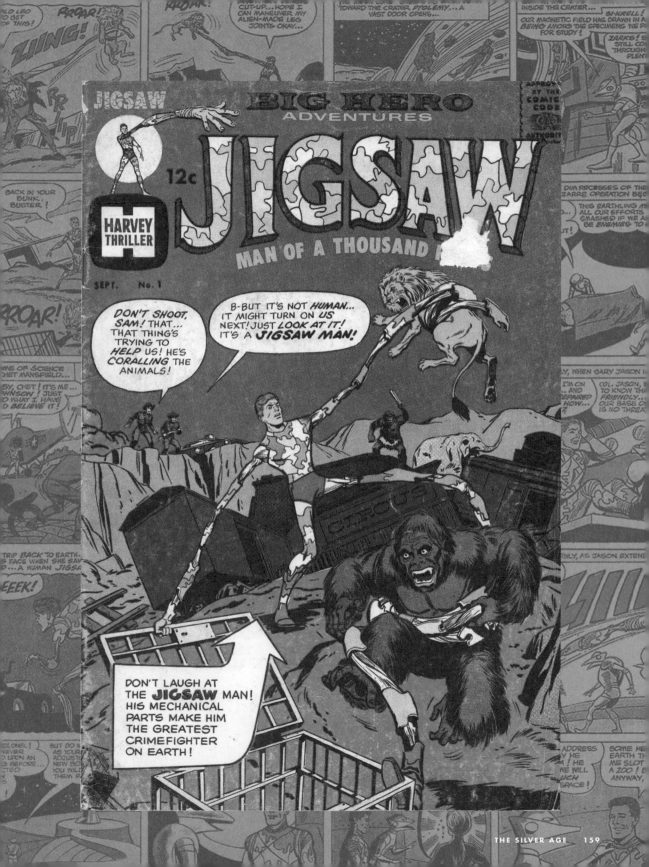

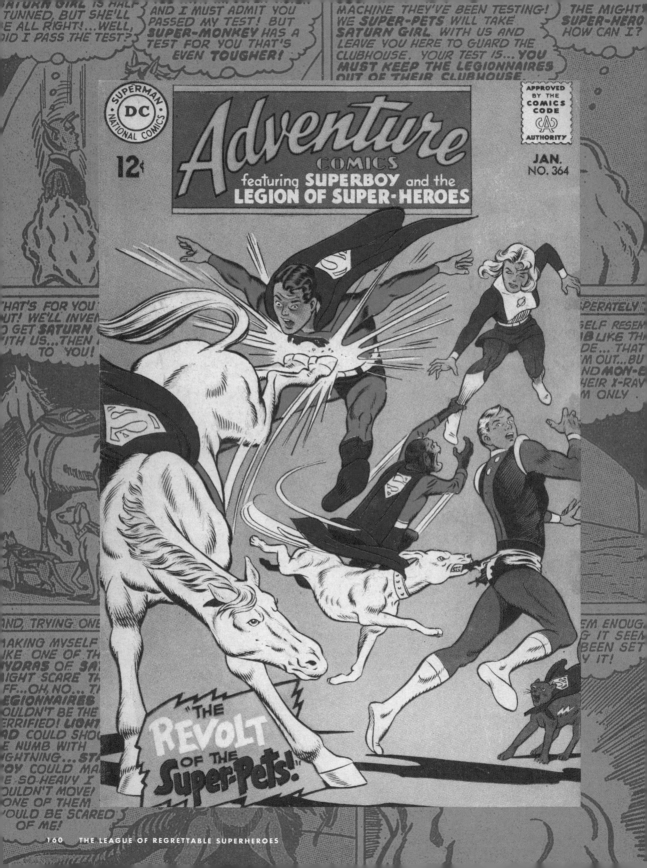

LEGION OF SUPER-PETS
"Woof!" "Whinny!" "Meow!" "Eep Eep!"

T HE LEGION OF SUPER-PETS is made up of, appropriately enough, the pets of Superman and his cousin Supergirl, each outfitted with costumes and possessed of their own superpowers. They were first assembled into a group to battle "The Brainglobes of Rambat," aliens whose telepathic powers were of no use against animals.

The founding members were

KRYPTO: Having been fired from Krypton in a test rocket built by Superman's father, Jor-El, superdog Krypto is reunited with his master when the rocket reaches earth. There, the happy pup adopts the secret identity of family pooch "Skip" (well, it's better than "Bark Kent," right?). Krypto was also a member of a second group of super-pets, the Space Canine Patrol Agency, along with such superpowered hounds as the fiery Hot Dog, the prescient Precognitive Pup, and Tusky Husky, who could instantly grow powerful jabbing tusks at will.

BEPPO: This super-monkey was a lab animal also launched from Krypton by Superman's father. He possessed all of Superman's mighty powers, but as an impish little monkey, he was given to mischief and antics. (One hopes he never threw his super-feces around.)

STREAKY: A regular ol' earth feline, Supergirl's pet cat gained powers similar to his owner's after playing with a chunk of "X-Kryptonite." Streaky's powers had a short lifespan, but he managed to stumble across X-Kryptonite regularly enough to fight evil alongside Supergirl.

COMET: The most tragic—and unsettling—of the Super-Pets was a human archer named Biron, who hailed from ancient Greece. He'd crossed the mythological witch Circe and been turned first into a centaur and then, in a botched attempt to cure his condition, into a full-on immortal horse with superpowers. When a certain comet passes by earth, Biron is restored to human form, and it's in this fashion that he and Supergirl fall in love. When the comet is gone, he returns to being her horse, with Supergirl unaware that her crush and her horse are one and the same. It's wrong to judge, but that relationship is messed up.

Although rarely called upon, the Legion of Super-Pets adopts a formal code, establishes a headquarters, and even tests new applicants, such as their fifth member, Proty II, a telepathic alien mass of protoplasm capable of changing its shape.

Created by:
Otto Binder and Curt Swan (Krypto the Superdog), Otto Binder and Jim Mooney (Streaky the Supercat), Jerry Siegel and Curt Swan (Comet the Superhorse), Otto Binder and George Papp (Beppo the Super-Monkey), Edmond Hamilton and John Forte (Proty II)

Debuted in:
Adventure Comics #293 (DC Comics, February 1962)

©1962 by DC Comics

MAGICMAN

"You've got no idea of the powers I've got. I'm magic!"

Created by:
Richard Hughes
(as "Zev Zimmer")
and Pete Costanza

Debuted in:
Forbidden Worlds
#125 (American
Comics Group,
February 1965)

**Attempt to make
the turban a popular
fashion accessory:**
Unsuccessful

© 1965 by American
Comics Group

AGIC RECEIVED A GROOVY revival during the swinging '60s, with TV shows like *Bewitched* and *I Dream of Jeannie* taking sorcerers and warlocks out of their spooky caves and ominous castles and plopping them down in the suburbs. Trading in peaked caps for bouffant hairdos and broomsticks for convertibles, a trend was afoot to make magic "hip."

Superheroes weren't excluded from the big change. Previously, sorcerous superheroing was a formal affair, complete with top hat and tails, and crime-fighting magicians bore exotic sobriquets like Zatara, Ibis, Sargon, or Mandrake. Not so with Magicman, a regular Joe with inherited magical powers, whose costume was literally retrieved from a scrap pile.

Magicman is the alter ego of Tom Cargill, the direct descendant of the eighteenth-century mystic Alessandro Cagliostro; in fact, Tom was Cagliostro's son, despite the century and a half separating his birth and his father's purported death. It must have been magic, much like the kind Tom inherits from his famous father.

Unusually for a superhero of the era, Tom was stationed in Vietnam when his series debuted. When the Viet Cong overwhelm his unit's barracks, Tom rescues castoff costume pieces from a trunk of theatrical getups and flies to the aid of his comrades as . . . Magicman! Although billed as the most powerful magician in the world, Magicman chooses to stick with his hand-me-down costume rather than whipping up something more mystical. He makes his name wearing the unusual combination of a domino mask, turban, and vest with plunging neckline.

Magicman ends up leaving the fighting to the boys over there and returns to the United States. He's accompanied by his former drill sergeant, the brave but uncouth Sgt. Kilkenny, who admires Magicman but derides Tom as "a sissy" (if only he knew the truth!). The pair ends up as unlikely roommates in their civilian lives, as a sort of superheroic Odd Couple.

In addition to his hectoring ex-sergeant sidekick, Magicman came complete with an opposite number, nemesis, and love interest all wrapped into one—Demonia, an evil sorceress with occasional altruistic leanings who rides around on a magical panther and occasionally spies for the "Red Chinese." In a way, the couple was the Sam and Diane of mid-'60s magical Cold War costumed wizards.

→

Magicman managed to conjure sixteen appearances before his run was canceled, which is pretty admirable considering his own creator had been opposed to the whole idea from the start. American Comics Group editor Richard Hughes was of the opinion that superheroes had run their course. Little did he know that the Batman-inspired superhero revival was right around the corner.

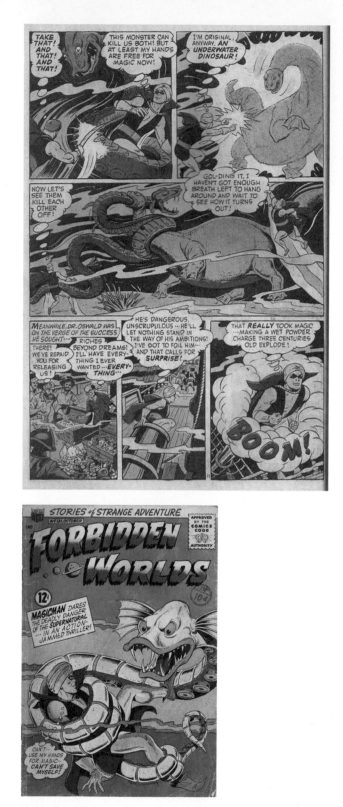

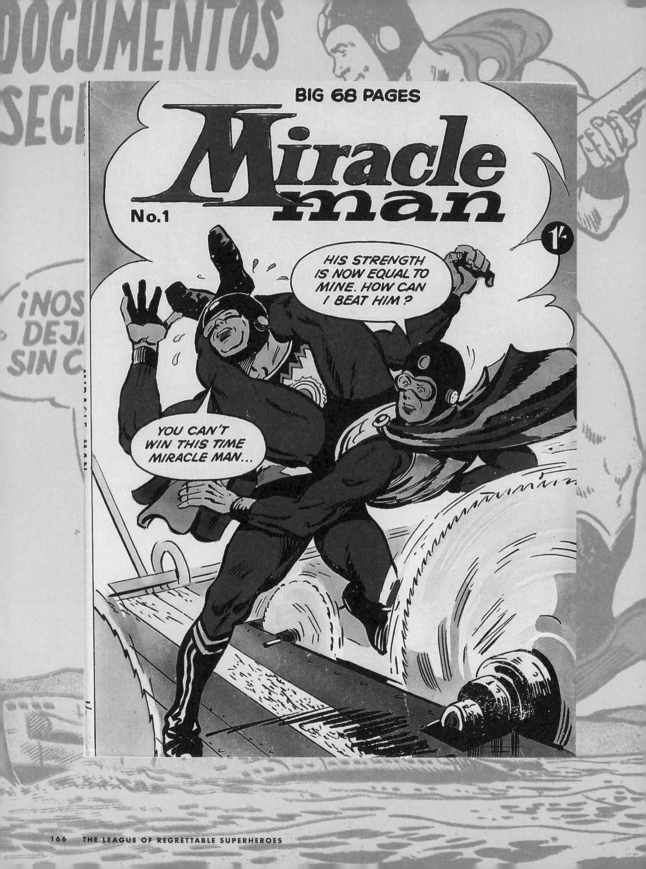

MIRACLE MAN
"Fantastic! Even I can't tell the difference!"

COMIC BOOK SUPERHEROES HAVE a long history of liberally "borrowing" from one another, which is a polite way of saying that some new characters are little more than modified copies of existing ones. In the case of "Mirakel Man"—a.k.a. "SuperHombre"—the mystery of who begat whom doesn't require a lot of detective work. This character sits in the middle of a lineage of imitators, most created by the same man, the British writer and artist Mick Anglo.

Long before SuperHombre, there was the original Captain Marvel, the popular American superhero who—his competitor's claims of copyright infringement notwithstanding—outsold even Superman during an extended period in the Golden Age of comics. The "Big Red Cheese" was equally popular overseas, and London-based publisher L. Miller & Son possessed the lucrative contract to republish the adventures of the Marvel family for U.K. audiences.

In 1953, however, the long-running lawsuit between the publishers of Superman and Captain Marvel came down in favor of the Man of Steel, drastically changing the superhero comics landscape. In the wake of the decision, publisher Fawcett ceased publication of all of its Captain Marvel–related titles and closed its comics publishing arm, a decision that left L. Miller & Son without its most popular title.

Under Mick Anglo's direction, L. Miller launched a suspiciously familiar character using the name "Marvelman." Boasting the same grinning squint and simplified linework of Captain Marvel, Marvelman even debuted under a Captain Marvel like logo. He changed from newsboy Mickey Moran (see Captain Marvel's Billy Batson) into Marvelman by using a magic word—in this case, not "Shazam!" but "Kimota!" And in place of the Captain's youthful sidekicks—Captain Marvel Jr. and Mary Marvel—Marvelman palled around with Young Marvelman and Kid Marvelman.

In the same year, Anglo created another Shazam-alike, Captain Universe, "The Super Marvel," whose look and abilities were likewise intended to invoke the idea of Captain Marvel. In his single appearance, Captain Universe attains his powers via the magic word "GALAP," an unlikely acronym standing for Galileo (Master of the Galaxies), Archimedes (Master of Physics), Leonardo da Vinci (Master of Invention), Aristotle (Master of Philosophy), and Pythagoras (Master of Geometry).

Then, in 1958, the Spanish publisher Editorial Ferma approached Anglo to oversee the creation of a new superhero for the Spanish-language market. →

Created by:
Mick Anglo

Debuted in:
Miracle Man #1
(Thorpe & Porter, 1965)

Known relatives:
Captain Marvel, Marvelman, Super-Hombre, Mirakel Man, Miracleman

© 1965 by Thorpe & Porter

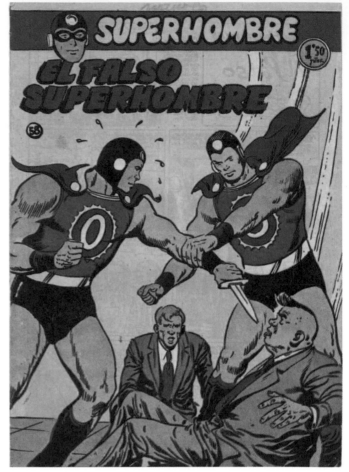

The result was "SuperHombre," another Captain Marvelesque superhero (bearing the same name that Superman held in the Mexican market).

With both Miracleman and SuperHombre thriving in 1960, Anglo split with publisher L. Miller, though his former employers continued issuing reprinted adventures of Marvelman. Meanwhile, Anglo created still another variation on the Captain Marvel model: Captain Miracle, whose magic word of power was "El Karim" (try saying it backward). If these adventures reminded readers of the old Marvelman stories, that's because they were meant to. In fact, they were redrawn versions of those stories, with Marvelman now in a new costume.

Yet, that still wasn't the end of Anglo's marvelous variations. In 1965, he debuted Miracle Man, "the superman of unlimited power," who was SuperHombre in all but name. Transforming himself into mighty Miracle Man by means of the magic word "sundisc"—not an acronym or reversed word but, rather, a description of the emblem he bore on his chest— Miracle Man and his sometimes-sidekick Supercoat marked the end of Anglo's reinventions. He shuttered his studio, leaving unknown how many more British iterations on the original Captain Marvel might have one day existed.

EDITOR'S NOTE...

Anglo's (somewhat) original character Marvelman was revived in the 1980s. To avoid legal conflict with publisher Marvel Comics, when reprinted in the United States, Marvelman was rebranded "Miracleman." As for the character who started this whole chain, DC has given up the name Captain Marvel and rebranded him as Shazam.

MIRACLES INC.

"We've got a private club with unique personalities ... but we have no purpose, no goal to achieve!"

Created by:
Wally Wood

Debuted in:
Unearthly Spectaculars #2
(Harvey Comics,
December 1966)

Also known as:
Rent-a-Hero,
Lease-a-Lawman,
Vend-a-Vigilante

© 1966 Harvey Comics

THE "HERO FOR HIRE" motif is surprisingly popular in superhero lore. Costumed vigilantes have to get their money somewhere, so it's only natural for some caped crusaders to seek compensation for their efforts. Miracles Inc., a short-lived and light-hearted expedition into this idea, was initiated by comics legend Wally Wood. A veteran of EC Comics, with extensive experience in both science-fiction thrillers and satirical comedy, Wood had created the straight-laced superheroes known as the T.H.U.N.D.E.R. Agents. But for Miracles Inc., Wood embraced superhero camp in a lighter vein.

The Miracles Inc. heroes operated out of a nondescript house in the American Midwest, far from New York's multitude of high-class superhero HQs. Their leader: the mysterious Professor Who, an elderly and brilliant scientist.

The other members of Miracles Inc. include

MANLET, "The Mighty Mite," who stands no taller than a sparrow and subsists on a diet of birdseed.

MISFIT, a hep-talking hairy man-mountain ("Don't blow your cool, Prof!").

REFLEX, a wing-headed super-speedster who "delivers lightning justice!" In his debut, he's easily tripped up by an opponent who merely steps out of his path.

THERMO, "The Human Inferno," who uses his powers primarily to keep the coffee hot and the ice cubes cold.

UNA, "Queen of the Love Stare," and also the professor's daughter, whose focused glance "singes" her opponents with undying adoration. "Another love-struck victim," she crows after one battle, "I'm simply overwhelming."

KLANG, "The Brain and Brawn Robot," who unfortunately gets too caught up in performing complex mathematics to effectively fight crime.

Lastly, THE WIZARD, called a "Master of Sorcery," although he is portrayed only as a strategic genius and is assigned mop duty by his peers.

In their second appearance, the team is joined by two new members: SUPER-CHEF, the Crime-Fighting Gourmet, and KAPUT, the Prince of Jinx, whose "bad luck" energy causes the bad guys' plans to come apart. The team manages to attract the attention of the Institute of Infamy, consisting of the Gong, King Cactus, Chain-o-Rama, and a crook named Counter-Fit armed with gimmicked coins. A dramatic battle ends with Miracles Inc. reigning victorious, which seems like a fortuitous place to end their run.

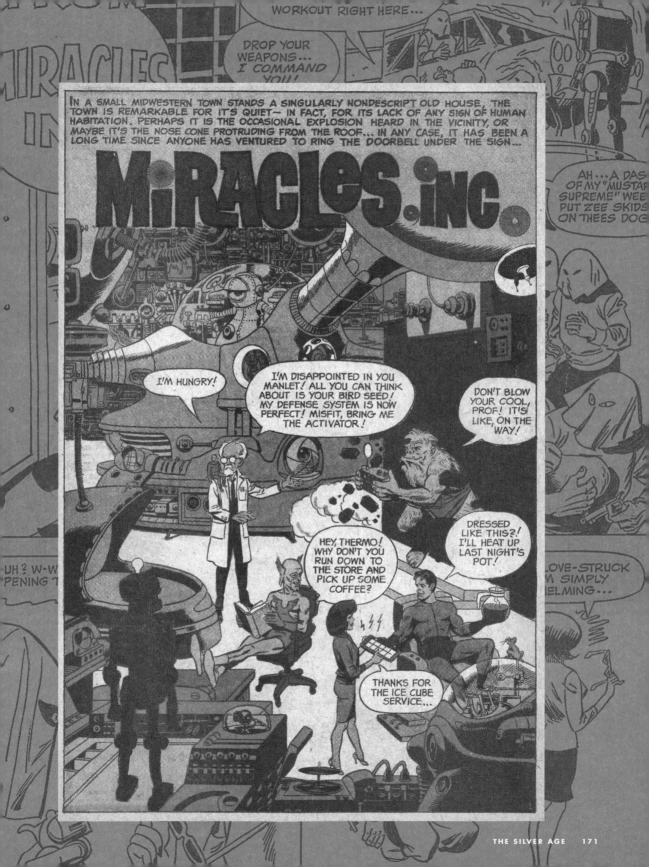

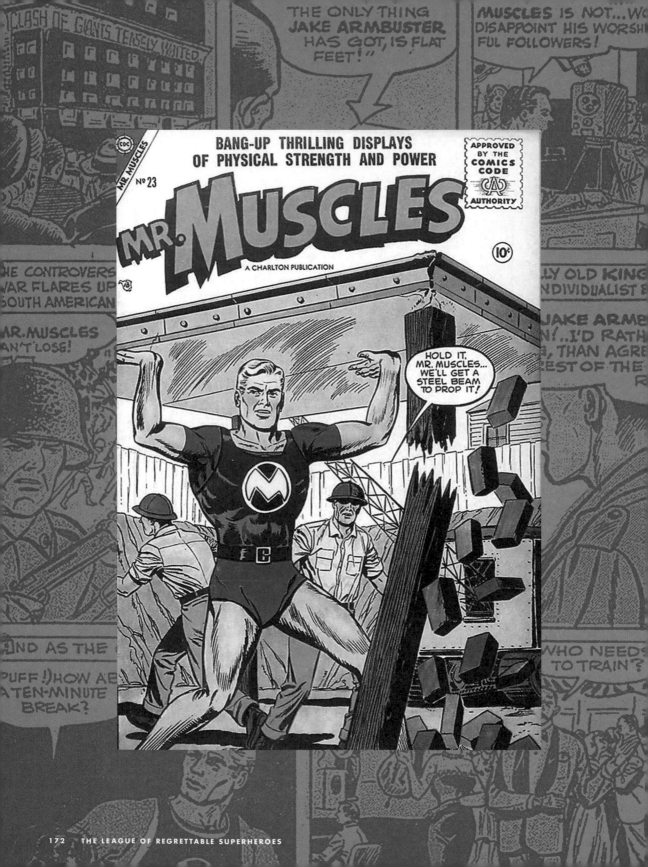

MR. MUSCLES

"Iron bars do not a prison make ...
particularly if you have muscle-power!"

THE **COVER TO HIS** debut appearance promises "Bang-up thrilling displays of physical strength and power," while inside the book, readers are offered a glimpse at "the world's mightiest man" and "the most perfect specimen of manhood alive," a.k.a. the "greatest crusader for clean living and justice the world has ever known!" It all sounds very exciting!

Mr. Muscles is a former weakling named Brett Carson, who, a few years before the beginning of the story, was suffering advanced stages of polio. Facing imminent paralysis, Brett dedicated himself to recovering his lost mobility. During the subsequent months of struggle, he slowly recovers in small, painful bursts—he moves his fingers, he is able to sit—while receiving consistent lack of encouragement from his doctors. After being told he'll never walk again, Brett proudly strolls out of the hospital, pledging to "achieve absolute perfection!"

That perfection takes the form of Mr. Muscles, Brett's costumed alter ego (although it's more of a nickname than an actual secret identity). As Mr. Muscles, Brett uses his tremendous physical strength and peak conditioning to foil criminals and generally save the day, in true superheroic fashion. Also in the old costumed crime-fighter tradition, Mr. Muscles picks up a couple of tagalongs. Miss Muscles is a female athlete who makes only one appearance, but she seems as famous for her physical perfection as is her male counterpart. There's also Kid Muscle, Mister Muscles's sidekick, a brash and energetic youngster who spends his spare time driving around wearing a wrestling singlet, apparently looking for trouble to quash.

Despite being a physical culture advocate first and a crime-fighter second, Mr. Muscles finds himself pitted against crooks and murderers with some frequency; among his foes are carnies, the Mob, a conniving wrestler named Jake Armbuster, a red-headed Abominable Snowman (portrayed as a giant, bearded man wearing an animal skin, with no explanation where he came from), and a mad zookeeper whose envy of Mr. Muscles's physique drives him to arrange a murder-by-tiger. When not thwarting crooks and murderers, Mr. Muscles indulges crowds with displays of his tremendous strength and endurance: doing one-handed headstand pushups, bending steel bars, and allowing folks to jump off a ladder onto his stomach while he's poised in a reverse crab, then catapulting them back up to the top of the ladder. We call that one a Number Three.

Obviously intended to promote the idea of physical fitness—extreme physical fitness, even—Mr. Muscles lacked the stamina to keep it up. Two issues was the super-bodybuilder's max rep before blowout. Mr. Muscles hasn't picked up a barbell since.

Created by:
Jerry Siegel

Debuted in:
Mr. Muscles #22
(Charlton Comics,
March 1956)

Issue oddity:
Mr. Muscles took over Charlton's *Blue Beetle* comic, replacing that hero's name in the title but keeping the numbering

© 1956 by
Charlton Comics

NATURE BOY
"Let 'er rip!"

Created by:
Jerry Siegel and
John Buscema

Debuted in:
Nature Boy #3
(Charlton Comics,
March 1956)

Issue oddity:
Nature Boy took
over the numbering
of fireman hero
Danny Blaze's title

© 1956 by
Charlton Comics

ERRY SIEGEL'S MOST FAMOUS creation (with artist Joe Shuster) was, of course, Superman. But he also created dozens of other, less popular superheroes, including the Star Spangled Kid and Stripesy, Robotman, Mr. Muscles (page 173), the Spectre ... and Nature Boy. The story of Nature Boy begins in a private plane tossed by terrible winds over a rocky sea. Inside, Myra Crandall snaps at her husband, Floyd: "You were out of your mind to take the baby and me along on a sky joyride, despite weather warnings!" "No time for recriminations," retorts her husband, as the plane nosedives into the tumultuous waves below.

Floyd and Myra are rescued by a passing fishing boat, but baby David is nowhere to be seen and is assumed drowned—that is, until he shows up unharmed at the front door of the Crandall family estate, only moments later, delivered on a gust of wind.

What happened in the interim? It seems that baby David's sinking form was intercepted by a council of gods who were hanging out underwater for no apparent reason. Taking pity on the poor infant, the deities adopt him as their own and then return him to his family home (evidently, *adoption* means something different to supernatural figureheads).

David grows up to become Nature Boy, a crusader for good entrusted with a fraction of the powers of his adopted godparents, only a few of whom are familiar to anyone who gave Edith Hamilton's *Mythology* a passing glance. There's the well-known Neptune, but also Gusto (god of the air), Fura (ruler of fire), Eartha (who, predictably enough, rules the earth), and then Allura, Azura, Electra, and Friga, who command the realms of love, sky, electricity, and cold. His title also featured the appearance of Nature Man—possibly Nature Boy as an adult—and Nature Girl, who protected the jungle by wielding the powers of gravity.

Unusual for a superhero, Nature Boy needed to appeal to his benefactors to deliver the tools to fight crime and injustice: lightning bolts (which he was able to ride), powerful winds, earthquakes, and so on. Pretty much the only power David seemed to have acquired on his own is the ability to change back and forth between his heroic and civilian identities, which he does in a flash (accompanied by his genuinely odd, if enthusiastic, exclamation, "Let 'er rip!"). He was, in short, one of the few superheroes who had to ask permission to use his powers!

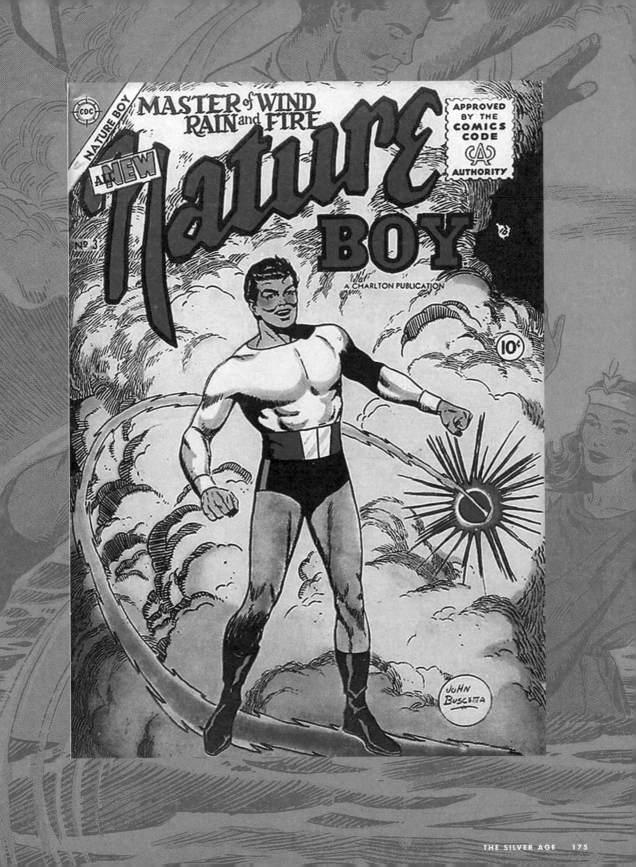

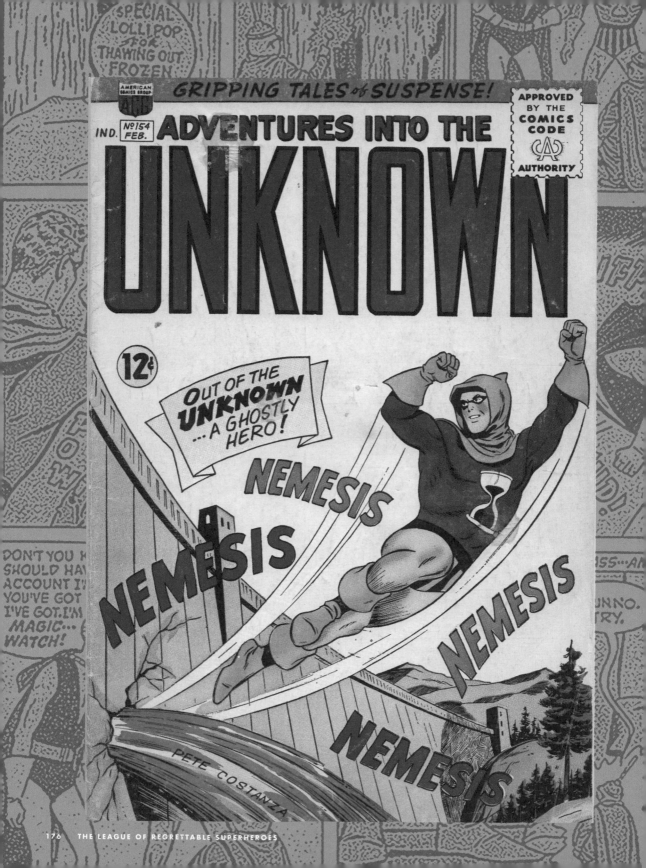

NEMESIS

"Make way for Nemesis!"

EFORE THEY CAN BEGIN their crime-fighting careers, some superheroes have to endure the most harrowing origin of all. First, they have to die! One of these postmortal paladins was Nemesis, formerly a police detective with the hardboiled name Steve Flint. While pursuing a murderous saboteur and mob boss named Goratti, Flint is run over by a train. End of story? No! Promptly dispatched to the afterlife, a green-tinted other-dimensional home of the dead called "The Unknown," Flint takes the opportunity of a backlogged admissions system to formally request that he be allowed to return to earth to avenge his own murder.

A newly hired Grim Reaper, himself a victim of Goratti's homicidal tendencies, not only allows Flint's request but outfits him with a costume designed to strike terror into the hearts of criminals: striped shorts and a T-shirt with a hood. Well, we did say Death was new at the job.

The freshly christened Nemesis does so well at his new calling—one-upping his own death by pushing Goratti into the path of a blazing rocket exhaust—that the Reaper allows him to retain his striped pants of office and continue defending the world of the living from murderers and crooks. In the tradition of the undead superhero, Nemesis is gifted with a series of powers so broadly defined as to render him omnipotent. Naturally, he can fly and possesses remarkable strength, and of course he could turn invisible and walk through walls, just like any other ghost. In addition, when necessary, Nemesis could also change his size, read minds, and travel through time.

All these powers came with limitations, however. Despite being dead, Nemesis still apparently had to breathe, and so he had to be wary of poison gas and drowning. More important, exposure to excessively strong illumination turned Nemesis into a powerless weakling, vulnerable to mortal weapons.

Life wasn't all duty and danger. Nemesis had a mortal earthly girlfriend, Lita Revelli Craig, although the Grim Reaper disapproved of the relationship (isn't that always the way?) and the couple had a tendency to argue (ditto). When taking time off from his duties, Nemesis retired to a high-rise apartment in one of the Unknown's swankier ZIP codes.

After a respectable few years battling evil on earth while balancing the ultimate in long-distance relationships, Nemesis hung up his hood for good. Presumably, he retired to the Unknown, where he is still waiting for his death certificate to be processed.

Created by:
Richard E. Hughes
(as "Zev Zimmer")
and Pete Costanza

Debuted in:
Adventures into the Unknown #154
(American Comics Group, February 1965)

Tailor:
Tim Burton, apparently

© 1965 by
American Comics Group

PEACEMAKER

"Nerve gas ... quicker than bullets ... and not as fatal!"

Created by:
Joe Gill and
Pat Boyette

Debuted in:
Fightin' 5 #40
(Charlton Comics,
November 1966)

Likely helmet inspirations:
A meatloaf pan,
a compost bin,
the Getty

© 1966 by
Charlton Comics

EACEMAKER WAS FAMOUSLY "the man who loves peace so much that he is willing to fight for it," or at least so the cover blurb on his first issue would have us believe. Arguably, that description applies to pretty much every superhero. What else are they fighting for, if not peace? Well, Peacemaker took the fight to a different level. For the most part, he didn't fight super-villains or rampaging monsters. His rogues' gallery was populated not by people but by nations.

Secretly Christopher Smith, a "peace envoy and diplomat," the Peacemaker is also a brilliant innovator of assorted nonlethal weaponry. Outfitted with a level of armaments one might normally associate with a small country, Smith wages a one-man war on would-be world conquerors, petty tyrants, and one of comics' rare Mad Doomsday Preppers.

Why does he do it? "Because man is civilized, governed by law," Smith explains, "but unfortunately there are madmen who will not obey those laws, and will not submit to the sanity of diplomacy!" To stay the hand of war and put down trouble-stirring dictators before innocent civilians suffer, the Peacemaker behaves like "an 'Action-Buffer' between these madmen and global war!"

Inspired by the example of his parents—his father was a soldier, statesman, and adventurer; his mother was a research scientist—Smith develops an array of varied skills, ranging from spear-fishing to engineering, and creates his own personal arsenal of un-deadly arms. He carried a gun with fired "medicated pellets" to stun his enemies insensate, plus knockout gas that could be fired "at supersonic speeds." His credo: end conflicts with nonviolent solutions (although he apparently didn't count "tremendous explosions" as violence).

Despite his lofty ambitions, the Peacemaker is remembered primarily for wearing a helmet that resembled a toilet seat. As a matter of fact, the helmet—and his entire costume—was packed with weaponry. The helmet held a laser and was impregnated with high explosives and a hidden fuse; his gloves became fire bombs when a secret vial sewn into them was crushed; the heels of his boots were densely packed plastic explosives; even his shirt was woven of highly flammable material. Basically, the Peacemaker was always an errant spark away from exploding into a million bits.

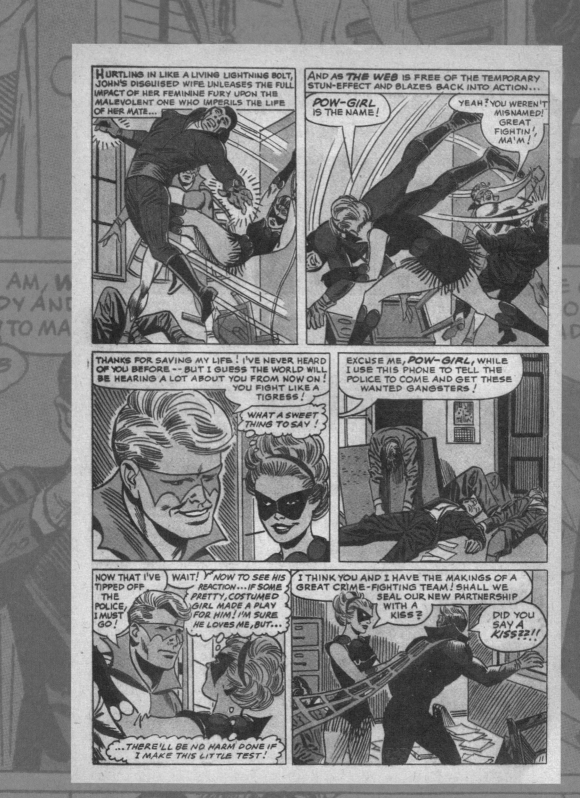

POW-GIRL

"I swore to stick to you, sweetie, till death do us part!"

OR THE MOST PART, costumed tagalongs come in a handful of common varieties: young ward, younger brother or sister, devoted girlfriend, even well-trained pet. But only Archie Comics' yellow-and-green hero known as the Web had his wife as a sidekick—and didn't even know it!

Dressing up in the Web's colorful costume, criminology professor John Raymond had a lengthy career as a crime fighter. Throughout the campy 1960s superhero revival, Raymond was hectored about his costumed career both by his wife, Rose—who dreaded seeing her beloved husband come to any harm—and by Rose's domineering mother, who was concerned that her daughter would be left a widow. Billed as "The Hen-Pecked Hero," the Web faced battles both on the streets and in the home.

Rose's concern for Raymond's safety grew so severe that she fabricated a costumed identity of her own to keep an eye on him. Taking gymnastics and martial arts classes on the sly, housewife Rose trained her body to a physical peak and created an alter ego. "Since my darling insists on taking crazy chances as The Web," she explains, "somebody's got to look after his safety! And that certain somebody will be . . . Pow-Girl!"

A refreshing element about Pow-Girl was that her creators resisted the temptation to give her "girl-themed" weapons, an unfortunate and patronizing staple of many female superheroes from the Golden Age through the 1960s camp revival. Instead of such accessories as weaponized powder puffs or titanium sewing needles, Pow-Girl got the job done with old-fashioned fisticuffs.

Pow-Girl makes only a single appearance in the comics, but she accomplishes a lot in just a little time. When the Web is overwhelmed by the combined onslaught of assorted nogoodniks, Pow-Girl swings in and saves the day. Comics being what they are, the Web is unable to detect Pow-Girl's true identity. Instead, he congratulates the unknown heroine on her successful debut. "I guess the world will be hearing a lot about you from now on," he tells the "stranger."

Rose returns home in advance of her heroic husband, who nonetheless is remanded to sleeping on the couch. "Strangely enough, I enjoyed being Pow-Girl," she notes after her sole adventure. "Could it be," she asks, "I'll continue in action in my secret identity?" The answer was that no, in fact, Pow-Girl would not continue; she disappeared after this debut. Presumably, the Web never tumbled to his wife's secret identity.

Created by:
Jerry Siegel and
Paul Reinman

Debuted in:
Mighty Comics #43
(Archie Comics,
February 1967)

Unused alternate identities:
Wonder Wife,
Mystery Mate,
Super Spouse

© 1967 by Archie Comics

THE SENTINELS

"Togetherness is for the birds, baby!"

Created by:
Gary Friedrich and
Sam Grainger

Debuted in:
Thunderbolt vol.
3, #54 (Charlton
Comics, October
1966)

**Current
whereabouts:**
Probably "on the
road" (get it?)

© 1966 by
Charlton Comics

MID ALL THE OTHER prominent crazes of the mid-1960s—the jet age, the space race, super-spies, and Batman-inspired high camp—the Sentinels hold the distinction of cornering the superhero market in the burgeoning counterculture beat movement. While other costumed crime-fighters held day jobs as scientists, reporters, and idle millionaires, the Sentinels were an up-and-coming trio of protest singers, a sort of superheroic Peter, Paul, and Mary.

As "The Protestors" performing such cheerful ditties as "The Doomsday Dirge" (sample lyric: "The doomsday dirge, the doubters we'll purge") and folksy jailhouse hits (daring censure with hard-hitting lyrics, like "Then I threw a pie in the Warden's face . . . "), the Sentinels' three members turned a typical comic book convention on its head. In their civilian identities, they wore domino masks as part of their musical gimmick, like a really toned-down KISS.

The Sentinels may also be the only superhero team to gain powers from their landlord. The elderly "Mr. Jones" (actually "Kolotov"), secretly a brilliant Russian scientist who fled the Soviets, hands his young lodgers super-scientific outfits that give them amazing powers. Front man Rick Strong becomes the high-flying Helios, lovely Cindy Carson becomes the telepathic Mentalia, and big lug "Crunch" Wilson becomes the hard-hitting Brute.

The Sentinels spend as much time arguing among themselves as they do fighting evil. And though their benefactor's deathbed remit was to battle the spread of communism, they spend most of their energy tackling a hooded world-beater named Mind-Bender and his android assistant, the Titan. Frankly, it's probably for the best that they limited their opposition to smaller targets because they weren't particularly good at superhero-ing. At one point, Helios takes a bump on the head that renders him a confused amnesiac for a full third of the Sentinels' few adventures together.

The most unfortunate aspect of the Sentinels, though, is that the beatnik gimmick isn't followed through. All three have fame and fortune on their mind, they hate communism, and they're downright deferential to authority figures. What kind of protestors are these? As the band sings:

> *Got me a great big explodin' bomb*
> *Fixin' to drop it on Viet Nam*
> *But I lost my way and instead*
> *I dropped it on my uncle's head!*

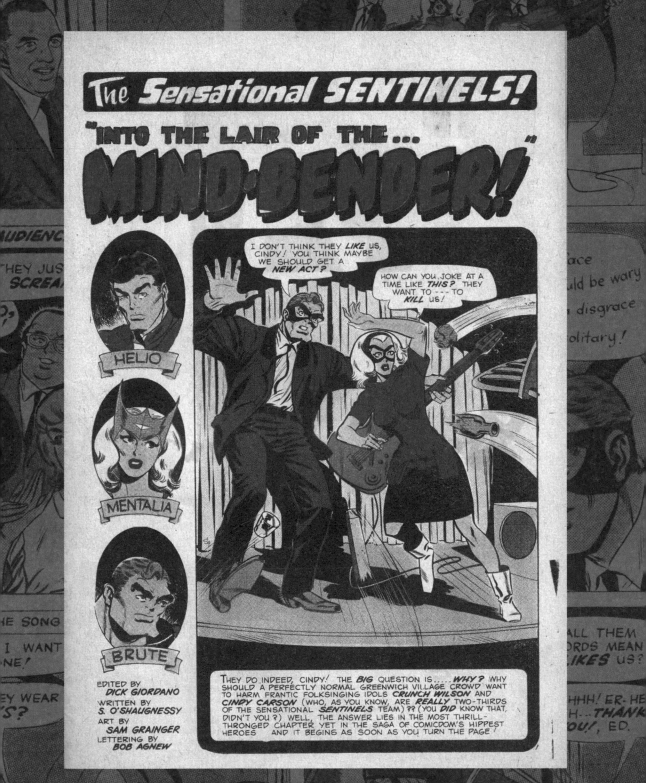

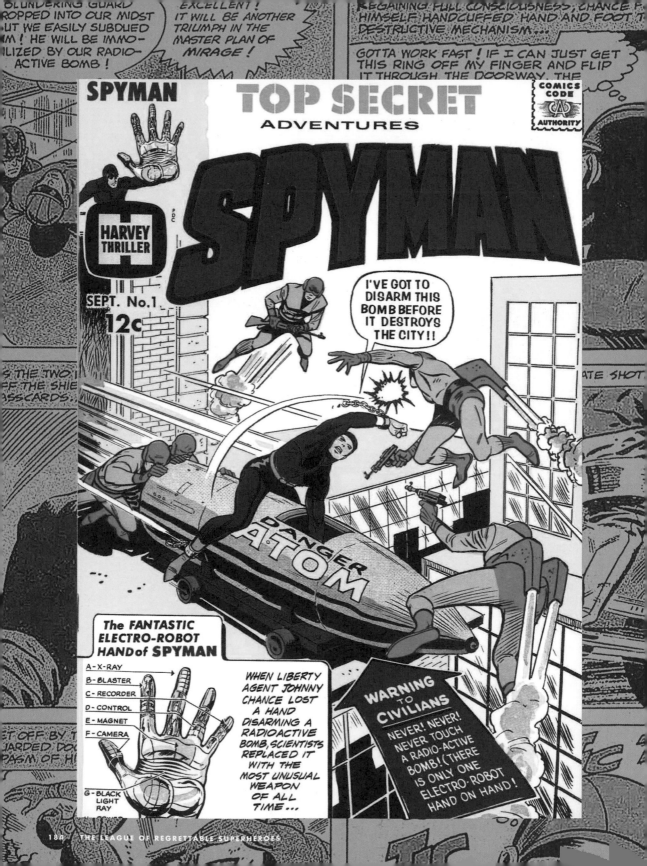

SPYMAN

"Maybe I can't fire a lightning bolt but ... what's to keep me from making like Gorgeous George!"

JAMES BOND MAY HAVE been the secret agent with all the best gadgets, but this comic book counterespionage counterpart had him beat in terms of convenience. Spyman carried his entire arsenal of slick spy goodies in his *artificial robot hand*!

Spyman is secretly Johnny Chance, agent of the American counterintelligence organization known only as LIBERTY (an acronym so secret that not even the reader is told what it stands for). Disarming a nuclear bomb set by enemy agents, our man Chance manages to save thousands of lives by removing the bomb's radioactive core, but at the cost of his left hand.

In a fantastic stroke of luck, the radioactivity that destroyed his hand altered his cellular structure, allowing miracle surgery that would otherwise fail. The result: Agent Chance wakes up with a cybernetic left hand, which is packed with gadgets and deadly weapons. Imagine!

Spyman's cybernetic "Electro Robot Hand" contains pretty much everything a jet-age super-spy might need. Diagrams in every issue of his comic outline the specifics. There's an X-Ray probe, a recording device, and an "electro-blast unit"; one finger is capable of emitting "the black ray," an all-obscuring beam of pure darkness. And if one of the Electro Robot Hand's built-in fingers doesn't do the trick, he can swap in a new one. "The pouches on this belt hold spare fingers" explains Spyman's fellow agent Dr. Vane, describing the world's most unsettling fashion accessory.

As secret spy organizations go, LIBERTY doesn't invest all that heavily in secrecy. For one thing, it maintains its headquarters inside the Statue of Liberty, where, one would imagine, tourists might notice all the helicopters flying in and out of the torch. And for another thing, the official LIBERTY agent uniform—Spyman's included—is a skintight bright-red bodysuit that would stand out even on the streets of New York City.

Still, Spyman and his pals at LIBERTY manage to defeat weird villains like the ID Machine, Cyclops, and the Whisperer as well as evil organizations like the Evil Eye Society and MIRAGE (possibly the only group in the world to use a reverse acronym: the Empire of Guerilla Assassination, Revenge, and International Menace).

Despite featuring some of the very first comic book art from comics legend Jim Steranko, Spyman and his Electro Robot Hand failed to grab a significant fan following. After three appearances, he folded up his bright-red jumpsuit, packed away his extra fingers, and left for parts unknown. Possibly, he's trying his hand at a less conspicuous career.

Created by:
Joe Simon and Jim Steranko

Debuted in:
Spyman #1
(Harvey Comics,
September 1966)

Additional secret agent gadgets:
Spare house key, can opener, dog whistle

© 1966 by Harvey Comics

ULTRA THE MULTI-ALIEN
"I've somehow become a weird alien — four of them!"

Created by:
Dave Wood and
Lee Elias

Debuted in:
Mystery in Space
#103 (DC Comics,
November 1965)

Favorite band:
The Four Tops

© 1965 by DC Comics

N THE MID-1960s, the space race between the United States and the Soviet Union was very much on the minds of, well, everyone. *Sputnik*, Yuri Gagarin, and space dog Laika were practically ancient history. The moon landing was still half a decade away. And so the two great superpowers were competing to rack up as many interstellar "firsts" as possible and come out on top.

It only makes sense that superheroes would make a race for space as well. Notable crime busters who frequented DC's comics of the era included the Flash Gorden-esque Adam Strange, space adventurers the Star Rovers, futuristic mystery man Space Ranger, space detective Star Hawkins, and space cabbie Space Cabbie (yes, outer space was so intriguing that even the cab drivers led interesting lives). But the weirdest of all was Ultra, the Multi-Alien.

Capturing the jet age appeal of the daring test pilot, Ultra's alter ego was the unlikely named Ace Arn, a space flyer from the not-too-distant future whose rocket crash-lands on a strange alien world. Ace then stumbles across four otherworldly criminals in the middle of an arms deal and becomes a simultaneous victim of the questionable quartet's strange ray guns. See, their brand of gun was designed to transform the target into an obedient member of the shooter's alien species. How convenient.

Struck by all four at once, Ace is transformed into four aliens in one, with each quarter of his body differently transmuted. His left leg becomes a blazing lightning bolt possessed of electric powers; his right leg, a feathered talon that grants him the power of flight. The right side of his upper body, along with his head, becomes a shaggy mass of powerful green muscles, and his hairless blue left side is now possessed of tremendous magnetic powers.

Alien abilities notwithstanding, Ultra resembles a mixed-up box of puzzle pieces. Likewise, he assembled his superheroic pseudonym by making an acronym of his assailants' home planets: Ulla, Laroo, Traga, and Ragan (sticklers will want to know that the final "A" is taken from Ace Arn's own initials). The newly dubbed "Ultra" turned tragedy into opportunity by using his tremendous powers as a scourge against intergalactic crime.

Well, for a little while, anyway. After eight issues, the comic in which his story unfolded was canceled, and Ultra was retired. The Multi-Alien is occasionally revived at parent company DC, albeit—indignity heaped upon indignity— usually as the butt of a joke.

PART THREE

THE MODERN AGE
1970–PRESENT

AS THE 1970S DAWNED, SUPERHEROES HAD begun to emerge from their adolescence and were ready to grow up. Where it had once been sufficient for a caped crime-fighter to keep his do-goodery confined to super-villains and the occasional agent of an enemy nation, superheroes increasingly found themselves directly addressing problems related to social issues. Drug abuse, civil rights, and profound existential dilemmas became as much the purview of the genre as radioactive eyebeams and bulletproof skin.

As the stories grew more serious, the violence levels ramped up as well, and superheroes of the 1980s onward were often part of a "grim and gritty" universe. An entire decade-plus of furious, bloodthirsty, and heavily armored heroes became the norm, a legacy that lingers today. On the positive side, the independent comics scene has flourished. More sophisticated storytelling, including such high-profile critical successes as Alan Moore and Dave Gibbons's *Watchmen*, encouraged a new generation of innovative writers and artists to invent some of the most fascinating, thoughtful, well-crafted superhero tales ever produced. We won't be talking about them, though. . . .

NOTE: Comic book historians often subdivide this period into a Bronze Age that begins with the socially relevant stories of the mid-1970s, followed by a Modern Age that starts with the grimmer tales of the mid-1980s.

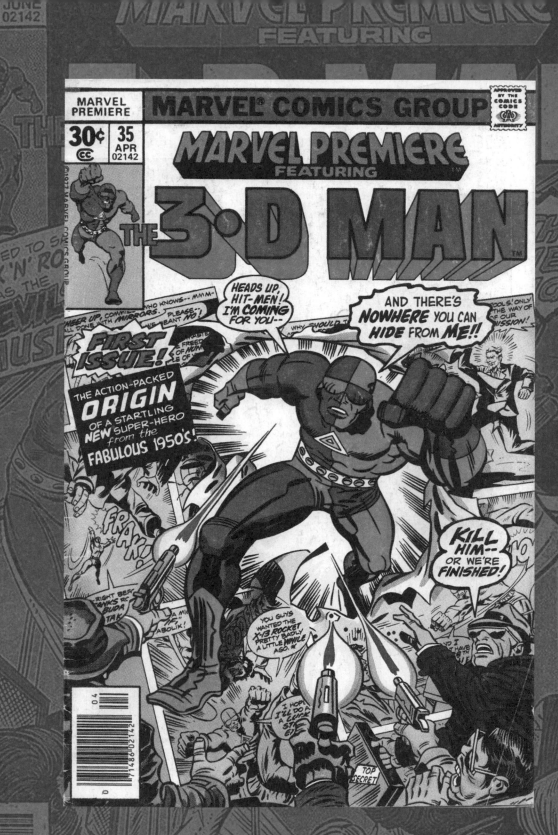

3-D MAN

"All right, Reds! Don't try anything stupid, and you won't get hurt!"

ARVEL COMICS SPENT THE 1970s experimenting with pretty much every fad and movement the decade had to offer. Over the course of what author Tom Wolfe called "The ME Decade," Marvel debuted heroes and villains based on roller disco, hippies, Hell's Angels, women's lib, celebrity stuntmen, kung-fu, and blaxploitation films, even throwing in a generous helping of occultism spiced with a soupçon of devil worship (see Son of Satan, page 243). With the red-and-green-clad 3-D Man, they tapped the most potent fad of all: nostalgia.

Although he debuted in the late 1970s, 3-D Man was a superhero set in the 1950s, complete with sock hops, *Sputniks*, and then-vice president Richard M. Nixon. Cocreator Roy Thomas has dedicated much of his career to reviving forgotten superheroes of the Golden Age of comics for the benefit of modern audiences. For 3-D Man, Thomas invented a new character of whole cloth, but one that was informed exclusively by events from twenty years prior. In his debut issue, 3-D Man manages to drop references to the Korean War, the Soviet invasion of Hungary, Jonas Salk, Johnny Unitas, the comic strip "Pogo," comedian George Gobel, "The Wild One," Roger Bannister's record-breaking four-minute mile, Fats Domino, Howdy Doody, and "Your Hit Parade," a then-popular Top 40 radio program. Whew!

Confusingly, perhaps, 3-D Man was in fact two men: polio-stricken Hal Chandler and his brother Chuck, a college football star turned dashing test pilot. When Chuck's flight in the experimental *XF-13* is interrupted by a flying saucer full of invading aliens, he's bathed in a weird energy that explosively transforms him into 3D-movie-style novelty eyeglasses, complete with his static afterimage burned onto the lenses. Chuck can live again only when Hal puts on the glasses, brings his brother's red and green images into focus, and then politely passes out as the dynamic 3-D Man takes over.

As they say, three is a magic number (even if you're a combination of two people). The Christmas-colored crime-buster possesses three times the strength, speed, and endurance of a normal human, but he can remain in his three-dimensional state for only three hours.

Although the character was eventually brought into modern-day Marvel comics, most of 3-D Man's published exploits center on his abbreviated career in the 1950s, when he fought such era-specific menaces as the Soviet spies of the deadly Diabolik, a temperature-manipulating villain subtly dubbed "Cold Warrior," and evil shape-changing aliens masquerading as Dick Clark and President Nixon.

Created by:
Roy Thomas
and Jim Craig

Debuted in:
Marvel Premiere #35
(Marvel Comics,
April 1977)

Hobbies:
Hula-hooping
to doo-wop
while wearing a
coonskin cap

© 1977 by Marvel Comics

AAU SHUPERSTAR

"My shupernatural powers tell me there's trouble afoot now!"

Created by:
Unknown

Debuted in:
Assorted titles, 1977

Shoe size:
Kept a secret to
protect his loved
ones

© 1977 by International
Seaway Trading Corp.

WHO'S THE FELLA IN the tracksuit who gets a kick out of giving bad guys the boot? Who's the sporty guy with the shoes who give villains the blues? Why, it's the world's foremost footwear-based crime-fighter, AAU Shuperstar!

Appearing in a trio of ads that graced the back covers of more than a few comics in the late 1970s, AAU Shuperstar was a shoe-themed superhero who defended humankind from the evils of sinister shoe-themed villains. Despite his brief time in the spotlight, he remains an ironic cultural touchstone for an entire generation of comic book readers.

Full-page ads designed to resemble comic book pages were not in short supply in the '70s. Most famously, Hostess Brands recruited major superheroes from DC and Marvel—as well as characters like Richie Rich, Casper, and assorted members of the Archie Comics cadre—to celebrate the company's sugary pastries and cakes. Not only for their flavor, but for their effectiveness against supervillains. Lots of snacks might have a sweet chocolaty taste, but how many can be used to foil the Penguin?

The makers of AAU athletic shoes went this trend one better by creating AAU Shuperstar, their own pun-happy, fleet-footed super-shill. Battling foes like the Dirty Sneaker, the skull-faced and horn-headed Sinister Sole, and the world-conquering Missile-Toe (whose boots fired missiles filled with "Toe-Main Poison"), AAU Shuperstar fought back with a combination of wordplay and fast footwork. Shoe-based puns raised the ads to the level of memorable high camp.

"The jig is up, Missile-Toe, and so is the jog," the Shuperstar declares, knocking out his foe with a well-placed kick. "In my AAU shoes I can run all the heels out of the world!" Chasing down the Sinister Sole, Shuperstar declares, "Hold your tongue," prompting the defeated foe to moan, "I'm a toe-tal failure." Facing down the Dirty Sneaker at a disco dance contest, Shuperstar admonishes his foe that "this boogie contest isn't open to boogey men!" Pretty good repartee for such a straight-laced guy.

What powers AAU Shuperstar possessed were something of a mystery. Evidently, he's super-strong, capable of kicking the Dirty Sneaker out of the earth's atmosphere, for example. Otherwise, the canvas-shod crime-fighter relies on his "Shupernatural" powers, all engineered to promote the performance of AAU shoes: running quickly, jumping nimbly, deflecting deadly missiles, and, most important, repeatedly kicking bad guys in the face.

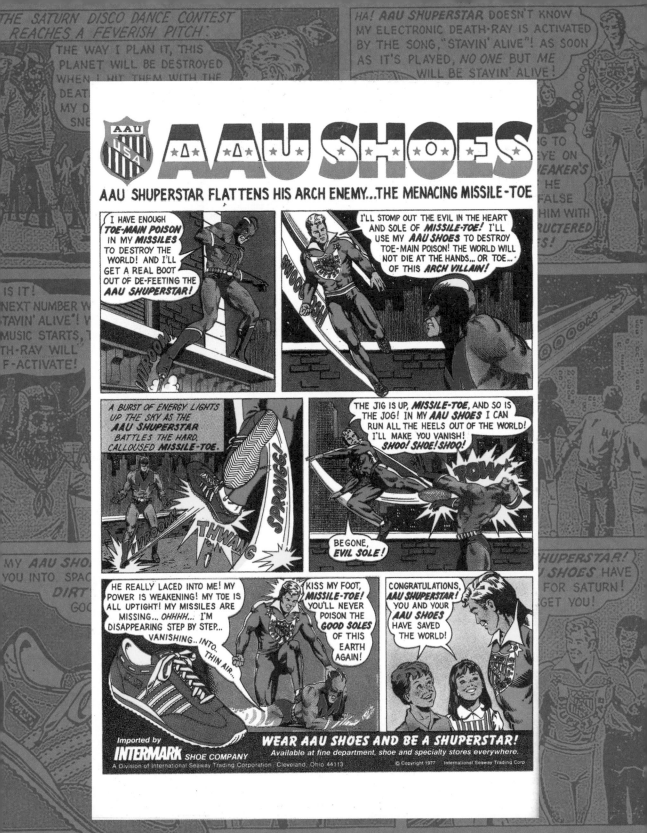

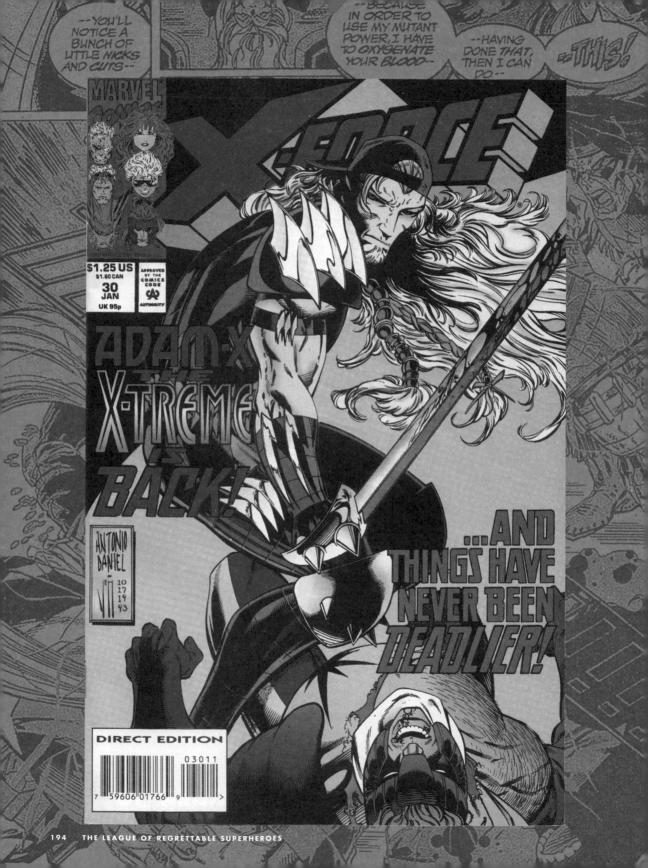

ADAM-X—THE X-TREME
"Burn!"

AS FAR AS THE world of comics is concerned, in the 1990s everything became extreme. Until then, the typical superhero could get by with a flashy set of superpowers, a bright costume, and a clear ethical code. But the twentieth century's last decade or so put a radical, outrageous, Cool Ranch–flavored spin on comics characters, adding blades, goatees, overcoats, amorality, and attitude to everyone and everything.

Enter Adam X, "The X-Treme," as radical as a pair of surf pants kicking a rad ollie on a skateboard. He's the most 1990s-est superhero ever produced by the House of Ideas—and that's saying a lot, considering that Marvel Comics all but created the trend in the first place. In 1990, the company introduced Cable, a tough-as-nails telekinetic mutant cyborg commando from a postapocalyptic future, effectively launching the decade's fascination with big guns, padded armor, and characters with tiny, tiny feet. When Cable's cocreator Rob Liefeld and others left Marvel to help found rival Image Comics, the elder company suddenly found itself needing to play catchup. Marvel had no choice but to try a few of its own hard-hitting, unforgiving, and willing-to-kill characters.

Adam-X was the apotheosis of the idea: a half-alien, half-mutant rebel from space, whose culture wasn't so foreign that it hadn't developed the backward baseball cap as a fashion statement. Also affixing Adam-X to his decade was a leonine mullet and a robust "soul patch" branding his chin. But mostly he was all about the edge; indeed, Adam-X's distinctive costume was festooned with cutting blades. Seriously, they were protruding from his shoulders, lining the outside of his gloves, sticking out from his hands, strapped around his arms and thighs, arranged in a ring around his belt, and jutting out from his kneepads. The guy was a one-man knife shop, and that isn't even counting his "Thet'je" blades, enormous double-bladed hooks he wielded with both hands. If Wolverine was cool because he had claws, then Adam-X was surely ten times as awesome!

Of course, a reasonable explanation for his knifery does exist: his mutant power relied on cutting his opponents. Adam-X possessed the unsettling ability to ignite the blood from any open wound on mental command, literally causing his opponent's blood to boil. Radical, indeed!

As the decade died down, so, too, did readers' collective fascination with heavily armed, heavily bladed superheroes clad in black leather. With little to support the character except his seemingly by-the-numbers adherence to the zeitgeist, Adam-X bowed out in quiet, and truly unradical, fashion.

Created by:
Fabian Nicieza and Tony Daniel

Debuted in:
X-Force Annual #2 (Marvel Comics, October 1993)

Alternate unused identities:
Ricky X the R-X-dical, Artie X the A-X-esome

© 1993 by Marvel Comics

BROTHER VOODOO

"Shed one drop of that child's blood— and I will surely destroy you!"

Created by:
Len Wein and
Gene Colan

Debuted in:
Strange Tales #169
(Marvel Comics,
September 1973)

Also known as:
Lord of the Loa,
He-Who-Has-Died-
Twice, Houngan
Supreme

© 1973 by Marvel Comics

THE COVER BLURB ON Brother Voodoo's debut appearance announced, "The Senses-Staggering Super-Hero Who Died—Yet Lives Again!" Brother Voodoo popped up at a time when death was more of a rarity in comics than it is today. The Comics Code Authority (the industry's once-powerful self-censoring group) had put strict limitations on the amount of straight-up morbidity comics could embrace. "Death" was one of the Authority's bugaboos, as was voodoo and, more specifically, "zombies." But the 1970s saw a waning of the CCA's influence. Code or no code, a voodoo superhero was practically an inevitability, given how quickly various werewolves, vampires, and Frankensteins were being grabbed up for other titles.

The hero known as Brother Voodoo is Jericho Drumm, a Haitian-born psychologist living and working in New York City; at the beginning of the story, he's utterly disinterested in mysticism and the supernatural. But when a novitiate of the serpent god Damballah murders his brother Daniel—the original Brother Voodoo—Jericho is summoned back to Port-au-Prince to take his place.

In lieu of repeating his brother's arduous training in the mysteries of voodoo, Jericho is magically saddled with Daniel's spirit in a sort-of Cliff's Notes method of acquiring mastery of the mystic arts—and mastery he gets! Brother Voodoo has access to just about any power under the sun. He can impart inorganic objects with life, heal injuries and illnesses, and transport himself instantaneously across distances—and that's just for starters. He also boasts a ghostly sidekick in the form of his departed brother. More unusual than that, Brother Voodoo is the exceptionally rare Afro-Caribbean hero, of which there can't be more than a half dozen in the history of American comics.

Unfortunately, what makes a superhero unique at first can become repetitive in time. After his debut, Brother Voodoo seemed locked into a cycle. With no title to call his own, he made only guest appearances in other heroes' books when voodoo-related menaces reared their ugly heads. Since no one ever thought to call on Brother Voodoo to help fight Magneto or Doctor Doom, his only chance to shine was in the rare instance of a Caribbean zombie cult causing trouble. In the end, this once-unique hero was reduced to a rarely seen cliché.

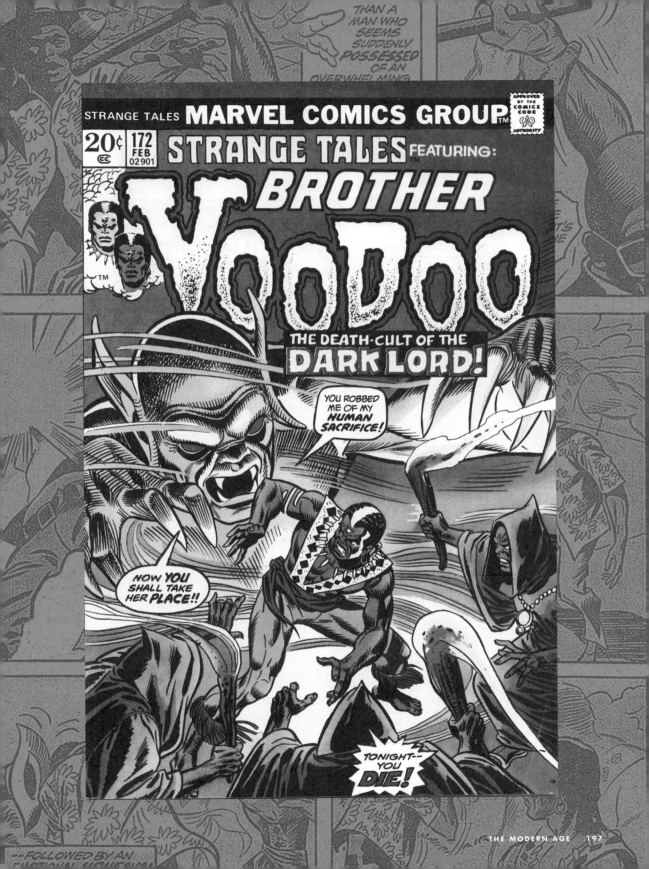

CAPTAIN ULTRA

"You don't like my costume? I designed it myself—and I like color."

QUITTING SMOKING OFFERS QUITE a few health benefits, but former plumber Griffin Gogol seems to have stumbled on the most amazing one of all: the acquisition of superpowers!

When one of Gogol's clients can't afford to pay his plumbing bill, the elderly gentleman (a hypnotist by trade) offers a free round of hypnotherapy in exchange for services rendered. The chain-smoking Gogol agrees in a bid to end his nicotine habit. What the hypnotist neglects to inform him is that he's not just any run-of-the-mill mesmerist—he's a camouflaged space alien. Moreover, he doesn't just cure Gogol of his smoking habit, he unlocks his patient's "Ultra-Potential"!

Finding himself suddenly superpowered, the soon-to-be Captain Ultra discovers he's able to fly and move at breakneck speeds; he's also super-strong, invulnerable to damage, can pass through solid matter, and is able to see through walls. And that's only the start. With his "Ultra-Potential" unleashed, he's capable of all sorts of amazing physical and mental feats.

Immensely powerful, Captain Ultra nonetheless lacks direction. Not sure what to do with his abilities but eager to use them, he creates the most garish costume imaginable and tries out for a team of villains being organized to battle the Fantastic Four. During his audition, the Captain learns of his single yet devastating weakness: his hypnosis session imbued him with a crippling fear of fire. That's quite a setback for someone expected to fight the Human Torch.

Switching sides, Captain Ultra next attempted to join Marvel's second-tier super-team, the Defenders. He answers an open call for admission alongside a few dozen other heroes, but the tryout ultimately doesn't pan out (for any of them).

Despite his tremendous power, Captain Ultra is primarily a background character in the Marvel universe. Typically dragged out only when an otherwise straightforward superhero story needs a power-packed punch line, Ultra has maintained a career primarily as an upright defender of justice (although he's found himself fighting the good guys on a few occasions). Luckily, he's in a position where getting laughs is a good thing—Captain Ultra retired from professional plumbing and shifted careers to stand-up comedy. As a comic, C.U. has defended the world against the menace of Ekl'r, the Demon without Humor, and used his "ultra-potential" to bring down the house with an "Ultra-Joke."

Created by:
Roy Thomas,
George Perez,
Joe Sinnott

Debuted in:
Fantastic Four
vol. 1, #177
(Marvel Comics,
December 1976)

Possible disabilities:
Might be color-blind

© 1976 by Marvel Comics

CAPTAIN VICTORY

"What we're looking at may be a serious breach of galactic law!"

Created by:
Jack Kirby

Debuted in:
Captain Victory and the Galactic Rangers #1 (Pacific Comics, November 1981)

Occupation:
Soldier, peace officer, scion of a dark overlord

© 1981 by Jack Kirby

ACK "KING" KIRBY IS arguably the most influential and important American comics creator in the history of the medium. Over the course of six decades, Kirby was responsible for cocreating the lion's share of the industry's most famous superheroes, from Captain America, the X-Men, and the Fantastic Four to the multitude of characters involved in his legendary Fourth World. Many of Kirby's creations were the work of partnerships with writers such as Joe Simon and Stan Lee, or were developed under strict editorial oversight. Kirby, for all his limitless creativity, craft, and enthusiasm for the medium, was rarely allowed to let his imagination run wild. Until Captain Victory.

Recently founded comics publisher Pacific Comics approached Kirby with a tantalizing opportunity: full creative control and full ownership of his creation. Dusting off a decade-old concept, Kirby helped launch the fledgling company's publishing arm with *Captain Victory and the Galactic Rangers*.

As the first truly unfettered creation from Kirby's catalog, Captain Victory contained all the hallmarks of the King's fervent imagination. "Forces from the star worlds clash on Earth!" cried the cover blurb. Inside, a multispecies team of alien peacekeepers tackled the menace of "The Insectons," a race of humanoid bugs that devastated entire worlds. Launching "Micro-Troops," the "Energy Rip-Off," and an armored "Spirit Brother" (summoned forth by "Cyclotronic Conversion," of course) to battle the menace of the terrifying Lightning Lady, the Rangers also find themselves confronting such menaces as the Goozlebobber and the dreaded Paranex, a.k.a. the Fighting Fetus.

At the center of it all stands the stern, intensely focused Captain Victory, aided by a cadre of strange but noble allies and the comical but supremely intelligent, egg-shaped "Mister Mind." In the last few issues, the Captain relates his beginnings to the crew, revealing to the attentive reader a strangely familiar upbringing. Although some characters' names have been changed or omitted, it's clear that Captain Victory is intended to be the hero Orion from Kirby's unfinished multibook "Fourth World Saga." Which makes the Captain's grandfather the universe-conquering, ultimate evil baddie Darkseid.

The original run of Captain Victory ended after a little more than a dozen issues, but efforts have been made to revisit the character. Unfortunately, since Kirby passed away in 1994, these attempts are devoid of the King's unique touch.

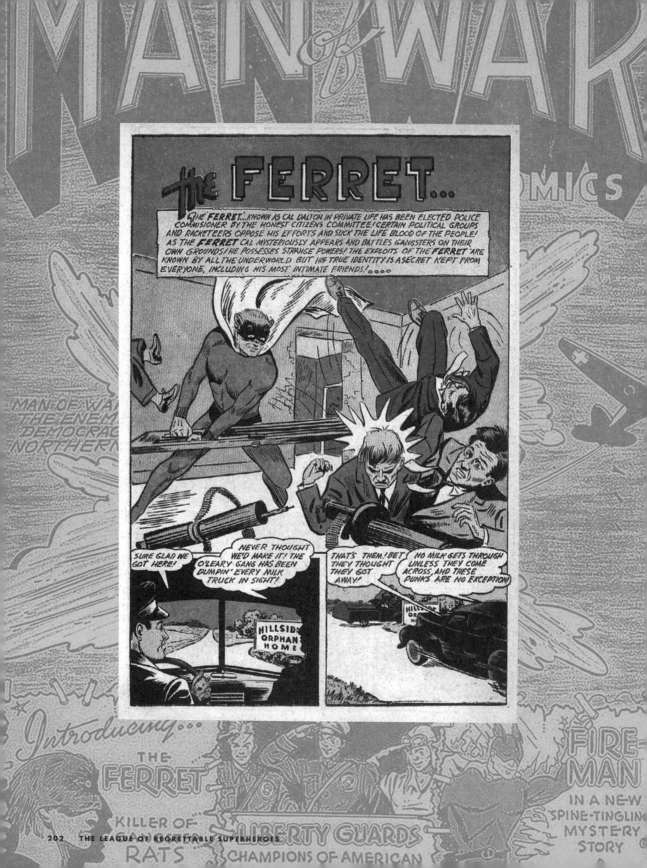

THE FERRET

"A rat will never get The Ferret!"

HIS NAME MAY NOT be particularly intimidating, but the very least you can say about the Ferret is that he has longevity on his side. Debuting in the Golden Age, the original Ferret bowed out after a single appearance but found a second life as a clawed vigilante in the 1990s.

In his sole appearance in the early 1940s, the Ferret is secretly the police commissioner Cal Dalton. Possessing "strange powers"—including unexplained (and un-ferret-like) super-strength and the ability to fly—Dalton resolves to take the fight against racketeers and gangsters to their own doorstep. Decked out in blue tights, a yellow cape, and a furry tan cowl designed to resemble a ferret's head, the fuzzy-topped hero cuts a unique though short-lived figure.

Flash-forward to 1992, when Malibu Comics took advantage of the then-recently lapsed copyright on more than a dozen comic book superheroes. Alongside other obscure Golden Age characters like Man of War, Airman, the Fantom of the Fair, and Amazing-Man (page 15), the Ferret was revived to become part of the new decade's stock of grim, gritty, bloodthirsty characters.

The Ferret's blue-and-yellow tights were replaced with a green-and-orange ensemble, but he kept at least a hint of his old polecat-like cap: a luxurious blonde mullet, arguably the most impressive example of the hairstyle ever displayed in comics. Gone also was the Ferret's power of flight, although he kept his super-strength and gained a few new abilities as well. Likely inspired by the popularity of the mutant superhero Wolverine, the Ferret now possessed a wide array of enhanced, animal-like senses, not to mention vicious claws attached to his gloves.

Plus, he had a bad attitude. Now a former police commissioner—he left his post amid charges of police brutality—the slightly re-monikered Cal Denton makes his living as a musician. Like the claw-popping mutant superhero who inspired his redesign, the new Ferret spends a fair amount of time fighting ninjas and secret government-engineered super-villains while struggling against his own innate desire to throw off the restrictions of "good guy" behavior. With super-strength, sharp claws, and animal instincts on his side, the updated Ferret was as likely to kill or maim foes as he was to leave them lying around until the police arrived.

The revamped Ferret managed to craft a relatively lengthy career as both a member of the Protectors and a solo hero before Malibu Comics closed down the line completely. A second revival seems unlikely. When Malibu shut down the →

Created by:
Unknown (original);
R. A. Jones and
Tom Derenick
(revival)

Debuted in:
Man of War
#2 (Centaur
Publications,
January 1942)

**Not to be
confused with:**
Wolverine, although
clearly someone
wanted you to

© 1942 by
Centaur Publications

Protectors and all related titles, they chose to go out with a bang: a final confrontation between heroes and villains that led to the opening of an interdimensional portal, completely destroying the earth in one climactic explosion.

EDITOR'S NOTE...

In the 1990s, "gimmick covers" were a hot collectible commodity, with many comics tricked out with embossing, foil stamping, holograms, and glow-in-the-dark effects. The Ferret holds the distinction of having starred in an issue that was die-cut to fit the shape of his face.

GUNFIRE

"You gorillas can stuff those cannons sideways!"

Created by:
Len Wein and
Steve Erwin

Debuted in:
Deathstroke Annual
#2 (DC Comics,
October 1993)

Caliber:
Low

© 1993 by DC Comics

N THE EARLY 1990S, a new wave of comic book heroes arrived on the scene. Until this time, superheroes published by DC Comics had earned a reputation, justified or not, as being the squeaky-clean heroes. Marvel's were seen to be more like "regular people." But the new breed of superheroes emerging from Image Comics was considered cutting edge. Compared to Image's hardcore, often vicious, and generally lethal breed of heroes—typically with names beginning and/or ending with "Blood," "Kill," and "Death"—DC's characters seemed at least thirty years past their heyday.

In response came "Bloodlines," a story arc that crossed dozens of DC titles and dramatically increased the company's roster with a few dozen new, grim, edgy, and bloodthirsty heroes. Heroes like Gunfire. Along with his fellow "New Blood" heroes, Gunfire was the victim of an attack by giant alien parasites who fed on the spinal fluid of human beings. A small percentage of the parasites' victims not only survived the experience but also developed superpowers thanks to some X-factor in their genetic makeup. Each emerged with a different ability. In Gunfire's case, that power was simultaneously deadly and absurd: anything in his hands becomes a gun. Whether a block of wood, a coffee mug, a stapler, a toilet seat lid . . . whatever Gunfire gets his hands on transforms itself into a firearm that, incidentally, shoots concussive force beams rather than bullets.

Gunfire was a short-lived and awkward concept, but he wasn't alone. His Bloodlines peers included Anima, a magical grunge rocker; Mongrel, a young half Vietnamese, half African American who possessed something called a "darkforce"; a rampaging, Hulk-like man-monster named Loose Cannon; Loria and Razorsharp, superheroines who could turn themselves into some form of "living metal"; and Geist the Twilight Man, a hero who was invisible except when immersed in absolute darkness (but everyone's invisible in the dark, aren't they?). These newborn heroes all had "radical" names like Jamm, Hook, Ballistic, Nightblade, and Shadowstryke. Naturally, Gunfire had an opposite number named Ricochet. Other foes included Purge, Maraud, Ragnarok, and—the most ill-conceived pseudonym of them all—Blow-Out.

Gunfire ended up a casualty in one of those all-out superhero/supervillain brawls that seem to be a constant in comics. In a distinctly satirical follow-up story, an inheritor of Gunfire's superpowers accidentally converts his own posterior into a live grenade and blows himself to pieces.

THE AMAZING ADVENTURES OF HOLOMAN

HOLO-MAN

"Those poor tourists look like they've just seen a ghost! Better concentrate and ... become ... invisible?!!"

CIENCE-BASED SUPERHEROES ARE nothing new, but the creators of Holo-Man threw pretty much every high-tech gimmick they could find into the character. This multicolored masked man was the product of not only the hologram from which he borrowed his name, but also lasers, "thermo-nuclear fusion," and the power of audio.

Peter Pan Records had experienced terrific success with a series of book-and-record sets aimed at children. Pairing illustrated storybooks with vinyl LPs, which contained sound effects, music, and dramatic readings of the story so that children could read along, the company primarily produced licensed products. The Peter Pan catalog was rife with properties from television shows, films, cartoons, and, in no small amount, superhero comic books. After a few years of producing audio adventures for everyone from Spider-Man and Batman to Man-Thing and Metamorpho, Peter Pan decided to try marketing an original superhero of its own making: enter, Holo-Man!

The story begins as noted "laser physicist" Dr. James Robinson plays host to the president of the United States at the "Top secret U.S. Government Laser Development Complex." Suddenly, saboteurs strike, just as Dr. Robinson is in the middle of demonstrating a revolutionary new fuel source powered by "laser induced thermo-nuclear fusion." The machines housing the lasers explode. Robinson narrowly saves the president's life but, in doing so, is disintegrated.

I know what you're thinking, but that's not the end of the story! At this point, the soon-to-be Holo-Man's origin comes fast and furious (and ridiculous). The good doctor is somehow encased safely in a nearby, life-sized holographic plate, which is then shunted into another "dimensional plateau" somewhere within something called a "mind-aura," where a bearded and cloaked figure named "Laserman" grants Robinson tremendous powers that are controlled by a "holodisc" from a "future time dimension." (Good thing these quote marks are sold in bulk.) The gibberish gets even thicker as Laserman charges Holo-Man with his mission:

"The coherent laser beams converge within your body and transform you into the world's first living hologram! Your abilities are awesome, and may be called upon by concentrating your thought-energies with definite purpose . . . just concentrate and these powers will be yours!" The bearded space wizard encourages Holo-Man to "engage the forces of evil in battles from which the preservation of good must triumph and the suffering of mankind shall be eased from the world!"

Created by:
Vincent A. Fusco and Donald M. Kasen

Debuted in:
The Amazing Adventures of Holo-Man (Peter Pan Records, 1978)

Not to be confused with:
T. S. Elliot's Hollow Man, Hulu.com, Hello Kitty

© 1978 by Peter Pan Records

\rightarrow

That's one tall order for a man dressed like a melting Popsicle. Decked out in an outfit resembling a bad accident at a tie-dye shirt factory, Holo-Man attempts to save America from an attack by insidious "Surrian" invaders. (What, the Russians weren't available? Oh, wait, I get it.) He's equipped with powers of invisibility, illusion-making, and "molecular teleportation"—which, one assumes, is the same as plain old teleportation.

Holo-Man's inaugural adventure ends on a quite a cliffhanger: thousands of holographic Surrian nuclear missiles rain down from the skies over Washington, D.C., leaving our hero mere seconds to prevent utter panic from sweeping the streets. My guess is he somehow does it with holograms.

The series was obviously intended to continue after Holo-Man's solo holo-showing. Besides ending on the pre-apocalyptic cliffhanger mentioned above, the book featured a full-page pinup introducing the audience to Holo-Man's allies, most of whom had yet to be introduced. Along with Laserman, the "Holo Squad" consisted of the regal and tiara-topped Utopia, the youthful Wavelength and his animal pets, and a clipboard-wielding Laserwoman. Also featured was a lightning-framed, purple-shirted figure who most likely would have turned out to be Holo-Man's archnemesis, had the book (and record) managed to last beyond a single appearance.

THE HUMAN FLY

"Blast throwing me off balance! Mag-clamps tearing free! I'm being swept from the jet!"

Created by:
Bill Mantlo

Debuted in:
The Human Fly #1
(Marvel Comics,
September 1977)

**Percent of his
body that is
manufactured:**
60%, just like his
backstory

© 1977 by Marvel Comics

FEW COMIC BOOK CHARACTERS can be said to be based on a real-life costumed adventurer. But the Human Fly can.

In 1976, a courageous Canadian in a custom-made, full-body costume and cape—calling himself the Human Fly—challenged big-name performer Evel Knievel's dominance of the daredevil circuit, debuting with a high-profile stunt involving "wing-walking" on an airborne DC-8 over the Mojave Desert. The event turned the Human Fly into a promotional juggernaut, and the subsequent marketing blitz included adding him to the lineup of Marvel Comics as a bona fide superhero.

For nineteen issues, a four-color version of the Human Fly rubbed shoulders with established heroes like Spider-Man, Ghost Rider, and (appropriately enough) Daredevil. The Fly battled super-villains and saboteurs (plus the occasional robot bird, for good measure) and performed an increasingly unlikely array of super-stunts, from tightrope walking between dirigibles to riding a motorcycle up and down the Gateway Arch in St. Louis.

Though the comic book Human Fly never revealed his identity, the real-life Fly is believed to be stuntman Rick Rojatt. The comic book version's origin draws inspiration from the real-world Human Fly's promotional material: badly injured in a devastating accident, the future hero has more than 60 percent of his body replaced with steel supports and is told he'll never walk again. Defying the odds, the Fly summons all his willpower, healing his body and dedicating himself to becoming a record-breaking stunt performer. His goal: to inspire others and raise funds for ailing children.

Risking his neck for a noble goal is all well and good. Plus, it's a convenient way to move the story along. In issue after issue, the Human Fly finds himself facing down crooks looking to rob or sabotage his charity stunts. You wouldn't think it, but apparently charity events are magnets for trouble and disaster.

The Human Fly disappeared from comics soon after the real-life Fly announced an end to his stunt career. To break a record set by Evel Knievel, the Human Fly attempted to jump a rocket-powered motorcycle at a predicted 300 miles per hour over an astonishing twenty-six school buses parked side by side. The result saw the bike—and the Human Fly—spin wildly out of control, leaving him with extensive injuries that ended his career.

By comparison, the comic book version was allowed to happily walk away, with his arms thrown chummily around his friends' shoulders—a happier, and strangely quiet, conclusion for a such a bombastic character.

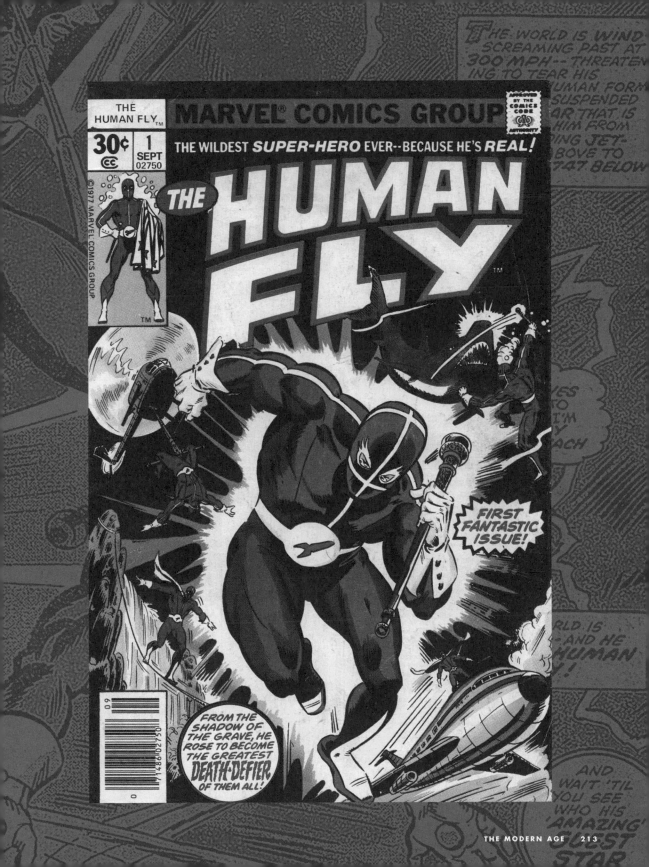

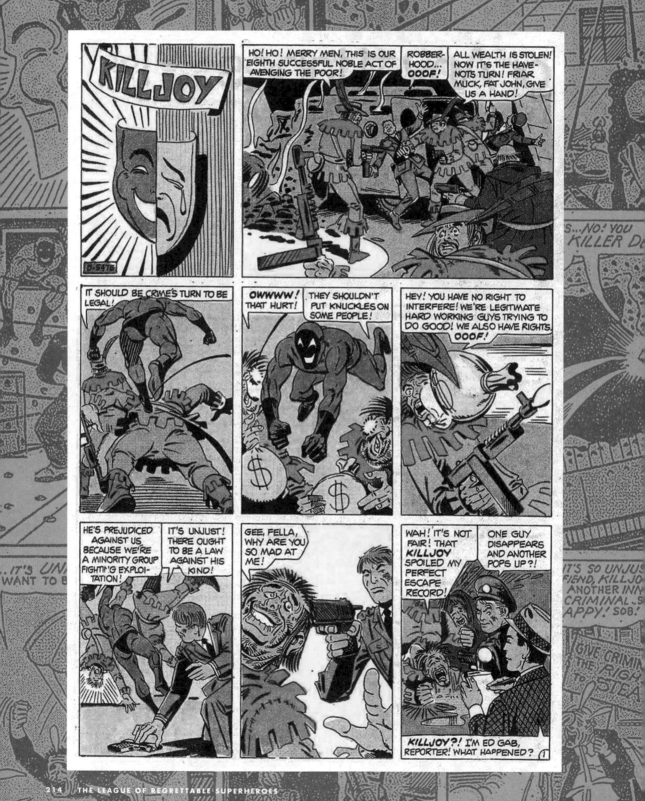

KILLJOY
:) [Killjoy doesn't speak!]

ONE OF THE BEST-KNOWN and best-regarded comic creators in the history of the medium, the reclusive Steve Ditko can claim a roster of original creations that reads like a who's who of the best-known and most innovative superheroes of the past fifty years. He was cocreator of Marvel Comics' Spider-Man and Dr. Strange, as well as some classically offbeat characters, including Hawk & Dove and the Creeper for DC, a host of heroes and villains for Charlton Comics, and relatively recent introductions Speedball and Squirrel Girl (page 244).

But it's when he's working solo, or minus an editor to stay his hand, that Ditko comes up with his wildest inspirations. Take, for example, the frenetic Static, the bizarre Missing Man, and the Objectivist vigilante Mister A, a metal-masked superhero dedicated to philosophical absolutism ("A equals A," as he says, a mathematical formula that supposes unqualified moral definitions). Many of Ditko's most interesting characters are as likely to lecture their enemies on ethical absolutism as they are to clobber them senseless.

Much in this vein is Killjoy, an orange-suited hero who knocks crybaby criminals unconscious in a satire that combines the action of Spider-Man with the objective ethics of the Question (or at least Ditko's original version of that oft-repurposed character). Killjoy's world is overrun with criminals crying for equal rights. Amid an armed robbery, the green-suited Robber Hood and his Merry Men argue, "All wealth is stolen!" advocating that "it should be crime's turn to be legal!" The militaristic General Disaster shouts that he has "a right to be a dictator!" An entire rogues' gallery of whining crooks populate Killjoy's densely packed eight-page stories, including the advocates for societal change called Mr. Hart and Mr. Sole. The pair bemoans that it is cruel to prevent criminals from pursuing their profession.

Killjoy's story is a broad parody of what Ditko sees as a society that has compromised its ethics. Killjoy never utters a word during his appearances . . . or does he? After the hero departs the scenes of his repeated triumphs, inevitably another person shows up: Ed Gab (reporter), Al Ace (counterintelligence), Jud Lah (lawyer), and others, any of whom might be Killjoy in disguise. We're never given an origin for the character. But those details are beside the point for such a weirdly entertaining figure.

Created by:
Steve Ditko

Debuted in:
E-Man #2
(Charlton Comics,
December 1973)

**Possible secret
identity:**
Ayn Rand

© 1973 by Steve Ditko

MAGGOTT (and other regrettable X-Men)

"I know, no need to say it ... the coolest. The mack. To die for. I could go on ... Newest X-Man, huh?"

Created by:
Scott Lobdell and Joe Madureira (Maggott); various (others; original X-Men created by Stan Lee and Jack Kirby)

Debuted in:
1997 (Maggot), various (others)

Odds that Professor X will return calls:
Not good

© by Marvel Comics

MARVEL COMICS' UNCANNY X-MEN—superpowered mutants who fight to save a world that hates and fears them—have managed a lucrative fifty-year career that includes several big-budget films. Yet, as wildly popular as the concept became, more than a few members are of course unlikely to achieve widespread esteem. Here are some examples of X-weirdos who will not be coming to a theater near you anytime soon:

Maggott: A mutant superhero whose power is "being infested with parasites," Maggott finds that his abdomen plays host to a pair of squirmy wormlike creatures that consume matter and transfer the calories back to their host, who transforms it into prodigious muscle mass. Few mutants seem grosser, but then again there's . . .

Marrow: Capable of growing new bones at will, Marrow turns some of her skeleton into armor and breaks off other pieces to use as weapons.

Longneck: Competitions for the least-practical mutant power may begin and end with Longneck, a creature whose neck is indeed very long! His gift proved to be a liability when his powers were turned off and his neck promptly snapped.

Rubbermaid: Stretchable superheroes are always useful to have around, but as far as code names go, this one is a stinker.

Forgetmenot: This unassuming young X-Man possessed the mutant power of forgettability—whoever sees him forgets his existence the moment he is out of sight. Apparently he's been a member of the X-Men for a long time, but no one remembers to count him.

Glob Herman: A protoplasmic humanoid mass made of "bio-paraffin," Herman's skeleton and internal organs can clearly be seen through his semi-transparent body. He'll not likely star in his own movie anytime soon.

Beak: You could do worse than end up with bird-related mutant powers, but Beak didn't exactly win the genetic lottery. He has light bones and weird feathered limbs, but he can't really fly; his only offensive power is pecking.

Snot: With the ability to fire overwhelming volumes of mucus from his nose with immense velocity, this mutant gains points for effectiveness, if not for pleasantness.

Cypher: Doug Ramsey, rookie X-Man, had the power to instantly interpret any language in the universe. It's a useful ability, but it doesn't do a lot of good against getting shot, which is how this young mutant snuffed it.

MAN-WOLF

"Right now I don't know just what I am ... except that I'm not a god!"

BY THE TIME MAN-WOLF got his superheroing career fully off the ground, Marvel was already swimming in horror-based heroes, including another werewolf do-gooder in the form of a character dubbed Werewolf by Night (who knows what he was up to by day; even werewolves need some private time). Still, Man-Wolf had a lot going for him that Marvel's other fang-toothed good guys didn't: a long-term connection with Spider-Man, the exclusive honor of being the first werewolf on the moon, and, of course, he was a god!

Specifically, Man-Wolf was Stargod, a wolf-headed cosmic superhero who straddled both the star-faring and the fang-baring sides of Marvel's collection of heroes in the 1970s. Before that, however, he was astronaut John Jameson, the son of Spider-Man's hectoring editorial anti-fan, the newspaper publisher J. Jonah Jameson. Having debuted way back in Spider-Man's first eponymous issue—his returning spacecraft malfunctioned on reentry, requiring a rescue by Spidey—the man who would become Man-Wolf had a lengthy and generally congenial history with the wall crawler. It wasn't until ten years after his first appearance that a lunar gemstone transformed man into Man-Wolf. As the astronaut discovered during a return sojourn to the moon, that rock was the legendary Godstone, left for Jameson to find by the quasimedieval residents of an extradimensional land of magic called "The Other Realm." Man-Wolf was now that realm's de facto leader, a cosmic-powered, sword-swinging warrior-king called Stargod.

One of the things that makes superhero comics so enjoyable is that there are few, if any, limits on what can happen. Characters are free to be as odd and atypical as imagination allows. However, Man-Wolf/Stargod's complicated backstory, and the unlikely sight of a white-furred, sword-wielding, wolf-headed superhero decked out in grass-green armor battling nebulous evils in a medieval world inside the moon, might have been a bit too many "interesting" affectations for a single character to support. After a short spurt, Man-Wolf's superheroic career petered out, and the former astronaut was cured of his lupine affliction. While Jameson has occasionally remanifested his furry form, it's always been brief, and usually without the voluminous backstory.

Created by:
Gerry Conway and Gil Kane

Debuted in:
The Amazing Spider-Man #124 (Marvel Comics, September 1973)

Weaknesses:
Fleas, squeaky toys, the mailman

© 1973 by Marvel Comics

MORLOCK 2001
"I like the birds because they are so free!"

Created by:
Michael Fleischer
and Al Milgrom

Debuted in:
Morlock 2001 #1
(Atlas Comics,
February 1975)

Care instructions:
Plant 12 inches
apart, full to
partial sun

© 1975 by Atlas Comics

HE LEAD CHARACTER OF *Morlock 2001* may have the most ignoble origin in the history of comics. While other heroes launched their careers from fantastic alien worlds, high-tech laboratories, or your average island paradise, Morlock started life as . . . an eggplant.

Proving that heroes are not only born or made but also sometimes harvested, Morlock was the product of forbidden horticultural experiments in the far-flung dystopian future, the year 2001. Confiscated by the brutally repressive regime of the world government, the pods containing Morlock and his unhatched siblings revealed plant-human hybrids—beings who looked like men, but whose bodies were made of a strange "Fibro-Cellular Structure."

Morlock emerges from his cocoon fully grown, possessing the power of speech, a human form, and a pointy white hairstyle that makes him look like the mascot for a brand of soft-serve ice cream. Evidently that is exactly the kind of breakthrough the government has been looking for because they quickly indoctrinate the plant-man into their ranks.

Government life doesn't suit Morlock, particularly since the gentle man-plant loves peace and can't wrap his rutabaga around the actions of the repressive regime that pays his celery—er, *salary*. In fact, as a superhero, Morlock doesn't do much except look awfully good compared to the excesses of the futuristic government. Unless, that is, you make him angry.

Like the Hulk, during moments of stress the gentle Morlock transforms into a terrifying, mindless, super-strong monster. Unlike the original comic book man-monster, however, Morlock doesn't just hop around racking up property damage and mangling the spoken word. He eats people! When his violent alter ego takes over, Morlock, looking to all the world like a walking radish made out of beef jerky, is just as likely to kill and consume his allies as his enemies.

After two issues, the decision came down that Morlock had gone about as far as a man-eating vegetable could conceivably go. With his third issue title amended to add "and The Midnight Men," Morlock meets the leader of said group, who is called "The Midnight Man." Wanted by the government, the Midnight Man doesn't take long to realize that an uncontrollable fern that feeds on human beings is less an asset than a hindrance. With government agents bearing down on him, the Midnight Man puts a bullet in his newfound ally. He then proceeds to blow himself up, along with his men and his headquarters, because "better death than slavery!" How the story may have resolved from there is anyone's guess. Atlas-Seaboard folded shortly thereafter.

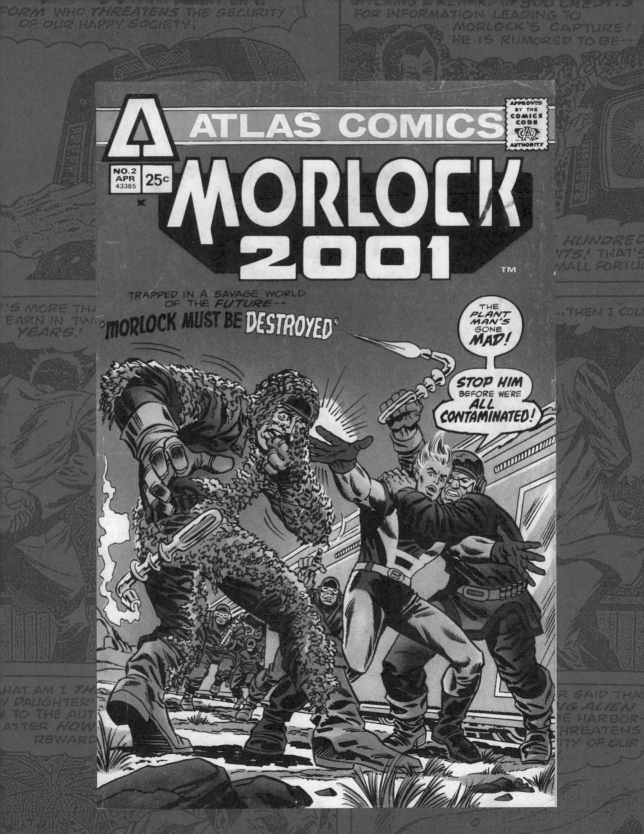

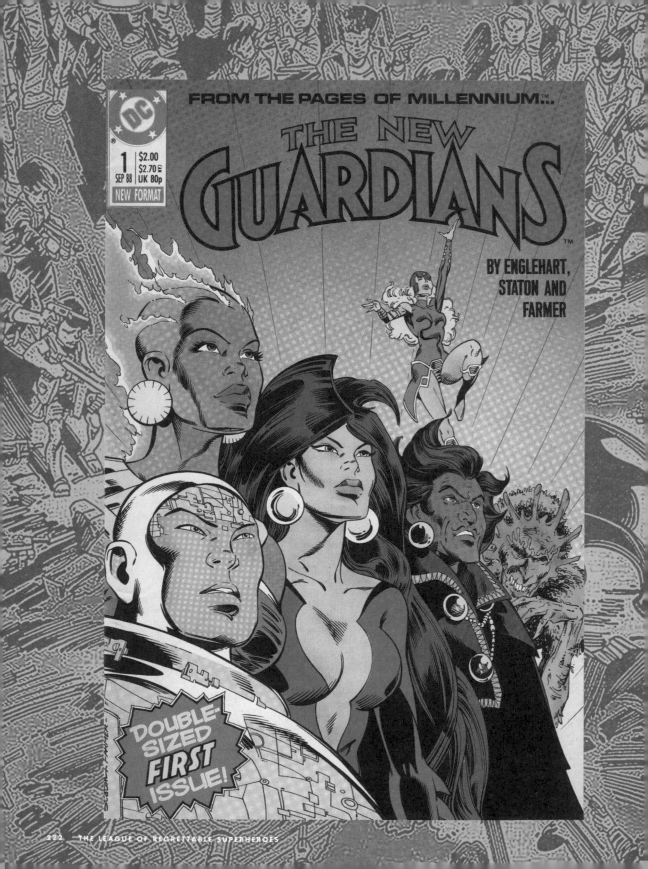

NEW GUARDIANS

"But you're here to breed—and let's not forget, Floro's a plant!"

ITH THE TWENTY-FIRST CENTURY still twelve years away, DC Comics decided to get the jump on the competition by creating the first superheroes for the upcoming new millennium. Chosen by wise, immortal space aliens, a handful of seemingly normal humans was to usher humanity to its destiny a thousand years in the future. But despite the project's best intentions, the book ended up being a mishmash of cultural and ethnic stereotypes hobbled by its own attempts to appear relevant.

The New Guardians debuted in a series called *Millennium* intended to underline the future importance of these characters. The high-profile launch instead seemed to underscore their limitations.

Three of the New Guardians had already appeared in DC comics. Tom Kalmaku (who had been saddled with the unfortunate nickname of "Pieface" for the first twenty years of his existence) was an Inuit engineer and confidante of Green Lantern. Harbinger was the gal Friday of an interdimensional doomsday prepper named "The Monitor." And Floro, formerly a plant-themed villain known as the Floronic Man, was recast as a living vegetable and dippy tree-hugging shrub. The other New Guardians included:

Betty Clawman, an aboriginal Australian whose powers manifested—because this is the same power all aboriginal Australian comic book characters seem to have—as "a connection to the Dreamtime."

Extraño a flamboyant, gaudy sorcerer dressed in Liberace's hand-me-downs and allegedly comics' first "openly" homosexual character. The in-house editorial team prohibited the character from ever saying as much.

Gloss, a Chinese superwoman whose powers were tied to the "dragon-force" of mystical global ley lines.

Jet, an anti-authoritarian activist native to Britain by way of Jamaica. Not just a black woman who shared her superhero name with a well-known magazine aimed at African Americans, she employed dialogue that was painfully riddled with clichéd speech patterns (e.g., "I-and-I got a lot ta say about dat!").

Ram, a Japanese businessman whose superpowers manifested as "being very good with computers."

And *Janwillem Kroef*, a white South African who was so disgusted with his team's multiculturalism that he dashed off to found a white supremacist movement.

The team's adversaries were equally ill-conceived. The roster included the Hemogoblin (a vampire with AIDS) and Snowflame (a super-villain powered by cocaine).

Created by:
Steve Engelhart
and Joe Staton

Debuted in:
Millennium #1
(DC Comics,
January 1988)

**Not to be
confused with:**
New Improved
Guardians;
Guardians, Now
with Extra Fluoride

© 1988 by DC Comics

NFL SUPERPRO

"It's nice to be recognized by your fans, isn't it?"

Created by:
Fabian Nicieza
and Jose Delbo

Debuted in:
*NFL SuperPro Super
Bowl Special* #1
(Marvel Comics,
September 1991)

No relation to:
NHL Superpuck,
NASCAR Supercar,
NBA Hooperpro

© 1991 by Marvel Comics

S THERE ANYTHING MORE American than product placement? Probably yes, but it was only a matter of time before an all-American superhero bore a major corporate brand on the front of his costume. Hence NFL Superpro, a collaboration between Marvel Comics and the National Football League, in an attempt to create a kid-friendly comic hero who could further popularize American football. One doesn't normally think of pro football as an industry that needs more exposure, but there you have it.

The character's origin is even harder to swallow. In fact, it's among the most unlikely in comics: NFL Superpro gains his super-powers from inhaling toxic souvenirs.

Phil Grayfield, a promising NFL star, must give up his ball-playing career when he blows out a knee while saving a baby from a fatal fall. Resigning himself to life as a mere sports reporter, Grayfield finds himself interviewing a wealthy NFL superfan whose valuable collection becomes the target of fire-wielding vandals. Trapped under tons of burning memorabilia and game footage, Phil is—in his own words—"drenched in chemical foam, gasoline, plastics and chemicals from the old films." All of which, amazingly, combine to give him the familiar array of superhuman strength, speed, and endurance (instead of, say, third-degree burns and cancer). Donning the wealthy collector's experimental football uniform, a bulletproof super-suit allows him to pursue the homicidal firebugs in his newly christened identity of Superpro.

That experience gives Phil a taste for crook-catching, and so he continues his mission "to fight crime and defend the sport he loves from those forces that would seek to corrupt it." Predictably, the ex-footballer encounters plenty of gridiron-themed super-villains. He tackles (literally) a steroid-chomping rookie player turned into a mountain-sized monster; a former teammate who uses his kicking skills as a ninja assassin; a high-tech hitman with an instant replay-themed gimmick; even an opposing team of evil football-themed super-villains.

Superpro also fought that standby baddie of the 1990s—the anti-environmentalist nutcase—and a few Z-list nemeses borrowed from other Marvel heroes. One issue's crew of crooks decked out as Native American kachinas earned Superpro's publisher a censure from the Hopi nation—whoops! After twelve issues, NFL Superpro left the gridiron with some level of notoriety, in no small part owing to the cynical marketing and branding taking place in lieu of character.

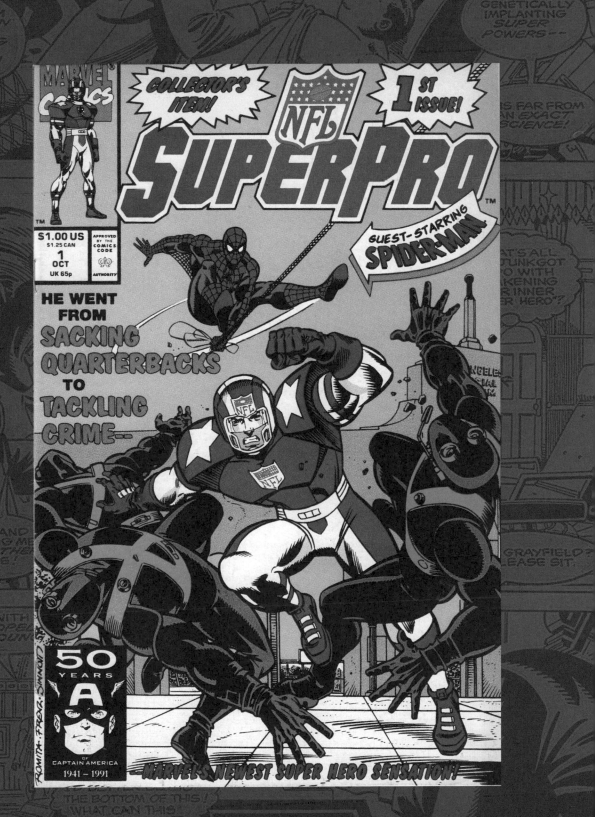

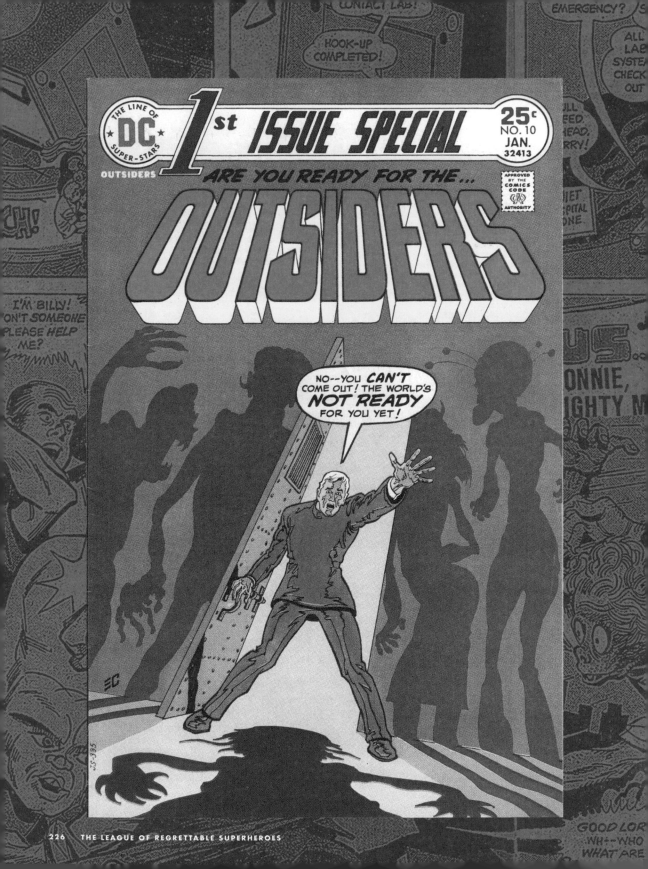

THE OUTSIDERS

"Let's face it ... I'm a FREAK!"

THEY'RE A TEAM OF weird-looking mutants who fight for a world that hates and fears them, banded together to protect their own from the often deadly prejudice they face merely for being . . . different. Surely it's the X-Men, right? Nope! We're talking about the Outsiders, a team of outlandish superheroes who made a sole outing in the mid-1970s. "The world's not ready for you yet!" cries a figure on the cover, and he was clearly right.

A quintet (plus a midissue addition) of self-described "freaks," the Outsiders resembled the outlandish designs of hot-rod artist Ed "Big Daddy" Roth more than strait-laced crime-fighters. The team was made up of Amazing Ronnie (a four-armed green-skinned Cyclops), Lizard Johnny (a squinting, bespectacled frog-man who could regrow damaged limbs), the immensely strong Mighty Mary (a gorgeous sloe-eyed blonde—from the collar up, anyway; below the neckline, she sported thick fish-scaled limbs), and Hairy Larry, a.k.a. "The Wheeler Dealer" (the team's wheel man—literally! Larry is somehow bonded to the truck that transports the Outsiders and bears their team logo).

The Outsiders even have a theme song, although it's surprisingly specific to the young weirdo they save from an angry mob: "Hang in there Billy . . . it's US . . . US . . . We're the Outsiders!" they sing before introducing each member and leaping into the fray. ("Billy" is a toddler sporting a gigantic bald head the size of a foot locker and is harder than steel!)

Leading the Outsiders is "Ol' Doc Scary," a fright-faced cyborg. The good doctor lost his handsome features after returning from a botched space mission to investigate alien "laser signals." Why NASA sent a surgeon to check in on alien broadcasts is anyone's guess, but the result is that Doc returns . . . changed. Having crashed on the world where the alien signals originated, Doc is rebuilt by extraterrestrials who give him eerily precise and fast cybernetic hands and a hideously disfigured face. (This origin story is similar to that of Jigsaw, another Joe Simon character highlighted on page 158.)

Hiding his horrifying new appearance under a latex mask, Doc recruits other "Freaks" to hang out with him in his lavish private quarters, a sprawling secret headquarters twenty stories below the hospital. The team didn't last, but parent company DC Comics repurposed their name about a decade later for a roster of outcasts and C-listers assembled by Batman. That group developed various incarnations, while the original Outsiders are probably still huddled around the television in their subbasement two miles below the surface of the earth.

Created by:
Joe Simon and
Jerry Grandenetti

Debuted in:
First Issue Special
#10 (DC Comics,
January 1976)

Primary problems:
Low self-esteem,
rampaging mobs

© 1976 by DC Comics

PHOENIX THE PROTECTOR

"I guess I always knew mankind would manage to destroy itself someday ... "

Created by:
Jeff Rovin and
Sal Amendola

Debuted in:
Phoenix #1
(Atlas Comics,
January 1975)

**Not to be
confused with:**
Phoenix, a.k.a. Jean
Grey; Phoenix, AZ;
the University of
Phoenix

© 1975 by Atlas Comics

N THE FAR-DISTANT FUTURE of 1977, disaster strikes the orbital space station *Threshold I.* The astronauts make an emergency evacuation, and their escape pod crashes in the Arctic. One survivor, Ed Tyler, is left freezing upon the ice.

Fortunately, Tyler's plight is noticed by the Deiei, a race of seemingly all-powerful aliens. Rescuing him from certain death, the extraterrestrials inform him that they are responsible for the evolution of humankind. They then shock the astronaut by announcing that because humanity is too violent and flawed to be allowed to continue to exist, they plan to destroy the very race they helped create. Making a break for it, Tyler helps himself to an alien spacesuit loaded with "atomic transistors" that convey tremendous powers. He then becomes the Phoenix, humanity's superpowered savior!

Phoenix is known as a surprisingly depressing comic; even the title character finds himself succumbing to pessimism. "The planet is doomed," he thinks, adding, "and I share the grim responsibility" before using his powers to carve a mountain into a king-sized gravestone for humanity that reads: "R.I.P. Planet Earth 1977."

Phoenix may best be remembered, however, for explicitly portraying its hero as a Christ-like figure. In the second issue, Phoenix describes himself as "a man to lead them away from evil—to show them the path to salvation!" With the sun creating a halo behind his head, Tyler adds, "As did I, so will man rise from the ashes of hatred and prejudice! For I am . . . PHOENIX!" He goes on to fight a sinister Deiei tyrant who calls himself "Satan" and, later, parts the waters of the Hudson River.

In its fourth issue, the editorial powers-that-be decided to turn the book's glum, foreboding tone on its ear. Helpful aliens intervene, calling themselves the Protectors of the Universe. They promptly rid the planet of the Deiei and outfit Phoenix with new clothes, fresh powers, and a novel identity.

The Protectors send Tyler (now known as "Phoenix the Protector," certainly not because competitor Marvel Comics already boasted a superhero named Phoenix, right?) back to earth to serve as the planet's guardian. Their new mission comes with a warning, though. "The moment you show hatred, bigotry, greed or any of the other human plagues," they explain, "Mankind will be doomed!" Gulp.

Luckily for humanity, the Phoenix doesn't have long to ponder the seriousness of his new mission. Its publisher Atlas Comics folded promptly after the book's fourth issue.

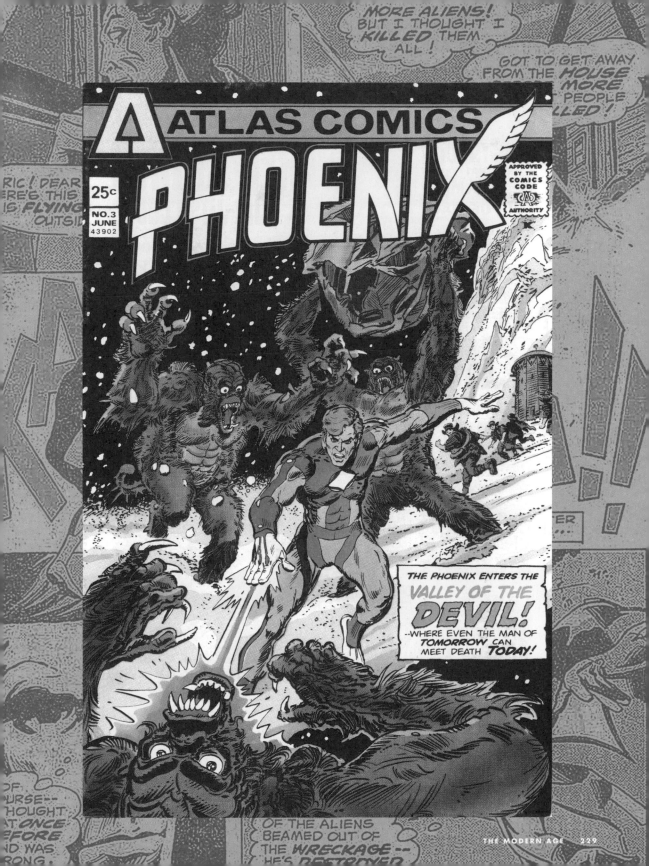

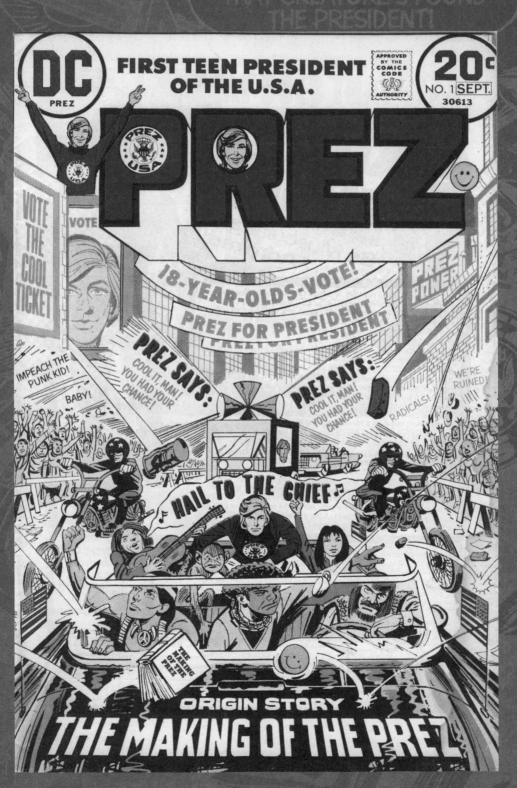

PREZ

"One thing bothers me—if the clocks aren't on time, how do we know when it's election day?"

THE YEAR IS 1973, and America is in turmoil. The wounds of Vietnam, the Watergate scandal, PONG's release, the birth of Carson Daly . . . it is, in many ways, the country's darkest hour. Surely, the only hope lies in electing a clock-obsessed teenager to be president of the United States.

Prez (a.k.a. "First Teen President") was the brainchild of Joe Simon, the man who, along with Jack "King" Kirby, created literally thousands of pages of comics and dozens of superheroes, including the paterfamilias of the patriotic superhero set, Captain America. Now teamed with artist Jerry Grandenetti, Simon was ushering in a completely new kind of patriotic superhero.

Prez Rickard is the favorite son of the modest burg of Steadfast, a town adorned with hundreds—maybe thousands—of beautifully crafted clocks. Unfortunately, no two of them keep the same time. One by one, with focus and dedication, Prez fixes all the clocks of Steadfast. This herculean task brings him to the attention of Boss Smiley, a round-headed wretch whose cartoonishly grinning mug resembles the insipid smiley face button made popular in the '70s. Seeing an opportunity, Smiley endorses the immensely popular twenty-one-year-old (yes, the "Teen President" tagline lied) for a career as the youngest senator in the United States and, following a shoved-through constitutional amendment, the youngest president in history.

Eventually, Prez rejects Boss Smiley's control, aided by his Native American pal Eagle Free, a friend to animals and director of the FBI. Prez and his administration go on to defend the U.S.A. from many familiar threats. There are assassination attempts, rabble-rousing activists, contrarian members of Congress, legless vampires, giant evil robot chess pieces—you know, the kind of day-in day-out struggles typically faced by any world leader.

For all the werewolves and robots, the real villain is the status quo. Simon used Prez to represent the idealism of baby boomer culture versus the business-as-usual protocol of success-hungry career politicians, power-craving quislings, and influential figures all too eager to turn traitor against the highest ideals of the nation. In an unpublished story, Prez even got to take on the Watergate scandal, liberating Washington, D.C., from a dual plague of "bugs" (both the electronic kind and the more familiar vermin type).

The allegory-rich story of Prez was effortlessly adapted in an issue of Neil Gaiman's well-regarded 1990s series *The Sandman*. Prez was recast as a Christ-like figure resisting the temptation of a satanic Boss Smiley. It's a shame Prez hasn't made a substantial return since. The world can never have enough heroes who stand for truth, justice, and the American Way.

Created by:
Joe Simon and Jerry Grandenetti

Debuted in:
Prez #1 (DC Comics, August/ September 1973)

Political affiliation:
Groovy

© 1973 by DC Comics

RAVAGE 2099
"Chew on some knuckles, ya scrud!"

Created by:
Stan Lee and
Paul Ryan

Debuted in:
Ravage 2099 #1
(Marvel Comics,
December 1992)

Secret superpower:
Reducing, reusing,
and recycling

© 1992 by Marvel Comics

STAN LEE IS PRACTICALLY a household name, what with having cocreated or—at one time or another—written the adventures of practically every Marvel Comics superhero that is now lighting up the silver screen. In the 1960s, Lee oversaw the invention of the "Marvel Universe." So in 1992, it only made sense that he would play a role in determining the shape of the Marvel 2099 series, a line of titles that depicted legacies of modern-day superheroes. Most of the books focused on the descendants of already-established superheroes of the twentieth century, but one of the title characters was brand new: Ravage!

Ravage was as attuned to the 1990s as Stan's original cocreations had been in step with the 1960s. Gone was the relentless self-doubt and existential drama of characters like Spider-Man. Also in decline was the optimistic science-can-do-anything message of the early Marvel Universe. No, the world of 2099 was a dismal, dystopian plutocracy run by corporations, and technology was a tool of oppression. Embracing both the environmental concerns of the decade and the permanent sense of irony that seemed to infuse the '90s, Ravage—in his civilian persona of the not-at-all-ominously-named Paul-Phillip Ravage—was the head of ECO, a domestic paramilitary arm formed to fight "polluters," sometimes with fatal results.

While trying to expose corruption within his agency's ranks, Ravage is framed for murder. On the run, he arms himself—and here's that irony mentioned earlier—in garbage. Decked out in scrap metal and discarded padding, wearing barbed wire as a belt, and shielding himself with—of all things—a hubcap, Ravage emerged from his origin looking like a dressed-down cousin to the decade's other heroes.

But the junk-draped hero and his armory of refuse didn't seem to cut it. Several issues into his run, Ravage was revamped, returning to Lee's old standby—powers gained by radiation. After undergoing a life-saving radioactivity treatment, Ravage emerged with the ability to fire destructive bolts of energy from his hands. Another few issues went by and Ravage was again rejiggered, this time acquiring a "beast form" from "man's distant origins—way before the ape." Complete with animal senses, deadly claws, and weird horns, Ravage ended up as a snarling man-monster flying around on a mutant bat.

Where Ravage might have gone next is anyone's guess. At the end of his final appearance, he winds up dead at the hands of 2099's version of Doctor Doom.

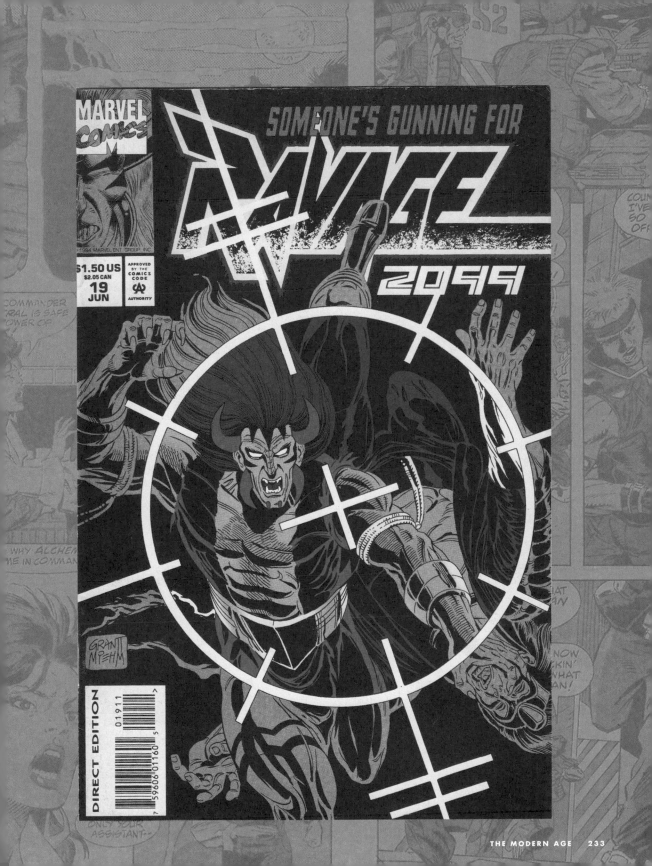

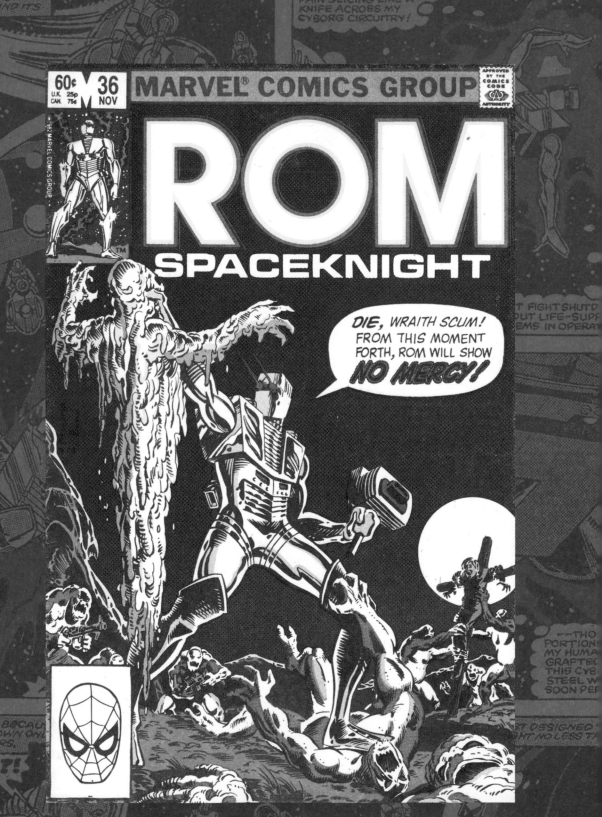

ROM, SPACEKNIGHT

"This sector is cleansed of Dire Wraiths! But my quest goes on!"

OM, A.K.A. "ROM, SPACEKNIGHT," remains an interesting conundrum in the world of comics. Despite that his long-lived comic remains a fan favorite, he will probably never again see the light of day.

When board-game manufacturer Parker Brothers decided to enter the lucrative late-1970s action figure market, competitor Kenner had opened up the market in an unprecedented way with its popular lines dedicated to the Star Wars franchise. So Parker Brothers launched its own intergalactic hero, a silver-plated robot from outer space named Rom.

The toy, manufactured cheaply and panned in a notorious *Time* magazine review, sold in disappointing numbers. But the comic book that Marvel Comics produced under license became a smash hit. Creating a backstory for Rom out of whole cloth and a few clues planted in the advertisement for the toy (which repeatedly stressed that children should only "pretend" that Rom could detect and fight evil), writer Bill Mantlo envisioned a conflict that spanned the universe.

A cyborg Spaceknight of the planet Galador, Rom has spent two centuries in an interplanetary conflict with the Dire Wraiths, a race of shape-shifting alien sorcerers. His crusade takes him to earth, where he discovers that the Dire Wraiths have adopted human form and integrated themselves into society, poised to destroy it from within.

No problem for Rom, though. The "Analyzer," one of his three toy accessories—sorry, "spaceknight weapons"—can detect Dire Wraiths in whatever form they possess. Rom's "Neutralizer" condemns them to a hellish "Shadow Zone." Unfortunately, the process leaves behind something strikingly similar to charred human remains. So, for all the human population knows, Rom is nothing more than a maniacal robot that arbitrarily turns people into smoking ash with a weird gun!

The comic book Rom was a talkative sort, even though his plastic incarnation was limited to an electronic fusillade of beeps, gongs, and labored breathing, so eventually he is able to explain his actions. He develops a supporting cast, including a love interest and a coterie of Spaceknight comrades (Trapper, Breaker, Scanner, Seeker, Starshine, Terminator, Hammerhand, and the unfortunately named Gloriole). Unfortunately, as well remembered as the series was, licensing obstacles make it unlikely that the original issues will ever be collected in a contemporary format, meaning that Rom's comic book adventures remain a rare and tantalizing find exclusive to back issue bins.

Created by:
Bing McCoy
(toy),
Bill Mantlo,
Sal Buscema
(comic)

Debuted in:
Rom #1
(Marvel Comics,
December 1979)

Accessories:
9-volt battery,
not included

© 1979 by Marvel Comics

SKATEMAN

"Hands off, jerkhole! ... We're forming a union! My foot and your face!"

Created by:
Neal Adams

Debuted in:
Skateman #1
(Pacific Comics,
November 1983)

Signature move:
Arming minors
with grenades

© 1983 by Pacific Comics

T'S A FAMILIAR STORY: martial artist Billy Moon returns from Vietnam to find that only roller derby can quell the turmoil in his soul. Unfortunately, Billy inadvertently crosses a branch of the mafia that apparently maintains an interest in the fortunes of the derby world (the dreaded Skate Mob, perhaps?). Soon he finds himself framed for the in-rink death of his closest pal, Jack.

Worse yet, when Billy begins to heal his wounded heart with the help of the beautiful blonde Angel, a biker gang swings by on a whim and slashes her to death with knives. It's a violent world Billy Moon inhabits, and he quickly takes to heart the maxim of an eye for an eye, and a roller-skate wheel kicking out another person's eye, and then more roller skates kicking different people in their assorted faces and eyes . . . for an eye.

Inspired by a young acquaintance's comic book collection, Billy decides to adopt the identity of a masked vigilante to avenge his friends' deaths. Looking back on the skills learned in his years of military service and lifelong study of the martial arts, he decides to base his costumed identity on roller skating, naturally. Thus, Skateman is born.

Created by comics legend Neal Adams, the *Skateman* publication boasts impeccable art but, unfortunately, questionable everything else. (Adams's more celebrated work includes iconic runs on the X-Men, Avengers, Deadman, Batman, and the groundbreaking Green Lantern/Green Arrow, plus tireless campaigning for comics creators' rights.) Allegedly developed as a tie-in for a potential licensing project, the book's ultraviolent storyline and objectionable language made it an unlikely candidate to sell whatever it was intended to market: roller skates, men's roller derby, headscarves, the mafia, whatever. Foul-mouthed, perpetually angry, and wildly irresponsible (at the climax of the book, Billy Moon gleefully sends his prepubescent assistant Paco into the bad guys' headquarters sporting a fanny pack full of live grenades), Skateman seems an unlikely choice to grace any product's packaging or advertising except, possibly, Prozac.

A low point in its creator's long and otherwise celebrated career, Skateman also has the honor of being one of the few street-level vigilantes in the history of comics to have taken justice into his own hands while wearing pristine white booty shorts. When *Skateman* #1—the first and only issue of Billy Moon's saga—ends abruptly on a climactic explosion, it's practically a blessing.

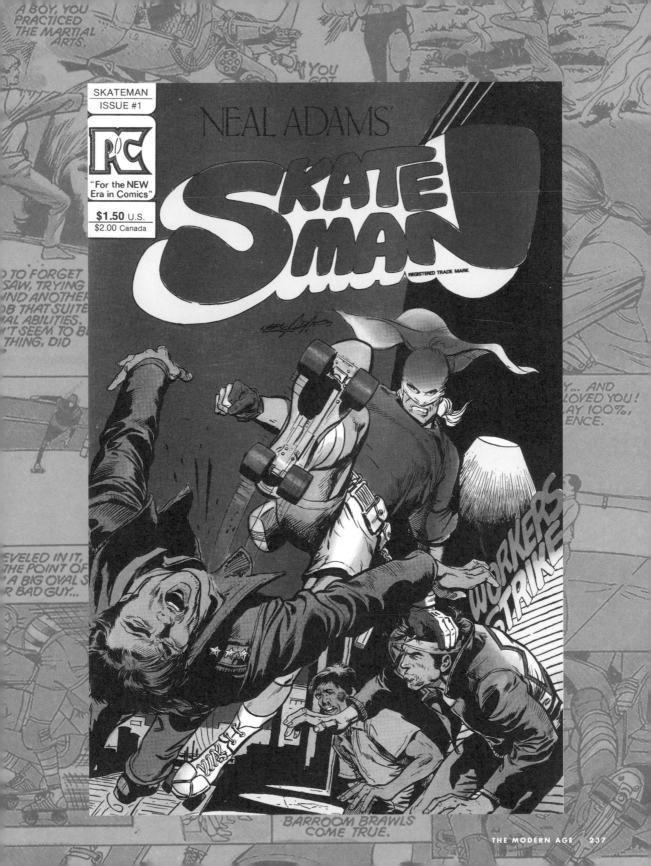

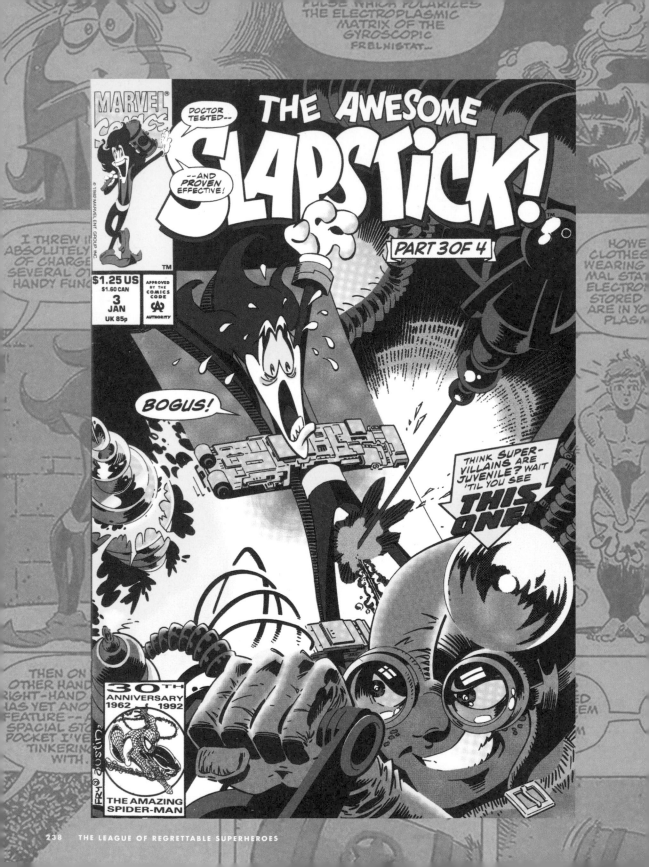

SLAPSTICK

"Earth is being invaded by evil clowns from Dimension X! I gotta do something!"

N THE EARLY 1990S, superheroes were at risk of losing their sense of humor altogether. Years of grim "mature reader" titles had popularized the idea that whimsy had no place in comics and that superheroes were meant to be taken seriously. As an antidote to that trend, the intentionally silly superhero Slapstick was a cure almost worse than the disease.

Slapstick is Steve Harmon, a high school smart aleck and "difficult child" with a lifelong interest in corny humor and practical jokes. Disguising himself as a clown to avenge himself on a rival (he's got a cream pie with this guy's name on it), Steve is sneaking around the back alleys of a traveling carnival when he discovers an insidious, unbelievable plot. Evil Clowns from Dimension X have opened a portal between worlds and are abducting unsuspecting carnival-goers in advance of a full-fledged invasion!

Leaping to the aid of the abductees, Steve is pulled across dimensions, undergoing a startling transformation along the way. His body becomes elastic, his appearance changes completely, and he suddenly has the ability to perform stunts straight out of a Looney Tunes cartoon! Armed with a gigantic mallet, Steve—as "The Awesome Slapstick!"—disarms the invasion fleet and returns to his home dimension, ready to begin his superhero career.

Slapstick, "the hero who laughs at danger," was set in the mainstream Marvel universe, allowing the rookie hero to team up with characters like Spider-Man. But that didn't mean there was no room for playful satire. Instead of meeting Marvel's vigilante antihero the Punisher, Slapstick finds himself facing a hulking, muscle-riddled gun-nut named "The Overkiller." Likewise, the villains of Slapstick's four-issue debut are absurd to the point of ridicule. Take Doctor Denton, a pint-sized genius young enough to require a babysitter, and his death-dealing android Teddy. Or an atomic-powered hobo who goes by the name "The Neutron Bum."

Stuck somewhere between a serious character in an already established universe and a parody character engaged in wide-swinging satire, Slapstick never seemed to settle comfortably into any particular niche. It didn't help that, while intended for a teen audience, many of the jokes in the book were based on movies and cartoons from earlier generations. (The first aliens that Slapstick meets in Dimension X resemble the Marx Brothers; a young Steve imitates a scene from the 1953 movie *The Robot Monster*, etc.) Given all that, it becomes clear why the audience just wasn't there, even if it was high time to reinject some comedy into superhero comics.

Created by:
Len Kaminski
and James Fry

Debuted in:
Slapstick #1
(Marvel Comics,
November 1992)

**Great but unused
name for his secret
headquarters:**
Clown Town

© 1992 by Marvel Comics

SONIK

"Sonik—Master of Sound! A super-hero to take the Eighties by storm!"

Created by:
Joey Cavilieri
and Stan Woch

Debuted in:
*World's Finest
Comics* vol. 1, #310
(DC Comics,
December 1984)

Brand of character:
Well intentioned,
well trod

© 1984 by DC Comics

OMIC BOOK SUPERHEROES SPENT their first few decades as an unintegrated lot. Nonwhite characters were typically depicted as offensive or degrad-ing caricatures, such as Captain Marvel's switchblade-wielding pal Steamboat, the Spirit's second-in-command Ebony White, and the Blackhawks' bucktoothed cleaver-happy Chinese cook Chop Chop, just to name a few.

It wasn't until the late 1960s that the first African American comic book superhero debuted: Marvel Comics' "The Falcon" (who followed comic's first black superhero, African prince/crime-fighter "The Black Panther," by a few years). Since then, efforts have been made to create more ethnically and culturally diverse superheroes, with credible origins and motivations. Not all the attempts have been successful.

Enter Sonik, an inner-city superhero with the power of sound at his command. Like a large number of African American superheroes who debuted in the 1970s and '80s, Sonik calls "the streets" his home turf. His character arc is equally familiar. Will Parker, born in an economically depressed urban center, leaves on a full college scholarship and returns with degree in hand to better the lot of the neighborhood. Blocking his best efforts are the local players: gangsters, shakedown artists, drug dealers, and pimps, home-grown crooks whose big success makes them role models to the current generation of kids.

Applying the engineering degree, Parker creates an arsenal of sound-powered weapons and gimmicks, like a jacked-up Walkman that produces a sonic boom. He takes to the streets as Sonik, decked out in a yellow jacket, orange leotards, and around half a dozen metal-studded leather bands and bandanas. The hero resembles a wardrobe explosion on the set of a music video.

Debuting alongside veteran heroes Superman and Batman, Sonik nonetheless manages only a pair of appearances. He uncovers a criminal conspiracy involving the Middle East and then plays bodyguard to a musical performer who bears more than a passing resemblance to Michael Jackson (and who is apparently under attack from mad robots).

Why didn't Sonik succeed? It certainly wasn't for lack of good intentions. But Sonik seemed to be retreading (or misstepping across) familiar ground. DC already had an African American superhero who'd returned to clean up his old neighborhood, the more popular electric hero Black Lightning. Also, Sonik was pretty firmly ensconced in the 1980s. A hero with a portable cassette player strapped to his belt seems unlikely to survive into the twenty-first century.

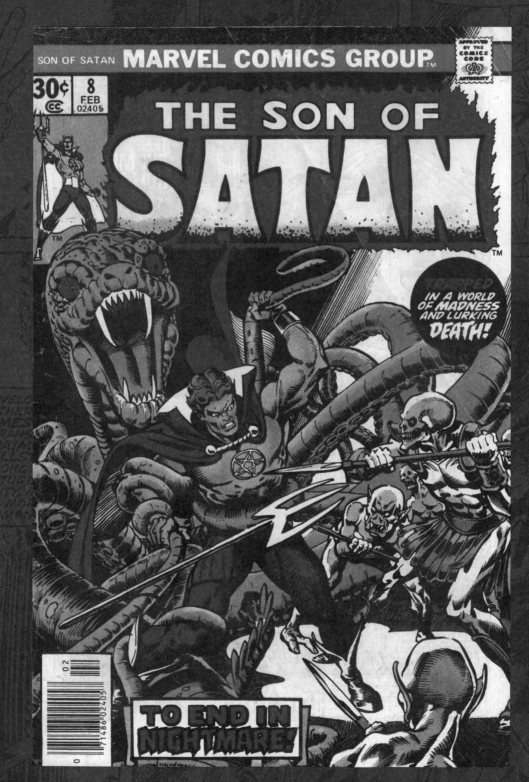

SON OF SATAN

"By night, my true and rightful heritage takes control—and I become my father's son!"

THEY SAY THAT SUCCESS depends not on what you know, but on whom you know. So, surely in the good-versus-evil industry, it's a big help to be directly related to the guy in charge of all the evil.

Or is it? Daimon Hellstrom isn't exactly following in his father's footsteps. As the demonically powered antihero Son of Satan, Hellstrom pits himself against the earthly machinations of his infernal father. Not to mention a host of demons and monsters from the pit, and even his own equally evil sister.

In the early 1970s, Marvel was having success with a wave of heroes inspired by horror movies and monster stories, from original concoctions like Man-Thing and the Haitian hero Brother Voodoo (page 196) to reimagined classic menaces such as Werewolf by Night, Morbius the Living Vampire, and the Living Mummy. The Son of Satan debuted in the pages of *Ghost Rider*, engaging with that flame-headed hero in a battle against a devil-worshipping villain called "The Witch Woman" while simultaneously launching his own ongoing run in a title called *Marvel Spotlight*. Idle hands, as they say . . .

Describing the Son of Satan's run as controversial is putting it lightly. Christian readers were unsettled by a superhero proudly bearing a satanic pseudonym, and readers sympathetic with wiccan and even satanic faiths objected to the unflattering portrayals. Visually, the bare-chested and trident-sporting superhero cut a unique figure. Where other heroes kept themselves to the city, Hellstrom, decked out more like a glam rocker than a do-gooder and getting around via a demon-drawn flaming chariot, was typically portrayed striding through the infernal landscapes of his pop's backyard, knocking over demons and posing amid a flame-blasted landscape.

An occult investigator by day, Hellstrom was bent on his mission on Earth: to foil his father's plans on the mortal plane, a never-ending battle that pitted him against a demonic horde with such interesting names as Kthara, Asmodeus, Ikthalon, Spyros, and Allatou, not to mention his own wicked sibling Satana.

The Son of Satan isn't as high profile as he once was, but he hasn't gone anywhere. Sill a fixture in the Marvel universe, these days Hellstrom rarely employs his satanic pseudonym.

Created by:
Gary Friedrich and Herb Trimpe

Debuted In:
Ghost Rider vol. 2, #1 (Marvel Comics, September 1973)

Religion:
Jesuit (honestly, it said so in the comic!)

© 1973 by Marvel Comics

SQUIRREL GIRL
"Nuts!"

Created by:
Steve Ditko and
Will Murray

Debuted in:
Marvel Super-Heroes
vol. 2, #8 (Marvel
Comics, January
1992)

Sidekicks:
Adorable squirrels
named Monkey Joe,
Tippy-Toe, Slippy
Pete, Mr. Freckle,
and Nutso (most are
dead now)

© 1992 by Marvel Comics

N 1992, THE ONCE-COLORFUL LANDSCAPE of superhero comics had taken on a grim cast. The trend had been triggered by the release, six years earlier, of Frank Miller's *The Dark Knight Returns* and Alan Moore and Dave Gibbon's collaborative year-long deconstruction of the superhero genre, *Watchmen*. The critical and commercial success of these comics milestones gave superhero comics—which had been flirting with an increasingly large adult readership over the better part of two decades—permission to become really serious.

In short order, death and depression infiltrated the superhero landscape. Former bad guy "The Punisher" racked up an impressive body count as a popular antihero. Old weirdo characters like the Doom Patrol and Shade the Changing Man were reinvented in tableaus of intense psychological trauma. Even Batman's youthful sidekick Robin (well, one of them anyway) became a victim of fatal super-villain violence.

Into this gritty environment came Squirrel Girl, created by writer Will Murray as an antidote to the perceived bleakness running rampant in Marvel Comics' multitude of X-Men-related titles. Doreen Green, optimistic young do-gooder (and novice mutant superhero) possessed powers of both the family *Sciuridae* and positive thinking. She boasted the relative strength, speed, and talents of squirrels—much as Spider-Man possessed arachnoid attributes—as well as a bushy prehensile tail, claws, and the ability to communicate with her furry fellows.

Aided by her squirrel sidekicks (with names like "Monkey Joe" and "Tippy-Toe"), Squirrel Girl proved to be a surprisingly powerful crime-fighter. In assorted battles, she managed to stand her own against such major Marvel menaces as MODOK, Thanos, and Dr. Doom. Despite an impressive win-loss record, it was almost a decade before Squirrel Girl's second appearance, this time in the company of Z-list Midwest American superhero team the Great Lakes Avengers.

Still, Squirrel Girl's bubbly, optimistic, and arguably frivolous presence seemed to recall a brighter time in superhero history, when stories were less rooted in real-world consequence. Accordingly, her popularity has grown among a dedicated core of supporters. In subsequent appearances, she racked up impressive additional wins against more of Marvel's ominous opponents, including the titanic Fin Fang Foom, the cosmic Terrax, and, well, the Bi-Beast, a guy with two faces. Marvel is planning to give her a title of her own in 2015—an impressive feat, considering how rarely she appeared in print.

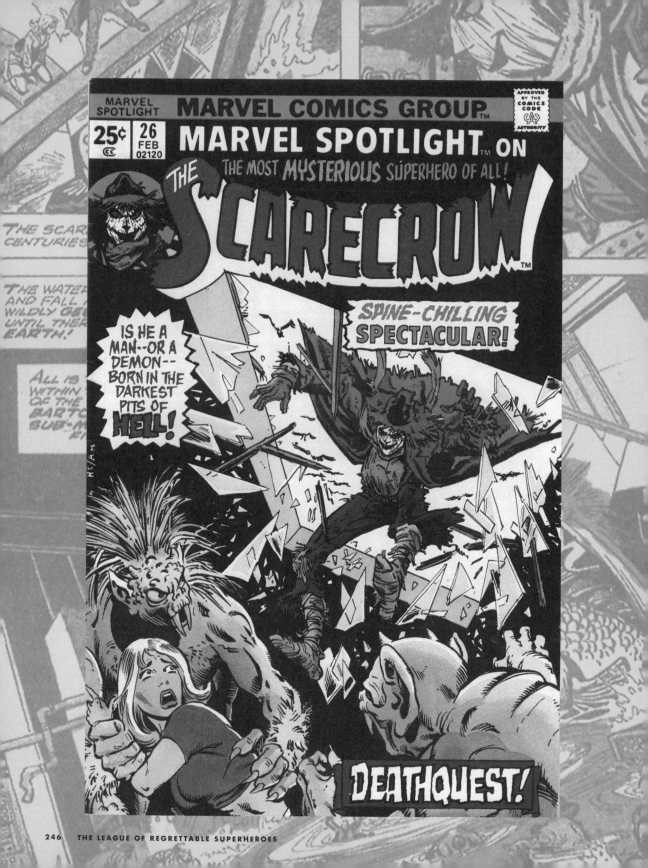

THE STRAW MAN
"HEE HEE HEE HEE"

AS ANTI-HEROES GREW in popularity throughout the increasingly seedy 1970s, the bright primary-colored superheroes of yesteryear were joined by—or replaced with—weird freaked-out monsters and die-hard killers decked out in black leather. Of the former was the Straw Man—which originally debuted as "The Scarecrow"—a demonic entity from another dimension whose heroism was mostly a matter of self-preservation and the maintenance of a long-running interdimensional grudge.

While other heroes made their headquarters in hidden caves or high-tech fortresses, the Straw Man occupied a mysterious other-dimensional world accessible only through a seemingly haunted painting. When trouble would arise (typically, trouble that targeted the painting's current owner, Jess Duncan, his art critic girlfriend Harmony Maxwell, and Jess's brother Dave), the Straw Man's keening laughter would be heard and the shambling, grinning figure would appear.

As a hero, the Straw Man was simply terrifying. His primary power was his "strangled" and "soul-rending" laughter, which appeared to have magical powers all its own. With it, the Straw Man is able to control birds, direct the weather, grow new bodies for himself, and more. In fact, the body that the Straw Man wears isn't even his true form, only a "grain-stalk" shell inhabited by whatever exists in the world on the other side of his mystic painting.

The Straw Man's early appearances detail a lengthy battle against the Cult of Kalumai, an old-fashioned type of get-together where everyone is decked out in blood-red robes and wears goat skulls for hats. But if one early letter-writer can be believed, that's not the most interesting thing about the character. In the letter column of one of his earliest appearances, a piece of correspondence (allegedly written by a professor of clinical psychology) lays out what is really going on. The writer describes the story as "a profound psychological essay" and celebrates "the exemplification of the prototypical authoritarian father-figure in the guise of a scarecrow, the frustrated cathexsis of libidinal energy towards the 'Kalumai' (ingenious!), and the subtle Freudian overtones," which are "all too apparent to the trained reader." Well, there you have it.

Despite such high praise, the Straw Man has made few appearances. Along with his unconventional appearance and modus operandi, there was also the problem of his original name. Having spent the first two decades of his existence as "The Scarecrow," the character ran the risk of confusion not only with another Marvel Comics character of the same name, but also with the well-known Batman villain, a wholly owned property belonging to the competition.

Created by:
Scott Edelman
and Rico Rival

Debuted in:
Dead of Night #11
(Marvel Comics,
August 1975)

Known enemies:
Fire, hungry horses,
flying monkeys

© 1975 by Marvel Comics

THE SUPER SONS OF BATMAN AND SUPERMAN
"Clark baby—we must be flippin' ... "

Created by:
Bob Haney and
Dick Dillin

Debuted in:
*World's Finest
Comics* vol. 1, #215
(DC Comics,
January 1973)

Groovy quotient:
Actually, they're
both pretty square

© 1973 by DC Comics

BY 1973, SUPERMAN AND BATMAN had been around for more than thirty years. The kids who'd read the heroes' original adventures were now in their forties and had families of their own. So, in an attempt to keep the Man of Tomorrow and the Caped Crusader relevant for younger audiences—considering that competitor Marvel Comics was making a splash on high school and college campuses—several issues of the long-running *World's Finest Comics* were handed over to the college-age offspring of the most famous superheroes in the world: the Super Sons of Batman and Superman.

Wearing costumes that were indistinguishable duplicates of their fathers' famous duds, the boy heroes went about their crime-fighting under the sound-alike pseudonyms of Superman Jr. and Batman Jr. Their civilian identities weren't any more creative: Clark Kent Jr. and Bruce Wayne Jr. Clark wore glasses identical to his father's everyday disguise, though in his defense, the son of Superman did bear just the merest hint of sideburns.

The Super Sons were intended to reflect the concerns of the college-age audience, and their adventures had them struggling to overcome the generation gap with their stodgy, often-disapproving dads. Beyond that, the Super Sons found occasion to cross swords with hinky self-help cults and suspicious gurus, not to mention out-of-control women's libbers—from space! The Super Sons didn't skimp on the teen slang of the day, either—or at least what the writers imagined that slang to be. Batman Jr. complains of a long trip's "endless highway jive." Superman Jr. laments his lack of "bread." They both refer to women as "chicks" and "dolls"—it's oh so very hip.

That the stories took place in the contemporary 1970s made for a puzzling situation. At the very least, it raised the question of how Superman and Batman were suddenly fathers to teenaged sons. In the elder heroes' individual titles, they remained unmarried and childless, but here Batman and Superman had wives (with their faces always hidden to keep readers guessing) and were no older than they were depicted in the pages of *Action Comics* or *Detective Comics*. Even Batman's sidekick Robin was still a teenager, yet apparently a peer to Batman!

In their final appearance, it was revealed that the Super Sons had only ever been computer simulations, created by Superman and Batman to judge whether fatherhood was a possibility, given the demands of their crime-fighting careers. Briefly brought to real life, the young heroes sacrificed themselves to save the world—although as figments of a computer program's imagination, there's always a possibility that the Super Sons could return someday.

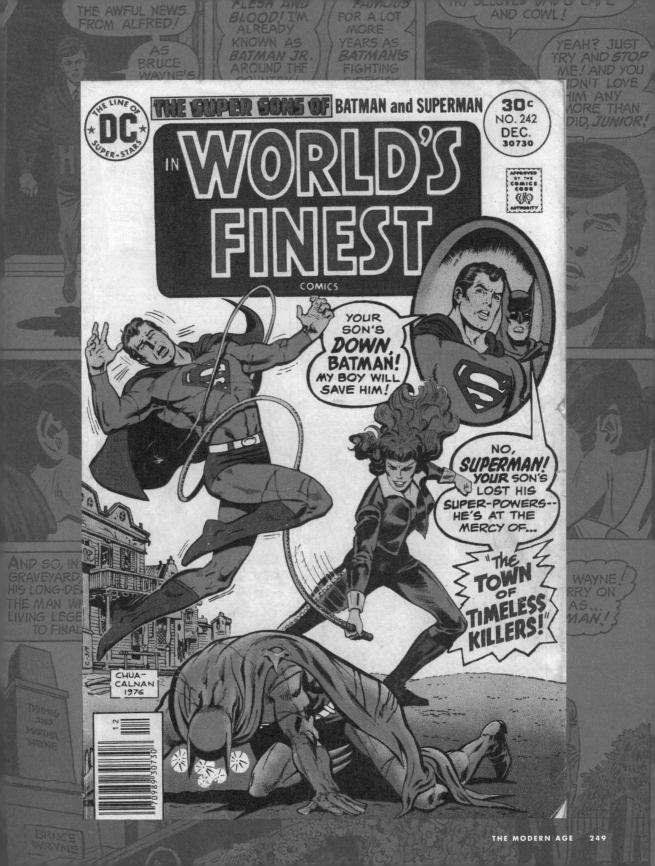

THUNDERBUNNY

"I have great power, but I become a rabbit to use it? I don't know if being a superhero is worth it!"

THE LONG-LASTING APPEAL of superheroes can be attributed, at least in part, to their inherent escapism, especially for young readers. Kids can imagine themselves decked out in a colorful costume and possessing all those wonderful powers, gadgets, and skills. Some heroes, like the original Captain Marvel, capitalize on that sense of wonder by having the hero transform from a child into a superpowered champion.

Such a transformation happens to Bobby Caswell, adolescent comic book fan, when he stumbles across a crashed spaceship. The ship's sole denizen—the last survivor of a doomed civilization—passes on to Bobby the power of his planet's greatest hero. All Bobby must do is concentrate, clap his hands, and he is transformed—into a giant pink rabbit clad in Spandex!

It's an absurd turn of events, though not a completely raw deal. While inhabiting the form of Thunderbunny, Bobby gains tremendous strength, is invulnerable to harm, and can move and fly with the speed of lightning. The one drawback (aside from looking like Bugs Bunny on steroids): the longer he remains in Thunderbunny's impressive cartoon-headed form, the more difficult it is to return to his human self. Bobby Caswell runs the risk of becoming an anthropomorphic bunny *for life*!

Bobby's superheroic career straddled an impressive line between spoof and homage. Facing foes like Doctor Fog, Snaka (an evil snake sporting cybernetic arms), and the robotic Big C.A.M., he also found the opportunity to team up with fellow superheroes the Mighty Crusaders, the THUNDER Agents, and even an assortment of obscure Golden Age heroes like Pat Parker, War Nurse (page 99) and Magicman (page 162).

Thunderbunny was one rabbit who had trouble finding a permanent hutch. The character originally appeared in fanzines—small-run magazines printed, edited, and distributed by comic book fans—before landing at Charlton Comics. When that company sold its stock of superheroes to DC Comics, Thunderbunny suddenly became homeless. Red Circle, a superhero-friendly imprint of Archie Comics, provided an early home, as did Warp Graphics. Thunderbunny then hopped over to Apple Comics, where his luck finally ran out.

Thunderbunny hasn't popped up since then, but it's comforting to know that—as of his final appearance—Bobby hadn't yet been permanently trapped in the form of his lagomorphic alter ego.

Created by:
Martin Greim

Debuted in:
Charlton Bullseye #6 (Charlton Comics, March 1982)

Other career options:
Delivering Easter eggs; outsmarting hunters with speech impediments

© 1982 by Martin Greim

U.S. 1

"I was beginning to forget what being a trucker was all about ... "

Created by:
Al Milgrom and
Herb Trimpe

Debuted in:
U.S. 1 #1 (Marvel
Comics, May 1983)

His current 20:
Hammer down for
the Milky Way

©1983 by Marvel Comics

AH, THE CHALLENGING LIFE of the American trucker: long hours, endless miles, tight deadlines, alien spaceships powered by raw chicken, black-masked whip-wielding motorcycle villains, cybernetic skull implants that allow a driver to control his truck telepathically . . .

The intent of *U.S. 1* was to excite kids' imagination about a set of collectible toy trucks. When the toy line failed to materialize, however, *U.S. 1* developed a spectacular world of its own—a world centered on trucking. *U.S. 1* depicts Ulysses Solomon Archer, natural athlete and born genius. U.S. seems to have a bright future ahead of him, but all he wants to do is drive a rig like his brother Jefferson. Then the pair is driven off the road by the seemingly supernatural Highwayman, a truck driver who sends unsuspecting long-haul truckers to their doom.

Jeff is believed dead in the crash, but U.S. makes it out, albeit in postsurgical possession of a high-tech metal shell replacing most of his damaged skull. Discovering that his skullcap lets him tap into C.B. broadcasts, Archer turns his considerable intellect toward outfitting his rig (the eponymous U.S. 1) with electronics more advanced than NASA mission control. His goal: find the Highwayman!

U.S. 1 exists in an entertainingly absurd world where long-haul trucking is the alpha and omega of existence. The battle for the highways even attracts the attention of an extraterrestrial race (who, of course, speak English by way of C.B. lingo: "Breaker breaker, good buddy!"). Every struggle seems to find its way back to the truck stop dive the Short Stop and its thematically nicknamed regulars (Wide Load Annie, Retread, Poppa Wheelie, and—straining the credulity of fanciful nicknaming—a wild-child lady trucker named Taryn "Down the Highway" O'Connell).

Archer faces Baron von Blimp and his Neo-Nazi soldiers; runs a deadly cross-country race hauling chicken parts at the behest of the checker-suited Chicken Colonel; and discovers his rig can be commanded telepathically, thanks to his C.B. skull. Then he confronts the Highwayman on the biggest stage of them all: outer space! As his alien pal "Al" explains: "What the universe really needs are truckers . . . men of courage and intelligence who are strong-willed and independent! Men who could stand up to the rigors, and most especially the solitude, of space!"

Freed from the limitations of earth-bound stories, Archer's rig is converted into a space-faring cargo vessel, the Short Stop is rebuilt as the space-based Star Stop, and U.S. Archer drives the great two-lane among the stars.

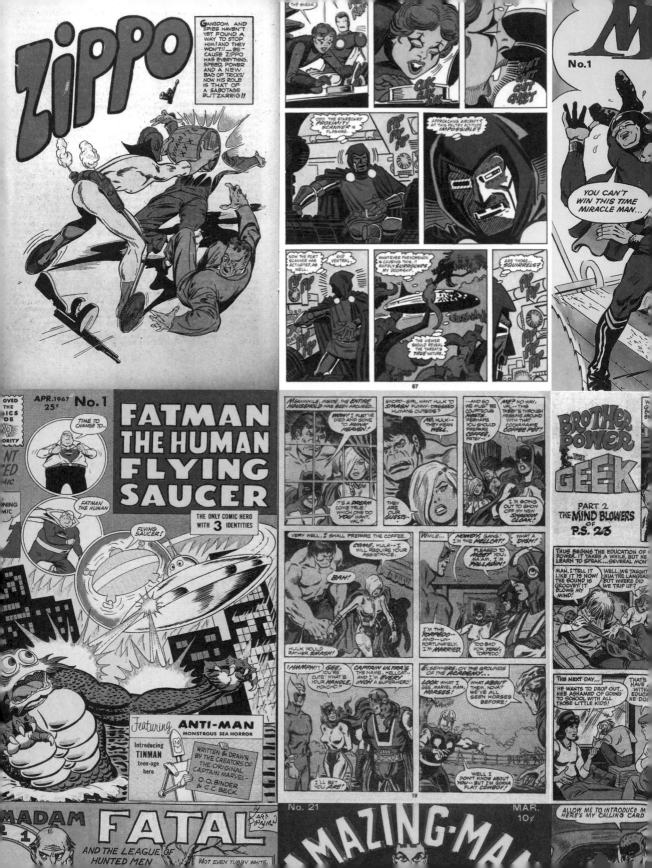

ACKNOWLEDGMENTS

The author would like to thank the Digital Comic Museum (digitalcomicmuseum.com) and Comic Book Plus (comicbookplus.com). Without their tireless archivists and exhaustive catalogs, the research for the majority of this book would have been impossible.

Thanks also to Jess Nevins for his invaluable *Encyclopedia of Golden Age Superheroes*, and additionally to the late Don Markstein for the always entertaining Toonopedia.com. Gratitude is also extended to the works of Les Daniels, Ron Goulart, and Gerard Jones.

Thanks to Hope Nicholson, associate producer of *Lost Heroes* and cofounder of Nelvana Comics, for her insight and feedback on Nelvana of the Northern Lights. Thanks to blogger Rob Kelly for material relating to Holo-Man.

Additional thanks to BillyWitchDoctor, NegroFrankenstein, NeoFishBoy, James W. Fry III, Wooly Rupert, and all the other regular commenters on my blog, *Gone&Forgotten*. When I couldn't think of anything dumb to say, you were there to pick up the slack. You're heroes, every one of you.

And lastly, thanks to everyone at Quirk Books!

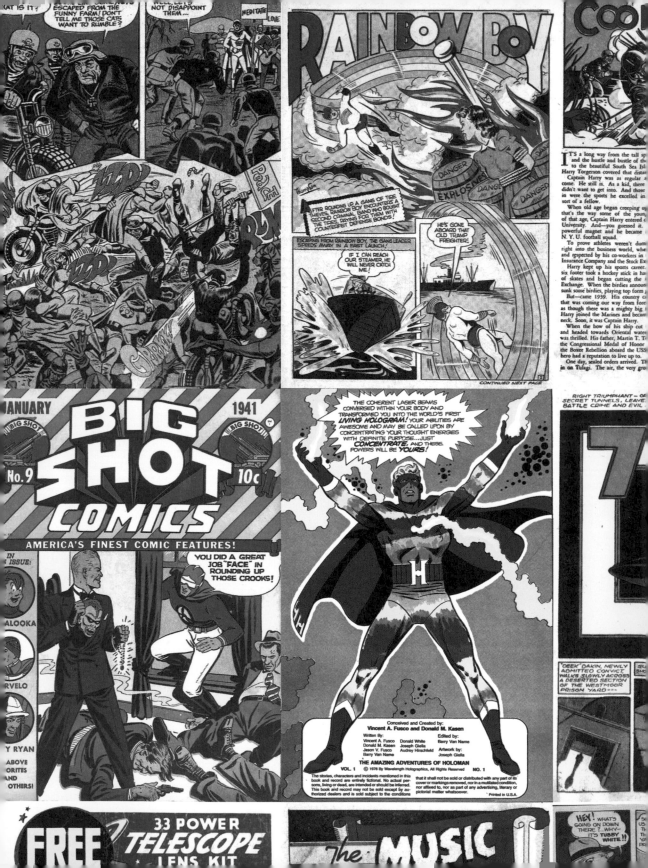